blood loss

blood

Duke University Press
Durham and London 2024

loss

A LOVE STORY OF
AIDS, ACTIVISM, AND ART

Keiko Lane

© 2024 DUKE UNIVERSITY PRESS. All rights reserved
Printed in the United States of America on acid-free paper ∞
Project Editor: Lisa Lawley | Designed by Aimee C. Harrison
Typeset in Minion Pro and SangBleu Kingdom by
Westchester Publishing Services

Library of Congress Cataloging-in-Publication Data
Names: Lane, Keiko, [date] author.
Title: Blood loss : a love story of AIDS, activism, and art /
Keiko Lane.
Description: Durham : Duke University Press, 2024. | Includes
bibliographical references and index.
Identifiers: LCCN 2023050716 (print)
LCCN 2023050717 (ebook)
ISBN 9781478030799 (paperback)
ISBN 9781478026556 (hardcover)
ISBN 9781478059783 (ebook)
Subjects: LCSH: Lane, Keiko, 1974– | AIDS activists—California—
Los Angeles—Biography. | LGBT activism—California—Los
Angeles. | Art—Political aspects—California—Los Angeles. |
BISAC: SOCIAL SCIENCE / LGBTQ Studies / Gay Studies |
ART / Art & Politics | LCGFT: Autobiographies.
Classification: LCC RC606.55.L36 A3 2024 (print) | LCC RC606.55.L36
(ebook) | DDC 362.19697/920092 [B]—dc23/eng/20240509
LC record available at https://lccn.loc.gov/2023050716
LC ebook record available at https://lccn.loc.gov/2023050717

Cover art: Cory Roberts Auli (1963–1996), *Power in America*
(Heteros), 1994. Blood on drywall, 96 × 72 in.

For my families,
the living and the dead

▲▶

Each night we sit around this table in America,
two stones, the wooden bowl
at its center. When
you were gone
the bowl held plums and we wrote
our words addressed to wherever you were
though the letters would never reach you
come home.
The history of each of us
is a call across distance
trying to name so many wounds
until finally we call death
an absence
when nothing can name the absent
their constant falling from this world.

MAXINE SCATES, "THE BORDER"

Let's face it. We're undone by each other. And if we're not, we're missing something. If this seems so clearly the case with grief, it is only because it was already the case with desire. One does not always stay intact. It may be that one wants to, or does, but it may also be that despite one's best efforts, one is undone, in the face of the other, by the touch, by the scent, by the feel, by the prospect of the touch, by the memory of the feel. And so, when we speak about *my* sexuality or *my* gender, as we do (and as we must), we mean something complicated by it. Neither of these is precisely a possession, but both are to be understood as *modes of being dispossessed*, ways of being for another, or, indeed, by virtue of another.

JUDITH BUTLER, *UNDOING GENDER*

contents

the problem of the story

WE WANT TO IMAGINE that there might be a time after. We want to remember a time before. There is no before. Even when we can call up some narrative of our lives before, there is no feeling that, in its recollection, is not refelt and reimagined through the anticipatory veil of what we have seen, what lives in our bodies and in the hollow echo of our stilted breath. We remember the first hospital the first hospice the first dying the first death the first memorial bonfire. We want to imagine that there will be a time after. But there won't be. Having lived through (though maybe not survived), there is no future in which this did not happen.

◤

CORY CALLED ME TO HIS HOUSE in the middle of the night during the first week of queer rebellion in response to California governor Pete Wilson's veto of AB-101, the 1991 queer housing and employment nondiscrimination act. Cory had been thrown to the ground by riot police, trampled, hog-tied, beaten, detained. Released, he was home again, alone, and wanted me.

He told me he had been hurt, but still I couldn't have prepared for the damage. I walked in the door of the darkened house and leaned up to kiss him. He turned his mouth away from me, and my lips ricocheted off his jaw and he winced. He had showered but couldn't bear to put clothing back on his wounded skin. He was standing naked in the dark living room. I turned on the light in the corner of the room to look at him closely. His skin was scraped raw along his arms, jaw, cheekbones, legs, and chest. His lips were swollen and split. His chest, arms, and back were blooming with deep purple bruises from the knees and clubs of police who had thrown him to the ground, pinning him down. "Oh, my love," I said, and reached my hand to his cheek. He caught my hand in his and said, "Gloves."

It felt like hours, like days. I held ice packs to the visible bruises, and to his shoulders, which had been badly wrenched while he was handcuffed. I kept fighting with the gloves, which were too big for my small hands, trying to roll the glove fingers tight against my fingers, the latex slippery with antibiotic ointment. Frustrated, I started to take the gloves off. "Leave them on," he said, clenching through the pain as I gently palpated his shoulders, trying to distinguish between the swollen, spongy texture of bruised muscles and the frayed-rope edges of torn ligaments, his nerves battered and pinched in the swelling tissue. I kept wiping away streaks of ointment and blood. "I can't feel what I'm doing," I said, trying to push back the excess latex pooling around my fingertips. I bandaged him the best I could, stanching the bleeding from the deeper cuts on his arms, and we crawled into his bed.

We fell asleep in our usual pose, his arm draped across my chest, his face against the side of my face, my hands laced through his hands.

I woke up in the still-dark of not-quite-morning, hot and itchy. I slipped out from under his arm and walked to the bathroom. When I turned on the light and looked in the mirror, there were thick streaks of dried blood across my forehead, cheek, and lips where his cracked lips must have bled in his sleep. I could taste the sour iron residue of blood against my tongue. The metallic tang made my eyes water. My arms and hands were covered in blood, and my chest was painted with patches of still sticky and drying blood

from the wounds on his arms, which must have reopened where I hadn't bandaged them tightly enough. He'd bled through his bandages and then through my shirt.

Back in the bedroom, I turned on the bedside lamp and reached for his arm. He groaned, still half asleep, turning his face away from the light and pulling his arm away from me. "Sweetheart, let me see," I said, and took his arm back. "No hospital," he mumbled, and closed his eyes. Immediately his breathing deepened back into exhausted sleep. I pulled off the soaked bandages at the incision on his arm that I couldn't see clearly earlier, couldn't feel with gloves. It was one small, deep gouge in the middle of a long scrape. I didn't think it needed stitches.

I went back to the bathroom to get gauze, tape, a clean, damp cloth. I used my arm to push my hair out of my face, trying not to touch my eyes with my hands. I made a decision. Without the too-large gloves I could feel the subtlety and depth of the wound, where it opened, where it closed. I could feel the boundary of the outer layer of skin protecting the inner layer of vulnerable flesh. I felt the edges of the wound, washed it, patted it dry, applied more ointment with the naked pad of my index finger, then wrapped it again.

He only stirred a little, his breathing steady and deep, as I taped the gauze in place and turned out the light. Back in the bathroom, I put the first aid supplies away, then stripped and got into the shower, where I washed the blood—Cory's blood—from my arms, my chest, my face, and scraped it out from under my fingernails.

Dried blood, when washed, doesn't rehydrate, doesn't thicken back to crimson viscosity, but flakes off, sticking to the shower floor like chips of black gold at the bottom of a snowmelt river.

Standing in the spray of scalding water, my muscles coiled tight, my anger building and boiling, my fists clenched. A few nights before, we'd been up all night as part of the night-watch security team at the encampment where Rob was on hunger strike demanding that the governor sign the bill, which he had now rejected. A cold fall night, we'd paced to stay warm, vision gritty with fatigue, watching for bashers who might come in the form of vigilantes from the conservative church down the coast, or in the form of the local police department. I slammed my fist hard into the shower wall. The week before that, we had been up all night with Robert in the hospital, waiting for test results we already knew would, if he was lucky, come back as *Pneumocystis*. I slammed my hand against the shower wall again. Frustration. That midnight blurring of grief and rage. Cory's bloody face flashing in front of my closed eyes. My fist hard against the wall. Then, not wanting to wake Cory, I

wrapped my arms around myself, containing myself within the boundaries of my own arms, trying to slow my breathing. I don't know how long I stood under the pouring water. I couldn't stop crying. As the water cooled, I felt the sting of it hitting my raw skin. I had dug my fingernails into my arms and broken my skin, dragging thick scrapes from my shoulders to my biceps. My blood, brighter red and still liquid, poured down my arms in the spray of the shower and swirled around the dried flakes of Cory's blood, and our blood ran down the drain.

Cory stayed asleep when I crawled back into his bed. I rested my palm against his chest, and his muscles twitched and trembled as they began to relax and let go of their tension. As the gray light of morning pushed through the window, I checked that he had not bled through his bandages again and pressed my lips to his forehead as gently as I could, feeling for fever. I used my unbloodied hands to push my hair back away from my face. My arms had stopped bleeding, the raw tracks in my skin covered by a worn-thin SILENCE = DEATH T-shirt. In his sleep-delirium, Cory rolled toward me and draped his now tightly bandaged arm across my chest.

<div align="center">⬩</div>

I'VE CARRIED THAT NIGHT in my memory, in my body, since October 1991. And I pause, stuck, every time I try to tell it. Mary says, "Just tell the story. It's a love story. Tell the whole thing." And Mary is right. It is a love story. And it isn't just the story of me and Cory, though it is that story. It is also a little of the story of Steven, of Robert, of Mary and Nancy, of Jeff and Pete. It is the story of a queer family, how we found each other, how we've loved each other and held each other through space and time. How we've failed each other.

The problem of the story is the problem of memory. Each flashing image is one moment in time: Cory. Me. A cottage in Echo Park set into the side of a hill. The middle of one night. One decision. One moment of intimacy. And it is also the story of thousands of queers coming together to rebel against systemic oppression. To rebel against erasure. It is the story of the violence done to queer bodies. That violence is at once specific—Cory's body, Cory's battered limbs, Cory's broken skin—and symbolic—the ways in which most of us have been beaten, body and psyche, by forces both named and unnamable. And it is also the story of blood and the fragile boundaries of skin, the permeability of the air around us, our insistent desire to touch each other without anything between us. It is the story of our plague, which has not ended.

And as I write this, I hear the voice of the Showman, that underworld guide from *Queen of Angels*, the last play Jim wrote before he died, declaring in act 1:

> At the tym o the telun twaz a tayl withowt no indun
> 4 the playg that wuz visatun wuz stil desindun.
> Thiz stowree thin iz kunsurnin a man
> Hu luvd an lawst hiz fren 2 deth.
> An the lezun he lurnt wuz
> That he had not the kupasitee 2 breeng hem bak.
> Tiz the stowree so 2 speek o bekumun hewmun.[1]

> [At the time of the telling was a tale without no ending
> For the plague that was visiting was still descending.
> This story then is concerning a man
> Who loved and lost his friend to death.
> And the lesson he learned was
> That he had not the capacity to bring him back.
> 'Tis the story so to speak of becoming human.][2]

Some of these stories we've told. Some of these stories we tell together, trying to remember. Other stories happened in our private griefs and rages, and we've kept them hidden all these years, even from each other.

Mary says, "Tell the story, the whole story." But what is the story? It migrates, changes shape through the telling. I tell it, and it gets fixed in time. But in what time? And with what language? I tell it and wonder who the "I" is who speaks. The "I" who loved Cory, who loved Steven, who came of age into the fierce rebellions of ACT UP, has been changed. There is no way to travel back and tell it as it unfolded, as though it had not yet happened, and we had not seen what was to come. So, what did happen to us? To all of us who were there? The "I" who remembers and speaks now is the "I" who was created by the experience.

Does the process of remembering change the story? Neuroscience tells us that every time we remember and recollect and renarrate, we change the story, shift the point of focus, shape it to whatever image or feeling we are most driven by in that particular moment of telling. It isn't that we're lying, it isn't exactly that we're remembering something we had forgotten but simply that memory is a process of associations. We archive by association, and from association we call forth our embodied archives. We remember things not as they happened but as we felt them. Our lives move forward, collecting experience and feeling, and we drag our stories with us. We drag our ghosts into our imperfect, shifting embodied present.

Memory, like loss (or as loss?), as Jim's Showman tells us, is the process of becoming human.

In our queer world, things don't happen in order. We remember as we tell it, associating one moment to the next. When we all try to tell the story together, we are less of a chorus, synchronized, harmonized, than we are a quarreling murder of crows, cawing over each other, associating differently, asserting our singular, fragmented, discordant memories. Our singular, fragmented, discordant bodies.

We also remake our stories to avoid association. We want to forget as much as we want to remember.

We feel crazy when we convince ourselves that the story happened one way, but our bodies remember it another way.

There are so many ways the heart can be broken. And there are so many ways the body can be broken.

The great koan of AIDS veterans may be this: How is it possible for the plague to live in our bodies even when it doesn't live in our blood?

I won't be coy. I'll tell you that I came through the worst of the plague years seronegative, and I have stayed that way. I don't know how. The plague lives

not in my blood but in my sense memory. The way I curl my body around the absence of those I've loved and lean toward the ones who are still here.

Our queer family has become a space defined by absence. Those we've lost. The parts of ourselves we've lost along the way. When we rebuild, we're different. Maybe we're supposed to be different. Maybe that's the point of having loved. Of having lost. Of surviving still. Becoming human is one long story of love in the face of loss. And loss coming anyway.

The poet Carolyn Forché, who has documented the atrocities of the twentieth century through the archives of poetry, believes that when poets bear witness to the world, everyone they tell becomes responsible for what they have heard and what they come to know. What do we now know? Cory was a poet and a painter, his medium was words, and his medium was blood. Jim left plays. Steven, novels. They bore witness and did not survive. And those of us who witnessed their lives, who lived through them, with them, what is our responsibility? To the living? To the dead? The witness becomes a participant and is changed.

This story doesn't start at the beginning. It starts now, in the middle, radiates forward and backward in time, in feeling.

I'll tell you now what you've already guessed. In this story, Cory will die. Most of them will. That is neither the beginning of the story nor the end.

What we do to try to save each other, what we do to try to forget. The memories that won't be banished. That's the story.

the beginning

ON THE EVE OF WORLD AIDS DAY in 1990, Susan and I were sixteen, and juniors in high school. She called me late that Friday night, telling me to get ready for an all-night vigil. Highways Performance Space is tucked off of 18th Street in Santa Monica, the neighborhood quiet late at night, an uneasy truce of warehouses, newer trendy shops, and long-established bungalow-lined blocks where residents were just on the edge of being priced out of their family homes. Susan and I took all of this in as we parked on the dark street and walked into the arts complex.

What I remember about that night is as fragmented as the night itself. Even now. Memory as snapshots.

The permanent installation of the gallery space at Highways is an ACT UP project. The concrete floor is tattooed with Sharpie ink. Names of AIDS dead cover the floor. To walk through the gallery space, looking at the photos and paintings on the wall, is to walk on grave markers, sometimes all that is left, of the plague-vanished.

The back warehouse at Highways had not yet been converted into separate workspaces for artist residencies. It was mazelike that night, lit by candles. We started in a circle on the Highways stage, all of us talking quietly. How many of us were there? Did people come and go throughout the night? I looked around the candlelit circle, recognizing faces from antiwar Saturday mornings, from the pride march with ACT UP, from clinic defense mornings, and from A Different Light Books. A man I had seen in almost all of these spaces held out his hand to me. "Welcome," he said to me that night. Is he still alive?

Throughout the night people performed, read, spoke. I had not, at that point, lost anyone close. We knew people who were sick, but the fragmentation of constant, breathless, multiple loss had not yet permeated our life. And yet as we moved from room to room listening to the testimony offered into the space, I was, I recognized, in some deep and unarticulated way, home.

Fragments, feeling more than images, when I think back to that space. When I call Susan to ask what she remembers about that night, she leaves me a message saying, "There is so much that is vivid and so much that is hazy. It was one of the most memorable dance experiences of my life, that quarantine experience. Sleeping, not sleeping, mostly not sleeping. Talking, not talking. Candlelight. Moving around the space. Understanding we had happened onto something amazing."

When I hear her message, the word *quarantine*, it all comes back, not clear images, but feeling, fragmentation. Candlelight, sometime in the middle of the night, as we followed performers from space to space.

We follow dancer/choreographer Mehmet Sander into a partially enclosed space. With no words, adrenaline pumping, all body, all of us bodies, he rounds us up, herds us from one part of the room to another, closing in our space. Quarantined.

Sander is known as a physically punishing dancer, his choreography punctuated by deep, crashing thuds—no music to mask the sounds of bodies against each other, against walls, against floors, impact upon impact, deep awareness of the edges of possible space, the edges of bodily integrity, bodily endurance. He pushes us to our internal, wordless limit of tolerance for external restriction.

As Sander controls our movements through the space, some people follow his nonverbal instructions, vigilant, watching the perimeter, waiting to be released, some waiting for a chance to escape unseen. Some push through the group, through the energetic and spatial boundary set by Sander, who, it seemed, was multiple places at once, herding us back, back, back. Others watched, meditative and patient, waiting for a sign. Some paced.

I feel rising in me the push/pull, push/pull, of passive and not-passive resistance. My body still, frozen, spine straightening, muscles pulling close to the bone, externally motionless but also ready to flee. Head high, watching. The bodily tension between obedience and resistance. I close my eyes. Then the images start: A fence line. Dusty, parched gray-brown barren land. Barbed wire. A quiet highway. Dust swirling everywhere. The impulse in my legs to run. In front of me Sander pulses through the space. Behind my closed eyes, Manzanar: the detention camp in central California where my family and ten thousand other Japanese Americans and Okinawan Americans were incarcerated during

World War II. Where my mother was born. Where, as family stories recount, my uncles, who were young boys then, ran along the fence line, watching cars drive along the highway, wondering where they were going. My uncles were warned over and over to stay away from the guard tower where the guards kept their rifles aimed inside the fence. They ran and ran. Right up to the edge.

The movement impulse and phrase that comes to me as stilted sensation, even now as I write it: movement forward, chest leading, balance tipped forward propelling the movement, to a hesitating stop at the edge of a visible or invisible/felt boundary. Skittering backward, pulled from a curved midback, feet light/shuffling toe-heel, toe-heel, arms across my chest, chin tipped down. Did I move this phrase that night, in response to Sander's boundary? I don't think so. But I feel it, body movement phantom memory. I see it when I close my eyes.

I don't remember the rest of the night. I remember when Susan and I walked out of Highways early the next morning, the gritty gray light creeping over the dusty courtyard, we were changed. Altered from the sleeplessness, from the intensity of ritual and the people who now felt familiar though we didn't know more of anyone's dailiness than we did when we had entered the night before. Had it really only been one night? In the car driving back to Echo Park we were quiet.

After a few hours of separate sleep, Susan and I met up with some of our friends and drove back across town to the demonstration against the looming Gulf War. The closer we got to the war deadline, the more people were showing up on Saturdays. I was still exhausted, still swimming in the liminal dreamscape of the Highways vigil. Dizzy from sleeplessness and the opening of the world under my feet, my sensation of the antiwar demonstration was out of focus and far away. I was mostly quiet, listening to Susan try to describe our night to our friends. Then she stopped trying, and we just linked arms, carrying our NO BLOOD FOR OIL signs, walking in endless circles in front of the Wilshire Federal Building.

I was looking for the queers. I spotted a few and wondered where the rest were, if there was some other World AIDS Day event where they all were. This was the beginning of the tug toward a different world, even as I walked arm in arm with Susan and our friends. One dyke from Queer Nation was at the Federal Building, handing out stickers. We stopped to talk with her and attached her QUEERS AGAINST THE WAR stickers to our jackets. "You should come to a Queer Nation meeting," she said, smiling at us, "Saturday nights, Plummer Park."

WHEN I GOT HOME after the antiwar rally, my parents were already at my grandmother's house, where they spent Saturdays with my mother's siblings, helping my grandmother in her garden. Often when we'd arrive, if my grandmother wasn't in the garden tending rows of beans, leafy greens, tomatoes, and strawberries, she was kneeling on the front lawn, pulling out small weeds, one by one. "So small," I said to her once, when I was little, picking up a weed she had just plucked, its roots hair-thin. She didn't speak much English, and I speak even less Japanese. The one time I tried to take Japanese in school, I gave up: the formal, educated Japanese bore so little resemblance to the Okinawa-by-way-of-Hawai'i-little-formal-education rhythms of my grandmother's speech that I was even more confused. Only a few words were added to our already shared vocabulary made up mostly of food words. But she said, "Pull before they get big." It was a simple idea, kneeling, pulling weeds one by one, but even at age six or seven, something vast and endless scared me. Weed. Pull. Weed. Pull.

So, I had the house to myself that Saturday afternoon after the vigil. I sat on the deck for a long time, looking across the hill as lights were turned on against the early-arriving winter dark.

The hills of Echo Park were nicknamed the Red Hills in the 1920s, when communists and artists began moving to the neighborhood to make art and raise children. In the 1920s, 1930s, and early 1940s, nearby downtown Los Angeles had a thriving Japanese American community. Then in 1942 Executive Order 9066 was signed, and the local police helped the military round up the Japanese community. The community was dispersed to detention camps throughout the West Coast, including Manzanar.

Twenty years after wartime incarceration, my Okinawan American mother and white Jewish father migrated to Echo Park as working-class artists and social workers. Since then, the neighborhood has become home to a generation of refugees from every war the United States has perpetrated: a generation of Vietnamese and Cambodian refugees in the 1970s, Salvadorans and Guatemalans in the 1980s. Slowly the Japanese American community is returning. And always, people cross the border from Mexico hoping for a better life.

I got cold and came back into the house, turning on lights so I could see my father's stereo system, made up of components he had built, delicate switches and strange wirings with specific instructions for turning things on and off. I sifted through stacks of LPs, looking for something to match my

mood, the rising feeling of excitement, terror, recognition, and an unfamiliar sense of calm, which by then might have only been exhaustion from the night before. I settled on *Kind of Blue*, the sounds of Miles Davis, John Coltrane, and Bill Evans filling our small house.

I turned off the living room lights and sat on the floor in front of the tall, cylindrical speakers my father designed. My favorite way to listen to music when I had the house to myself, lights off, music turned up loud, my back pressed to the speakers he painted Ferrari Midnight Blue. The vibration traveling through my spine, rattling my teeth.

My father is a jazz musician. A saxophone player. Our house is the rehearsal space and recording studio for the bands he and his musical partner Ricky have fronted since before I was born. They play a combination of standards and original tunes in their current iteration as the Red Hill Quartet. Ricky's baby grand piano takes up most of our living room, and a set of his vibes lives in the studio. The music studio has a common wall to the kitchen, where my mother and I spend most of our time together, experimenting with recipes, feeding everyone who walks through the front door. Through the wall, and sometimes from the doorway, I've listened and watched as they work out charts for new material. They start with an idea, a chord progression, a rhythmic loop; someone has a bridge they can't get out of their head. And then they play. They fumble and riff off of each other.

I envy the looseness, the improvisational wordless conversations of breath and form, ease and struggle.

I like instructions. I like maps. I like to know what is going to happen next. Even in my own musical training, I'm much more at ease with musical theater. I can sing Stephen Sondheim librettos and Cole Porter songbooks and the later works of Billie Holiday. But I freeze at the suggestion of improvisation.

I used to think that I was the anomaly in the family, born to parents with a kind of flexibility that I lack. My mother can take anything in her kitchen or anything in the garden and make anything from it.

Then she started painting. She works mostly in acrylic on large canvas, and mostly from old family photographs. That's what I stared at as the living room light faded, while listening to the opening riffs of "Freddie Freeloader." My mother's Manzanar painting: there are three layers, the outermost layer Okinawan women in traditional dance, the second layer the barracks of Manzanar, and in the foreground, my grandmother holding my infant mother in her arms, my aunt and uncles flanking her behind the unseen fence of the detention camp. In the other painting in the series that hangs in her painting

studio, the canvas is a split screen. On the right side, in the muted blues and grays of an old black-and-white photo, is my mother as a baby, the image laid over the barracks of Manzanar. On the left side, the lush green lotus leaves of Echo Park Lake, the park near our house, where we would go and feed the ducks when I was little, where we would rent pedal boats and drift in the Los Angeles sunshine. Overlaid and crossing both halves of the painting is an image of my mother's adult hands, one hand outstretched, the other holding a red paintbrush.

Around the time my mother was working on these paintings, exploring her infancy behind barbed wire, the internment camps were invoked as arguments were made for and against the quarantine of people with AIDS. On the California ballot in 1986, Lyndon LaRouche's Proposition 64 would have required anyone with AIDS to be reported to the state, banned from jobs in schools or restaurants, and would have made a path for the government to begin a policy of quarantine. Some of the activists who worked on the campaign that defeated Prop 64 went on to help found ACT UP/LA.

The sky outside the window faded to dark. Sitting in the unlit room, looking toward the walls where my mother's painting hung, even though I couldn't see them, I stretched my hands out, the way hers are stretched out in the painting, hovering over and against the world she came from, and the world she created. The opening bars of "Flamenco Sketches" filled the airspace of the house, the piano and trumpet wailing up through the speakers and vibrating into my lungs. The song was recorded in one take, every catch of breath and unfelt hesitation or reach a part of the exquisite whole. How did they do it? Did they watch each other closely in the studio, reading each other's micro-cues about solos and rhythmic shifts? Or did they just feel into it, trusting each other, and having parallel experiences of the music that led them to the same place? Closing my eyes, I felt my body back at Highways, back in the candlelit circle, back in the darkened wall-less quarantine room, and my body pulled back and forth between the present and the possible.

WHEN I DON'T KNOW how a story starts, I start with the books. I was fourteen, then I was fifteen, then I was sixteen. After school I would go to A Different Light, the little queer bookstore in Silver Lake, sometimes with friends, sometimes alone. Dust motes drifted slowly through the air, lit by the sunlight that filtered through the iron bars on the front windows. I spent afternoons running my fingers over the spines of books, looking for models of who one could be. Of who I could be. Margaret Randall's books came home with me. Adrienne Rich. Audre Lorde. Olga Broumas and Gloria Anzaldúa and Paul Monette and James Baldwin. I looked at the flyers for ACT UP marches and Queer Nation meetings. I began to recognize clerks, who began to recognize me, to ask me about my day at the high school just a few blocks away.

For a few years I had been organizing with the Los Angeles Student Coalition, a collective of young people from across Los Angeles who had initially come together to organize against apartheid. I had come to know of them when they staged a multiday sit-in that shut down the South African consulate. I joined soon after. We had collaborated on citywide demonstrations with the Coalition Against Police Brutality, the South African International Student Congress, CISPES (Committee in Solidarity with the People of El Salvador), Justice for Janitors, and held weekend retreats with Children of War, developing friendships with young people brought to the United States from their war-torn homelands. We worked with ACT UP on universal health care actions and clinic defense mobilizations on Saturday mornings when Operation Rescue would come to the outer edges of Los Angeles County to try to shut down women's health clinics.

With a Central American solidarity organization, I spent a year focused on a project of dialogue and advocacy with a group of student refugees from El Salvador. Though one of the women who directed the organization was bisexual and had come out to me when I had come out to her as a lesbian, I was asked to keep my sexuality hidden, as it might scare off some of the more conservative funders who worked with the Central American sanctuary movement. I agreed to stay quiet. I felt like I had done something wrong, and it would be my fault for taking up too much space if anything happened with the project funding.

I was arrested for the first time at the downtown Federal Building as we linked arms and blocked the building to mark the tenth anniversary of the assassination in El Salvador by US-funded death squads of a Salvadoran

housekeeper and her daughter and the four American nuns and church workers they served. That day the media covered our press conference and our action, our demands for justice and the defunding of the death squads. Then the federal police cuffed us and led us away. It was peaceful, contained, organized. It felt safe, important, and a little distanced. Everything I was reading from the queer bookstore was about organizing where the political was not just personal in ethical and moral questioning but also reflective of interior experience and urgency. I understood why our arrest was important, but I couldn't feel my place within it.

During Saturday morning antiwar gatherings in the late fall of 1990, I watched from a distance as butches in leather jackets and men in dresses, beards, skirts, and beads chatted quietly together and passed out Queer Nation's ubiquitous crack-and-peel stickers in neon brights. I collected: QUEERS AGAINST THE WAR, ANTI-RACIST DYKE, and AN ATTACK ON ONE OF US IS AN ATTACK ON ALL OF US. I watched a Radical Faerie wearing a dark jungle-green camouflage skirt layered over a hot-pink tulle petticoat. I recognized him from ACT UP demonstrations. He ricocheted around federal police who raised their batons at him when he sprinkled flower petals on the Federal Building steps. He blew a kiss at them and danced across the building's front steps.

During the antiwar demonstration at the downtown Federal Building on January 15, 1991, the day of the deadline for the first Gulf War, I watched police use their nightsticks to shove an old man wearing a T-shirt that identified him as a member of Veterans for Peace. I was a member of an affinity group that planned to get arrested as part of coordinated acts of civil disobedience. We staged a guerrilla theater skit on the Federal Building steps that left us covered in fake blood. Then we sat on the steps and linked arms.

As we linked arms and sat on the building steps, the stage blood dripping down our necks, the police began pushing against us with their knees, then with their feet, first a steady pressure, then kicking, low to the ground, low on our backs, unseen by the media cameras covering the war-deadline demonstrations. They began pushing against our backs and ribs with the ends of their batons. We kept our arms linked, yelling back, unheard by the media, who were pushed farther back by the lines of police keeping other demonstrators from us, leaving us surrounded. The police pushed harder.

Our affinity group had talked about the Gandhian strategy of passive resistance, of going limp and refusing to cooperate in any way, allowing the police to haul our bodies away, dragging us up the Federal Building stairs

and walkway. It had sounded like a smart strategy, and I had seen footage of passive-resistance civil disobedience from peace movements around the world. I had wanted to join in that lineage.

As the two officers arresting me pried me from my friends on either side of me, dragging my body back toward the building, my arms twisted behind me, all the force of their pulling and my body's resistance caught in the torque of my shoulders. I tried to go limp, passive. Then something inside me stiffened. Rebelled. Terrified deep in my belly, unwilling to turn my body over to the state, unresistant to their violence. As they pulled, I pivoted and pulled my feet under me, leveraging against the baton against my back and standing, holding my head high, neck stiff from the effort of pulling myself upright, looking back over my shoulder as my friends, some dragged, some also standing, were handcuffed and led away.

While we were in a holding cell in the basement of the Federal Building, we sang and paced and worked to loosen the plastic handcuffs looped tightly around each other's wrists. The guards began cheering when the United States dropped the first bombs on Iraq. They watched the bombs fall on their small TV. What I picture, when I remember the sounds of the cheering over the drone of the network news, is Susan's back, her tangled blonde curls near my lips as I tried to loosen her handcuffs.

After we were released from jail, someone sent me two photographs of me being arrested and led away in handcuffs from the front steps of the Federal Building. In the grainy black-and-white photograph, my T-shirt, which can't be read from the distance of the photographer but reads I AM YOUR LOVER, is covered in blood. A friend, standing handcuffed next to me, whose T-shirt reads I AM YOUR BROTHER has our guerrilla theater blood running down the side of his face.

A FEW WEEKS AFTER THE GULF WAR deadline, I finally made it to my first Queer Nation meeting. I paced all evening, stalling, watching the clock. Nervous. Deciding. Even with my careful plotting of crosstown arteries on busy Saturday nights, I was late to the meeting. I parked in the crowded parking lot and stared at the low buildings of the community center. Through one window I could see a group of people sitting in an orderly circle, quietly listening to each other. From the other branch of the building, I could hear loud voices, snapping, cheering. Across the courtyard, through the open door, I saw splashes of color. I walked toward that room.

A pierced, tattooed Japanese American man stood by the sticker- and flyer-covered table by the front door. He smiled at me as I walked in the door. "Hi, I'm Eddie." "Hi, Eddie. I'm Keiko." I looked around, uncertain of where to go. There were several circles of people scattered throughout the room.

"Oh, they're meeting in committees." Eddie pointed at different circles. "Um, queer street patrol, some sort of march, a response to police brutality, gender and dynamics in the group. Welcome committee is usually over there." He gestured toward the far corner.

I stood and watched. Each circle had men in skirts and dresses and men in jeans and T-shirts. Each circle had women in lipstick and women in leather jackets and heavy boots. Some people were genders I couldn't easily identify. And each circle had people of different ages and different racial presentations. I looked at the corner with the newcomers' circle. Later I would come to know Richard, who wanted to make sure that all queers felt welcome and so, with his gray beard and sweet smile, led the breakout group most weeks. I thought about joining them, but then I noticed that another circle had people I recognized from the bookstore and antiwar demonstrations. I made my way across the room to that circle and pulled a chair to the edge. I don't remember what they were talking about, but I remember the energy of the exchange, the way they were confident, adamant when they spoke, cheering each other on, or disagreeing but mostly listening to each other. The men mostly did not talk over the women.

When the committees stopped to take a midmeeting break, a few people smiled at me, nodding for me to follow them. Outside in the courtyard, people introduced themselves to me, asked me who I was, welcomed me. That first night I was acutely aware of being the youngest person in the room, but not because they were dismissive. The opposite. They wanted to know what I needed. I had no idea.

A lithe man wearing jeans and a leather jacket that had a sticker declaring INFECTED FAGGOT smiled at me from across the room. He started walking my direction but was intercepted by Richard. They hugged and kissed and started talking excitedly, but I couldn't hear what they were talking about.

When I think about that first night, it isn't the content that I remember, though I'm sure Judy remembers what the committees were planning, and Kate will remember exactly who was there. They're better at that kind of memory. They always have been. Maybe it was then that our roles began to develop: Judy's steadfast analysis and strategic interventions, Kate's enthusiasm and patience pulling everyone in close, Pete's bulldog time-running-out fury weaving a spell of equal parts protection and provocation, and Wayne's chain-smoking, pacing rants about liberation for faggots, faeries, and dykes.

I remember the feelings. Sweetness and ferocity, tears and outrage when the committees reported back to the whole group after the break. *Who are these people?* I kept thinking to myself. When one committee reported back about the rise in queer bashings and the need to track violence against faggots, Wayne stood up and said, "And dykes. We can't track the faggots without tracking the dykes." When the man who had been speaking asked if the dykes could track themselves, and then maybe notes could be compared after, Wayne let loose and yelled about how the queers needed to take care of each other, that the faggots needed to deal with their sexism, to hold each other accountable, to be in alliance with the dykes. That likewise the dykes needed to be accountable for managing each other's AIDS phobia, that not only the movement but the community would only survive with each other. People cheered after he spoke, snapping their fingers and whistling and calling out in approval.

The mundane and the magical coming together, under the glaring fluorescent lights of the community center.

People stayed after the meeting was over, talking in clusters. Robin, who I had met at the bookstore and antiwar demonstrations, came over to say hello before she left. From across the room I watched as the man with the INFECTED FAGGOT sticker, beat-up jeans, and a leather jacket that hung off of his thin shoulders said goodbye to Wayne. Wayne's fishnet stockings, skirt, beard, long hair, and leather jacket were my first up-close exposure to the particular kind of genderfuck that permeated the community: a loose gathering of signifiers, borrowing favorite elements—both campy and sincere. When they hugged, the zippers on their leather jackets made an audible scrape.

The INFECTED FAGGOT-stickered man made his way over to where I was talking with Judy and Kate. We were somehow already drawn, already curious. His frame was thin in a way that suggested both natural litheness and illness, his hair baby fine and short. His skin was pale, but something in his features and eyes told me that he wasn't white, though I couldn't tell what. He tilted his head to the left, then tipped it quickly back, a glance over his left shoulder, a brief movement phrase I would learn to recognize as his quick assessment, his unconscious recalibration of his sense of ease with someone, which would end in either him turning away or him leading the person deeper into connection. An offering. He stayed.

"So, who are you?" he asked.

"Um," I fumbled. I wanted to be a little offended, except that his smile was teasing and sweet. "Who are you?" I asked.

"Resident fag."

"We only have one?" That was Judy: jet-black hair. Pale skin. Bright red lips. Raising her perfectly drawn eyebrows.

"One of," he amended his statement, "the infected faggots of the family. I'm Cory." He watched for my response.

"Hi, Cory. I'm Keiko."

He smiled at me, relaxing. "Hi, Keiko. So, you're a dyke?"

I smiled back at him. And I paused. For months I had been coveting the unmistakably loud Queer Nation stickers, turning the labels over and over in my fingers, whispering them to myself. But I had not said it out loud to anyone else. I had said *gay*, I had said *lesbian*. I was lucky: I had not been the only one in the Student Coalition who had come out the year before. But reclaiming the language of queerness was still new and contested politics. I was drawn to that edge. But I had not yet said it out loud. And now Cory was asking.

"Yes," I said, trying it on, saying the word out loud, "I'm a dyke."

"You sound uncertain," he said.

"No. I'm not. But the language is"—I hesitated—"new."

"Language matters. If we claim it, say not only is nothing wrong with being queer but we embrace our queerness, then there is nothing left for them to beat us with. You can call me a fag if I can call you a dyke."

I watched how he moved, pacing a little, leaning on the wall I sat on. "Don't scare her off," said Kate, swatting Cory gently on the arm.

"I don't scare so easily," I said, laughing, enjoying the feeling of sitting outside in the cold winter night with these queers paying attention to me,

welcoming me. But it was equal parts bluster and curiosity. Something in me had propelled me across town on a winter Saturday night by myself.

"Would you say if you did?" Kate asked me.

"If I did, what?" I looked more closely at Kate. She was slim, her smile open. She was really listening for my answer. I looked up at her and noticed how tall and long-limbed she was, her head above mine even though she was standing and I had jumped up onto the concrete wall I was sitting on.

"If you were scared. Would you say?" Kate asked.

"Probably not," I admitted, "but I'm not lying. Really."

"Good." Kate smiled wider.

"Why aren't you scared?" Cory asked.

"I have no idea." And I didn't. He paced, which I realized later was more about trying to stay warm than about energy. His movement was something between a swish and a strut, hips loose when he pivoted but shoulders squared. Or maybe not at the same time, but seamlessly and quickly moving back and forth between the two. Not uncommon, I would figure out, among queers who had turned tricks on the street, the need to exaggerate a gendered affect, then switch gears into an amplified don't-fuck-with-me stance.

If you pulled the scope back, looked from above, this is what you would see: Cory, Kate, Judy, and a girl, standing together, talking, laughing, some ripple of history and luck bringing them to this place. Their bodies are all tilted toward each other, almost imperceptibly. It is the beginning of their bodies in relation to each other. Their stances are softening. The girl sits on the edge of the wall, worrying the rough concrete with her fingertips, holding steady, a constantly shifting balance under her fingers as she swivels her head from side to side, watching each of these people, taking them in. She laughs at something Kate says and lets go of her grip on the wall, a wobbling moment of finding balance, automatically reaching out to steady herself in the air. Cory is closest to her, and he just as automatically reaches out a hand, and they steady each other. She can see clearly, for the first time in the evening, that he is profoundly not well under the energy and bravado. They are both aware of how closely she is watching him. Energy running down like sand in an hourglass, not slowing down, not aware of how much time is or isn't left, or maybe just not caring, not stopping. Not cautious. Unrelenting. She is fascinated and frightened.

She will drive back home on the arteries of Santa Monica Boulevard, and Sunset Boulevard, and Echo Park Avenue. She will say good night to her parents, her mother in bed, reading, her father in his music studio, practicing. From her bedroom window she can see lights across the hill that shine from

the bedrooms of queers and faeries who she does not yet know. Against the stillness of the late-night hills, she can hear her father's tenor saxophone start and stop, working out the melancholy melodic phrasing of a new composition. She will fall asleep to the ache of that sound.

She will sit in her chemistry class on Monday afternoon, an ordinary day of her junior year of high school. She will barely pay attention to the lecture. She will take notes in the margins of her notebook, wondering where her new friends are, how they have found their way into the world, in daylight, how they spend their time, how they pay their rent. Over the next few months, the spark of wonder and magic will slip into familiarity and ease. And still, sometimes, wonder.

IT WAS ALREADY DARK on Friday night a few weeks later when I drove into West Hollywood and circled around until I found parking on a residential side street. I heard the noise before I turned the corner onto Santa Monica Boulevard, the main drag in West Hollywood.

"We're here! We're Queer! And we're FABULOUS!!" I could hear the chanting. I could hear counter-yelling but not the words. I rounded the corner onto Santa Monica and saw where the noise was coming from: Wayne, Cory, Judy, Kate, and about a dozen other queers in bright crack-and-peel stickers were forming a human wall protecting the front of the West Hollywood branch of A Different Light Books from about a half-dozen protesters carrying signs that said SINNER REPENT, GOD HATES FAGS, and, in unintentionally ironic tonal juxtaposition, JESUS LOVES YOU.

I stood on the corner, watching, until Cory looked up and saw me. He waved and reached his hand out toward me. I ran over to him and hugged him hello, then hugged Kate and Judy.

"Welcome to Friday Night Fundies," Cory said.

"Fundies?"

"Fundamentalists. They're from Calvary Chapel in Orange County."

"Yeah, I know Calvary Chapel." Susan and I had come across this same fundamentalist Christian congregation many Saturday mornings as they worked with Operation Rescue to try to sabotage and close abortion-providing women's health clinics, and we tried to keep them open.

Cory told me that Calvary Chapel had been sending members of its congregation into West Hollywood to harass queers as they walked along the sidewalks between Mickey's and Rage, two of the main clubs in town, and the West Hollywood storefront of A Different Light Books.

For a few hours we walked parallel to the fundies as they moved along the sidewalk between the bookstore and the bars. There were enough of us to form a tight line toward the street side of the sidewalk, keeping a clear space between the sidewalk and the storefronts where people could walk. Wayne was passing out condoms to the queers walking in and out of the clubs. A broad-shouldered Chicano queer with bright pink hair wearing a shirt so covered with stickers that I couldn't tell what color the fabric was turned and introduced himself as Pete. "Cory told me about you."

I raised my eyebrows at Pete. "What did he tell you?"

"That a new ass-kicking young dyke had just joined Queer Nation."

I turned my back to the fundies and faced Pete, looking at him as he smiled at me. I was trying to think of a smart response, but I couldn't distinguish sweet teasing from what felt like strange, unnamable pressure. Before I could respond, Pete's eyes clouded over. What happened next was so quick I almost couldn't react.

One of the fundies, an older man, comes up behind me, waving a Bible right at me, coming closer, fast. I turn around to face the man as Pete pivots and stands between me and the fundie, who continues waving his Bible. I realize that he is yelling at me, "It's not too late! Save yourself! Come join us!" I'm stunned. He keeps yelling, "Repent! Sinner, repent!" I had faced off with these people before but at clinic defense, protecting a space, access for other women. They had never targeted me as a specific person. I'm frightened. He's so loud. Something in me, some bit of calmness or distance, breaks off, and I'm angry. I take a deep breath and step out from behind Pete, standing next to him, planting my feet firmly on the cracked sidewalk. "I am saving myself," I yell back. "Sinner," he starts yelling at me, more outraged. He lifts his Bible up over his head, yelling louder and taking a step closer to me. Pete steps back in front of me, straightening his spine, raising himself up on the full height of his boots, his arms stretched out, the neon red light from the club behind us making his pink hair glow, taking up as much space as he can, making himself twice as big as the fundie, and keeping me safe behind the reach of his arms. "You can't have our young people!" Pete is yelling as loudly as he can. Cars driving past slow to watch. "You're already destroying your young people! We need to save them from you! Stay the fuck away from ours!"

The fundie takes a step back, enfolded into his circle of people. Pete turns back to me. Kate, Wayne, and Cory have appeared next to me. "I'm fine," I tell them, though I'm trembling. "Yeah?" Kate puts her fingers under my chin, tilts my head up under the streetlamp and the glare of the neon bar sign, and makes me look her in the eye. "Really?" "Really. Fine." And I am. Trembling from adrenaline, but the adrenaline of fear has shifted into something brighter, hopeful, standing up for myself.

The fundies backed off several yards, still holding their signs, but quietly. We were all still charged from the exchange, pacing. Behind us, standing by the entrance to Rage, three young men, equally buffed and tanned, dressed in jeans and polo shirts, clapped. I hadn't noticed them behind us, hadn't realized we had an audience. I smiled.

Pete, however, still high on adrenaline and anger, turned to them with almost as much fury as he had unleashed on the fundies: "Why aren't you out

here with us? You just sit back and let us defend you? You should be out here fighting for your survival! What are you waiting for?" They shuffled uneasily. One of them laughed, which further infuriated Wayne, who had joined Pete and who yelled, "Shame on you!" Pete turned to walk toward the bar. I put my hand out to stop him, my palm wide and flat against the center of his chest. "Pete, let it go," I said. "But . . ." "I know, and you're right, but let it go." Pete stopped pushing against my hand and took a deep breath. He brought his hand up to mine against his chest, and I felt the steady beating of his heart under my fingers. "OK," he said, "for now. OK." Then the men outside of the bar turned and walked back into Rage.

We kept shadowing the fundies, keeping them away from pedestrians. After another half hour, the fundies left. We followed them to their cars, took down their license plate numbers, and watched them drive away.

"Why the license plate numbers?" I asked Judy.

"There's been an increase in queer bashings recently."

"And you think it's them?"

"I don't know. It could be. We want as much information as we can gather."

"Of course it's them," said Pete.

"We don't know that," Kate said, scanning up and down the street, making sure they were all gone.

"No," insisted Pete, "of course it is them. Maybe not those individuals exactly, but it's what they stand for. They'd condone it. It might as well be them."

We were all ready to leave and negotiating walking each other back to our cars.

"Anyone need a ride back to Echo Park?" I asked.

"Sure, I'll take a ride," said Cory. "Are you hungry? I'm hungry."

Twenty minutes later I pull the car up to the curb in front of Millie's diner on Sunset Boulevard in Silver Lake. The waitress, arms tattooed, nose and eyebrows pierced, waves her arm toward the open tables in the small room, then smiles and nods slightly as her eyes scan the neon crack-and-peel stickers on Cory's shirt. We find a table against the wall. Over salads we're telling stories about where we come from and how we got to Queer Nation and ACT UP. He tells me that he's been sick for a few years. "ARC, though, not AIDS," he says. He's playing with his fork, twisting a piece of a stem from his spinach salad. He looks far away. "I haven't been that sick," he continues, "not yet. Maybe I won't be. Maybe there will be a cure." He looks up at me. I don't yet know how to read the look in his eye. Hope. Irony. A dare.

There are so many things I want to say. That of course there will be a cure. That he'll be fine. That we'll . . . That we'll what? Make it through this together? Everyone? I want to have something useful to say, but I don't. He's sitting across the little table from me, my new friend who I am so quickly starting to adore. *Maybe there will be a cure.*

"Do you really think so?"

"No." He puts his fork down and sighs. "They don't care about us enough to find a cure. The faggots and the whores and the drug users. Yeah, I know, not only us. But visibly only us. We're expendable."

I want to argue with him. I want not to believe him. Except that I do believe him. I just don't want it to be true. I'm looking out the window at Sunset Boulevard. We're just down the street from the women's clinic where we gather some Saturday mornings to wait for notice of where Operation Rescue has sent people to shut down other health clinics. We jump into cars and race to the far corners of LA County to keep the clinics open. I know that ACT UP has organized similar kinds of actions to keep open the AIDS ward at Los Angeles County Hospital and to open Chris Brownlie Hospice in the hills a few miles away. But those demonstrations weren't about the fundies. That would have been easier. Those were about the government. And we had almost no power. I look back across the table at my friend.

"I don't regret any of it," Cory says to me, sitting taller, straightening his spine.

"Any of what?"

"Sex. Living. Love. Survival."

"Do you think that I think you should? Regret?"

"No. But that is the story, isn't it? That we should regret. Repent. I don't."

I wonder what it would feel like, not to have regrets. I can only imagine it by keeping still, by not taking risks. But I have already broken the silence, my silence, yelling back at the fundies. I can still feel the vibration in my throat. I don't think I've ever yelled that loud.

"What are you thinking?" he asks me.

"Well"—I take a deep breath; I don't know how to tell him what I'm thinking—"it isn't very Okinawan."

"What isn't?"

"Tonight. Living out loud. Rebellion."

"It's queer."

"Right. So, what do I do? Do I have to choose?"

"You can't choose. You're both."

"It isn't that easy, and you know it." Part of me is frustrated with him, but mostly I could feel myself settling into a deep ease, loving the conversation, loving that it was possible.

"But why isn't it? Shouldn't it be? What isn't Okinawan about tonight? You've been yelling in the streets for years, haven't you?"

"Of course, but it isn't the same thing. Yelling on behalf of something big like war, or even on behalf of other people, is fine. Sort of. It's a sort of negotiated fine enough, about cultural values. We could even make a Buddhist argument for it."

"Your family is Buddhist?"

"Well, sort of. Lineage, not practice. My dad's side is Jewish, but not practicing. My mom's side is now variations of Christian, but before the war, they were Buddhist. Some still are."

"Then explain to me what the problem is."

I stared at him. I couldn't figure out how to tell him what I was feeling, the gut sensation that I was betraying something my family had worked for, just by sitting with him in the little Silver Lake diner where I had spent so much time with Susan and our Student Coalition friends, passing mostly unnoticed. He had a bright green QUEER LIBERATION NOT ASSIMILATION sticker on his chest.

"It's the sticker." I put my fork down, giving up on my salad and pushing my plate away.

"What about it?"

"The Okinawan assimilation dance, at least in my family, has been about how to maintain cultural values about right and wrong but also go unnoticed. To draw attention to myself is to be at risk. To be in danger."

"At risk for what?" He pushed his plate away. We were delighted by the challenge of each other, energized, eyes shining, smiling as we worked it out, out loud.

"At risk for everything." I thought back to the stories of wartime incarceration, families rounded up, months in the holding pens of converted stalls at the racetrack before being shipped to Manzanar. I flashed back to Mehmet Sander's quarantine enactment at Highways on World AIDS Day and told Cory about that night.

He listened to me, his eyes tearing when I told him about the push-pull I felt between rebelling and freezing. He took a deep breath before speaking. "Do you really think that they don't hate us if we don't stick out? They just don't notice. So, we live in fear, and they get to be in charge through their obliviousness, and we don't know who might stand up for us. With us. When

they notice, they hate us, or they don't hate us, but we know it, know where we stand. And we don't spend our energy hiding. And when we hide, we have a harder time finding each other. What if it's the Okinawan in you that connected you to queer rebellion?"

I'm silenced by this idea. "Keep talking," I said, my breath catching a little, excited and scared of what was coming next.

Cory continued, more emphatically, "Any form of survival is an act of rebellion when they don't want us to survive. It doesn't matter if it is silence or screaming. That's the thing, our survival is the rebellion. Our bodies are always on the line. Always at risk, whether it's infection or quarantine."

"And so," I picked up where he left off, trying it out, "we put our bodies on the line for each other, for ourselves. It could always be any of us. It isn't just an idea. It's our experience as bodies in the world."

Both of us were teary. At some point in the conversation we had reached for each other's hands, and our fingers were interlocked on top of the table. We kept them there as the waitress came and cleared the remains of our salads. We were quiet for a few minutes, taking each other in. I felt the heat of his palm, the cooler, soft tips of his fingers.

Putting our bodies on the line for each other. What else is there? I still think about that first conversation with Cory, how certain we were, how some parts of us wanted to believe it would be enough. That we could save each other.

THE NEXT NIGHT AFTER FRIDAY NIGHT FUNDIES and my late-night dinner with Cory, we're back in Plummer Park for the Queer Nation meeting. Again, Eddie is standing by the table of stickers and flyers by the door and welcomes me. I watch as he assesses me again, and I catch the quick nod of recognition. I look at him, stickers on his sleeve that say QUEER'N'ASIAN, thick piercings through his ears. Could I be both, simultaneously enough so they overlapped into one integrated self?

Committees are reporting back about their work of the week. I'm starting to feel at home in this room, to recognize people, to light up at the returned smiles of faces I've secretly watched in the community for years, now smiling at me. Under the glaring lights, someone talks about the beginning of a plan to address homophobia in Hollywood. Someone else gives an update about the week's queer-bashing statistics. Kate is sitting on one side of me in the circle, Cory on the other. When it is time for a report on Friday Night Fundies, I look around the circle, waiting for Judy or Pete or Kate to speak. Kate turns to me: "You tell it." I look at her, a little panicked. I have not yet spoken on the floor of a meeting. I look across the circle at Judy, who nods. I take a deep breath and look around. I feel my feet on the floor, the straightening of my spine, lifting at the chest, the surge of energy in the room. I feel Kate's hand lightly on my back, supporting me. I tell the story about Pete saving me from the fundie. Then I spin a story about the gay guys outside the bar, watching but not participating, who turned against us when pushed. I wonder out loud how we can demand accountability from the community while still inviting them in, without taming our anger. Wayne is across the circle, snapping his fingers. I feel the warmth of Cory's body next to mine. Pete nods at me, smiling, from the left side of the room, his cropped pink hair glowing.

Do I know in that moment, as I look around the circle, how many of the men in the room won't be alive in five years? That we won't be sitting together, how much smaller the circle will be? The fluorescent overhead lights flicker, and for a moment in the overexposing light, Wayne and Cory both look ill. Pete's skin and glowing pink hair have a yellow undertone. Part of me is speaking, telling the story of Friday Night Fundies and making them laugh. Part of me is memorizing everything: Kate's laughter, Pete's pink hair, Judy's bright red lips, Cory's baby-fine hair.

What did I know that night about who these people would become? How long did it take for us to become a family?

Even in the retelling, or maybe only in the retelling, there is the stress of chronology, which is the fantasy of futurity crashing into what is already memory. We want to hold every moment, remember everything, begin the narration as it is happening, as though it has already happened, eliminate that horror of recognizing everything we hadn't known we could lose. We fight for the focus of specificity, of each story, of each storyteller. Their authority. Holding them in time with us.

We hold the moment both as itself contained and as the amplified foreshadowing of what might come next. Nothing is what we expect. No moment of connection random, casual, incidental. We fought for it. Every moment of it.

The idea that what doesn't kill you makes you stronger is bullshit. It isn't true. They aren't opposite, don't cancel each other out, the strength and the dying. That was what we learned. Even when we didn't die. Parts of ourselves broke off, lost, abandoned, unsavable. Scars formed in those places. Tough, nonelastic tissue. Unbreakable and tender to the touch. So tender.

How does intimacy develop? Do we notice as it happens, or is it what we remember in the retelling?

What do I remember?

There's the first kiss. The first sleepover. The first test. The first blood draw. The first illness. The second kiss. The first fight. The first hospital. The first middle-of-the-night delusion. The second fight. The first terror. The turning away. Then the coming back. Always the coming back.

THE GENERAL MEETINGS OF ACT UP and Queer Nation were electric. We moved against the respectability politics of elegant victimhood and gestured toward an erotics of fury and risk, lush with the energy and vitality of insistent survival. There was the vulnerability of not hiding in a corner. Grief and loss exposed as an organizing force. We would not be innocent victims. We were not the same as, not seeking assimilation or invisibility as negotiated terms of longevity. There were a few heterosexual members of ACT UP, but they were either already outsiders before their diagnosis or were entering outlaw territory because of their experiences of HIV discrimination.

In both organizations there were people who had been organizing for most of their lives and people who were new to grassroots movements, new to community, and new to the experience of outsiderness in the dominant paradigms of power that necessitated our organizing at the policy level and at the level of direct care and attention. The electricity was the rubbing together of recognitions and action, of having a place and being encouraged to bring one's whole self. Every skill was recruited.

The entire week could be filled with ACT UP meetings. The general meetings for ACT UP were on Monday nights, and there were committee meetings every other night of the week. Sometimes we ducked in and out of multiple meetings on the same night. Some people had committees that were their home base. Women's Caucus. People of Color Caucus. Prisoners with AIDS Advocacy Committee. Legal and Agitating. Fundraising. Arts and Graphics. Treatment and Data. Clean Needles Now, the pilot needle-exchange program in Los Angeles, began as a project of ACT UP before splitting off into its own organization and structure. On Sunday mornings the Coordinating Committee met at the ACT UP office (often followed by brunch) to work out the agenda for the following night's general meeting. Committees vied for floor time to recruit members for detailed work, to report back on coalition building with other organizations, and to get approval for large demonstrations, and then to report back with updates as plans were worked out in committees.

I migrated between committees depending on which actions I was working on. And within large committees there were affinity groups (smaller groups of people who organized specific actions or campaigns) who kept track of each other and took care of each other at demonstrations and covert actions—a kind of activist buddy system—making sure people were safe

and kept each other out of jail, or, failing that, bailed each other out. Affinity groups were often action and project specific but, amoeba-like, merged and pulled apart, with recognizable core groups of people who built deep trust together.

In ACT UP, projects and public health policy interventions were brought to the floor—the general meeting—for approval before being executed by smaller committees. There were often long, frustrated and frustrating debates as people spoke for and against proposals. Everyone had a stake in each proposal, and each one felt like life and death were the only possible outcomes. Sometimes that was true. Each side was that certain. That level of urgency. All the time. It was the job of the prechosen and trained facilitators to keep meetings on task and on schedule. The room was set up in a giant circle, and everyone could track everyone else. If there were too many people at a meeting to contain within the circle, another circle was set up behind it.

Unless I was directly part of a committee organizing a proposal, I was mostly quiet during ACT UP meetings. I liked the back of the circle, against the wall, by the door. Cory sometimes sat back there with me, and sitting by that door I got to know Robert, Gabe, and Pete. We'd listen to the arguments on the floor, and they'd tell me the backstory. Often those details, not filled in on the floor, were about the tension between pushing for drug releases and clinical trials so quickly and desperately that some of the men were willing to compromise and propose to support trials that excluded women, instead of continuing our ongoing fight with the CDC (Centers for Disease Control and Prevention) to change the definition of AIDS so that women were more accurately diagnosed and treated. The Women's Caucus held steady, along with a majority of the men, pushing back against policy and treatment proposals that would exclude anyone living with HIV. Pete and Nancy whispered to me, explaining the nuances of the criminalization laws that left PWAS (people living with HIV/AIDS) as well as people of color, IV drug users, and sex workers, who were assumed to be seropositive or at risk for seroconversion, vulnerable to police targeting and therefore were deterrents to testing and treatment.

I soaked up all the information I could. I'd take away the Xeroxes from Treatment and Data and from Prisoners with AIDS Advocacy, reading them when I was supposed to be studying European history and chemistry. It was a lesson not just in policy and biochemistry but in opposition prep—learning to read the news not just with skepticism but with the filter of historical context and knowledge. Though I had read the news that way for years in

relation to global news, union and labor negotiations, education, and health care policy, this was my first up-close life-and-death stakeholder experience of being targeted by misinformation.

Even though there was a huge overlap in membership, Queer Nation functioned very differently from ACT UP. Saturday nights we sat in a big circle in a room on the other side of Plummer Park. Facilitation rotated through whoever could be coaxed into attempting to steer the room of unruly queers. People were encouraged to take up space—and simultaneously people who were historically granted more space (mostly able-bodied, white, cisnormative men) were encouraged to step back and make space for women, people living with HIV, and queers of color to step forward. There was never an easily understandable or consistent structure for decision-making. Actions were taken by Queer Nationals as loosely affiliated individuals organizing into affinity groups more often than by Queer Nation as an organization. Yet occasionally actions were taken by the organization as a show of semiorganized force in the community. Committees formed and worked on projects, reporting back but not needing endorsement by the floor—instead empowering people to organize as they felt driven to.

One of the ways in which the organizations were different was that in ACT UP people leaned on already established expertise, integrating their skills into the organization as needed, keeping pace with fast policy and health care changes. In Queer Nation we encouraged each other to take risks, to develop new skills, to try things out with the idea that queer folks are so often denied the opportunity to bring our whole selves and experience into the room that we needed to help each other foster new skills.

In committees and affinity groups in both organizations, we learned what work we were best suited to.

It turned out that I was best suited to Gender Queeries.

Gender Queeries was Queer Nation LA's adaptation of an old-fashioned consciousness-raising group. On Saturday afternoons, after we'd recovered from Friday Night Fundies, we gathered in Wayne and Marco's apartment near MacArthur Park.

We sat on the once-white couches that had been painted with thick black lines by Wayne (think Keith Haring in his black-and-white mural phase) and got to know each other. Who were we spending our Saturdays with? Who were the queers who were drawn to the outlaw group that declared the rights to pleasure, self-determination, and community? We laughed a lot. Sometimes we cried. We talked about what we were afraid of. Some weeks people who usually sat in one corner of the living room drinking tea weren't there, and

we knew it was because they were too sick to come. Wayne, Cory, and Marco refused silence about it. They raged their pain about grieving fatigue, endless loss, the losses of their own bodies as they knew them. They asked us to remember every phase of their lives, of the time there was left. Cory looked right at me as they asked. Unblinking.

Patt and I were two of the dykes who almost never skipped Gender Queeries. In response to the pleas of our sick friends, we said, *Yes, but not so fast. How will you stand for us? How will you expand the space for us even if it means taking up less yourself?* These were the conversations that shaped how we steered the general meetings a few hours later. Who spoke. Who was listened to. Who was an expert on what experiences. Who would be injured and how we would protect each other and enable each other's voices.

In Gender Queeries we made room for the complexities that there often wasn't time or space for exploring, but on which our successes would depend, in the fast-paced organizing of survival at the level of policy and access and guerrilla intervention. We questioned a different kind of survival on those Saturday afternoons—something more about intimacy and connection, feeling and urgency, and the fear of loss. At ACT UP meetings, and mostly at Queer Nation meetings, our nervous systems were revved on high—we tracked multiple urgent action proposals and scrambled to write policy. I felt the deep stirrings of historical trauma embedded in me resonate with the traumas of the other queers in the room, the toll and fatigue of survival. The looming grief.

We learned to pay close attention to subtlety, to track each other's spoken and unspoken cues. I walked into the apartment one week as Wayne was grumbling to Patt about a new rash, shortness of breath. Patt, who was in acupuncture school at the time, was saying, "Let me see," and tending to him. I remember the tenderness and casualness and ease with which we began to pay attention to and take care of each other's bodies. The translation of gesture from external action and urgency to the quiet gestures of movement and reach toward each other's bodies.

We asked the hardest questions we could think of:

How do we remain loyal to our commitment to each other's survival more than our desire to be likable to each other?
How do we hold each other accountable?
How do we listen?
How do we act in the world, in service of what vision?
How do we hold each other?

When we left the apartment and drove west to Plummer Park for Saturday night Queer Nation meetings, we were closer. We felt more responsible for each other.

Outside Wayne and Marco's apartment, the sounds of the park drifted up through the windows. Music. Laughter. Children. Breaking glass. Sirens. The same park where soon Clean Needles Now would begin the city's first needle-exchange program. Outside, the world around us. We brought the world in. And we tried to find ourselves and each other in it.

MARGINALIA 1991

United States establishes a network of community-based
clinical trials for HIV treatment.

Clean Needles Now needle-exchange program started
in coalition with ACT UP/LA.

AIDS is the second-leading cause of death in men ages 25–44
and one of the five leading causes of death in women ages 15–44.

WAYNE WAS YELLOW under the hospital's eternal fluorescent glow. Cranky because he was tethered to an IV and couldn't smoke, he growled at all of us, waving his hands in the air, yellowed fingertips almost orange.

Dragging his IV with him, Pete circled the nurses' station, advocating for a scared patient across the hall without family. The doctors weren't explaining things. Pete yelled, long, loud, and emphatic, and the dyke nurse, excited by his tirade, took his pulse, expecting it to be stronger than it was.

Wade's room was soft peach in the sunset, his hair feathered around his face on the pillow. His breathing was quiet, so slow the air barely stirred around him. So peaceful we stood next to the bed holding our breath.

Driving home, exhausted. Stopping by Cory's house before the next hospital stop. (Was it Robert? Wade? Why couldn't they all be in one place?) We lay down on the bed. Just for a moment. At sunrise, I opened my eyes, Cory sleeping next to me, his arm draped across my chest, his fingers laced through my fingers.

CHRISTOPHER STREET WEST, the organization that ran the LA Pride Parade and Festival, announced an entrance fee. The crowded parade route would still be open and accessible, but the festival would be gated, with money collected at all entrances. Even though a portion of the collected funds were supposed to go back into the community, we imagined the in-the-moment experience of shaming as people were asked to pay to enter, to belong. We imagined the exclusion of queers of color. Of older fixed-income widowed queers. Of young queers escaping families and communities where they couldn't be young queers and then being turned away at the gates. The PWAS with limited income who had fought for the parade now being turned away.

Perhaps we gathered after a meeting, or on a Sunday afternoon. Someone had a computer. Someone made the coffee. We sat together and played with the language until we had a manifesto about liberation and space-holding free from the demands of capital.

Rumors started in the community that we were planning to cut the fences and the gates down with bolt cutters in the days before the parade, and extra security was hired by the parade organization. We didn't. But we marched the parade route passing out the Pride for the Few manifesto and with a giant banner of hand-painted (I still don't know who did the art—either no one remembers, or no one will say) bolt cutters.

After it was clear early into the Queer Nation contingent's strutting up the parade route handing out the flyers (leafletting had been on the list of activities banned by organizers) that we wouldn't be stopped by Christopher Street West security, Cory and some of our other friends peeled off and circled back to the parade queue to flank the float from Club Fuck!, the fetish/leather club that convened on Sunday nights at Basgo's in Silver Lake, which other nights of the week was a working-class Latino club. Just a few blocks away from the ACT UP office, Club Fuck! had community overlap with ACT UP and Queer Nation and was the Sunday night embodied celebratory capstone to a weekend of Friday Night Fundies and Saturday Gender Queeries and Queer Nation meetings. The Pride organizers were hassling club organizers and the flatbed truck-turned-float because of the club and float name, and because the glittery, nearly-naked-other-than-tattoos-piercings-and-leather dancing cohort wasn't family friendly and therefore not media friendly in the quest for marriage and homonormalization.

⭐

36 KEIKO LANE

"STOP HUFFING," Cory says, my annoyance annoying him.

I'm driving us across town on Sunset. I raise my eyebrows, glancing at him. "But you're late."

"Get used to it . . . I get a free pass."

"But, really late. We told Pete we'd be there at 1:30. It's 2 now. It will take us another half hour to get across town to him."

Cory shrugs. "I called him."

"That's it? That's how it will be, then?"

"Dying trumps everything."

"You're not dying."

"So you say."

"You're not."

"Well, maybe not this week."

"There's a hole in your argument."

"What?" he asks, as I brake hard for a mother with a stroller crossing the street at the intersection of Sunset and Parkman.

"Pete's sick, too, so how does it work? This hierarchy of who waits for whom?"

"T-cells."

"What about them?"

"Total count."

"Seriously?"

"Yes. T-cells trump everything. Whoever has more has to accommodate."

"What?" I turn my head to stare at him.

"Eyes on the road," Cory says. "Well, it migrates around, the count. For all of us, so when we don't have any, we get a little bit of a pass. Things are harder. You wouldn't understand."

There it is. He's right.

Cory continues, "Also, you know, we're good socialists. We share T-cells."

"How do you share T-cells?"

"We loan them to each other. Whoever needs them more. Right now, Pete has some of mine. So he can wait for me." He's pleased with his argument, smirking at me.

"If I loan you some of mine, will you be on time tomorrow?"

"It doesn't work that way. Infected faggot insider trading."

I'm laughing. And I'm trying not to cry. The absurdity. The sheer insanity of the scope of the conversation. I'm trying to still be mad because I don't want to keep Pete waiting. Why couldn't we just be two friends having a fight about who was late?

IT WAS A RELIEF to the ragged nurses. Someone to stay in the room. Someone else on the overcrowded AIDS ward to make sure he had ice chips, water, enough blankets. Someone else to take the blankets off when the layers were too hot or too heavy. The bed was narrow but not much more than the twin bed we usually slept in when I spent the night at his house. Cory raised his arm to keep the IV line away from me, and I crawled into the little space next to him. His neck hurt from the strain and effort of holding himself up. Holding himself awake before I could get there. *Shhh*, I said with no sound but the exhale of air through my lips, turning myself sideways in the bed. My knees knocking against his thighs. My one arm tucked under my head. My other arm across his chest, my hand reaching around his neck to rub the tired, taut muscles under my fingertips until he let go under the pressure, falling into gray hospital sleep. The fag nurse walked briskly into the room, slowing as he saw us. He crept to the bed and checked Cory's vitals, the beeping of the monitors steady as a heartbeat should be. Cory's eyelids fluttered, and the nurse and I held our singular breath. The nurse raised his eyebrows at me, a gesture of question. I smiled at him with my eyes. He backed out of the room, turning off the brightest overhead as he left.

DO CORY OR I SAY it out loud, that this is a bad idea? Do we say anything out loud? This will be the way we'll communicate for years. But we don't know that. We know only the timing of breath. The soft press of tongue. The fingertips moving across cheeks, his sunken, mine full and flushed. My fingers along the ridge of his occipital bone, his fingertips braiding through my hair. It was night. We were tired from driving back and forth between hospitals. It was afternoon. We stopped between hospitals to walk by the lake. It was hot, our skin sticky in the afternoon heat. It was an unusually chilly evening, we walked arm in arm, staying warm. Our throats were sore and tired from yelling at the fundies in West Hollywood all evening, keeping them away from the bars and bookstore. Chasing them away. Our voices were rough from yelling at the antiwar demonstration: NO BLOOD FOR OIL. And MONEY FOR AIDS NOT FOR WAR. The thin skin of our lips almost cracking. The desire to reach through everything to find each other. No words. This will be the way we'll communicate for the years we have left.

<p style="text-align: center;">◤</p>

BIG, GULPING GASP I WAKE sitting upright in bed. I don't recognize the room. The bed. The east-facing windows and morning light that don't match my bedroom or Cory's. The woman next to me opens her eyes. She won't ask what's wrong. She knows. On the floor next to the bed are gloves where we peeled them off, her QUEERS BASH BACK T-shirt, my sandals, my dress, her jeans. We left him in the hospital the night before. *Go*, he said to me, after she bent to kiss him hello, to tuck the blankets around him and check his pulse. Wayne prepared to stay the night but was outside chain-smoking for as long as we visited. It's still early. A rooster crows somewhere in the neighborhood. Cory will be asleep, or he won't. Wayne will be asleep in the corner or tucked into bed next to Cory, or he will have given up on sleep and will be in the courtyard smoking another pack. It's early, she says to me. I scan the room, the Queer Nation stickers scattered across a desk, the steel-toed boots. *Stay*, she says, and gets up to make coffee. She comes back with the steaming bitter cups we drink from. Then she takes my cup and pushes me back toward the bed. It's early. He won't be awake yet, but we are. The shaft of light just starting to peel through the corner of the window, the first morning bus brakes squeaking outside.

▶

DOES IT COUNT AS BOTH of us keeping a secret for decades if he was only alive for the first five of those years? Mostly, we didn't talk about it. When we did talk about it, it was an argument. Tense, slow moving, cautious. Shallow breath and electric skin.

The argument about the seduction—our seduction—was never resolved. Sometimes he needed to have been the one who seduced me, to take the responsibility. Sometimes I needed to have seduced him, to protect him from his own anxieties. Sometimes I needed him to have seduced me, to relieve me of my fears of manipulating him into loving me in my stubborn hope that it would keep him alive. Sometimes he needed me to have seduced him, to assuage him of any guilt.

But his guilt was predicated on risk. On the idea that sex was what put me at risk and was the only place of risk. On the idea that it is possible to mitigate risk. On the idea that there is any such thing as safety. Which was our fight.

And still, when a fight is largely silence and turned backs, how do we know what the other really meant, and what was interpretation and projection? Now, I can only imagine.

Even now, I'm not being clear. Even then, I couldn't be.

Whose secrets are they now that he's gone? They're mine still. Are they also his, still? Do I get to tell them now? Would he? How would we tell them together, now? How would the bodies of us reveal the secrets we kept? Would we still need to keep them?

What teenage girl doesn't tell her best friend who she's having sex with? Susan knew and didn't know. Some evenings we read Adrienne Rich's essays from *Lies, Secrets, and Silence* out loud, not saying what we knew to be true but allowing Rich's words to imply the story I couldn't say.

It was twenty years later when I said it out loud. We were having tea on a winter afternoon in our old neighborhood. She had known, of course, and not known, in the unarticulated ways we know things the people we love don't say. Can't say. And the way we wait patiently, sometimes for years, until our friend is ready to tell the story. As though we have time for patience. As though we still have time. (And because sometimes we do have time.) It took twenty years to tell Susan. Because I didn't know what to say. Even telling, not knowing how to say it. Now, this is what I'd say:

We fought so hard for the right to our queer erotic selves that we feared our own complications. We hid, even from ourselves. And yet, the way the stories are mostly told, the dykes loved and took care of the fags. And in the stories we allow to be complex, the fags took care of and loved us. And we were all queerer for it. But we couldn't tell the whole truth, because of what they might say. (And what would they say?)

Viral exposure. Gender traitors. What else? Whoever they were. And does it matter now? We internalized *they*.

And really, we saved each other. Every day.

(No language we could find, and so we left poems, fragments from other poets' tongues, slipped into each other's pockets to find when we were apart.)

> Finally
> > the only one I want
> > > to caress is you
>
> You watch the changing
> > light across the sky
> > > I watch your eyes[1]

Now, this is what I'd say:

It's an assertion of vitality in a context of annihilation. A counterhegemonic device of subversive aliveness. Sex is always about gender. Dykes and fags sleeping together doesn't negate queerness; it amplifies it.

But none of this is really the story of the ways that sex worked and the ways it didn't. That's what we couldn't talk about with each other. The erotics of intimacy. How different from the allowed urgency of uncareful lust. Is that what I didn't yet understand? Cory used to argue that my age showed there—in what I settled for with us. Not what I was and was not able to consent to but what I didn't know yet about what could be possible. I don't mean what bodies can do together. For those of us who came of age in the plague years, there was no sex without risk. No context other than the present moment. No sex that wasn't careful. No sex that didn't foreshadow loss.

What is sex outside of the context of fear? Intimacies culled from the truth of bodies, from saying what we want, from saying what we see, from the intimacy of touch when touch was supposed to be forbidden. Something was still forbidden. Fantasies of future buried by the urgency of survival and impending loss. Every moment stolen.

And, therefore, all sex held something back. Some part of ourselves withheld for the illusion of protection, the illusion that some part of the self couldn't be hurt.

Or maybe that was just my defense. Maybe that was just me.

There was never a before. There wasn't an erotic life separate from the conditions of risk and care. And in that way, the aftercare of a negotiated scene has as much charge as the scene itself.

But maybe that we couldn't generate or sustain the heat of us was the reason we stopped. When we could no longer generate lust without the vigilance of caretaking. When I couldn't. Which made sex an impossible escape. As though it ever was.

There is no sex without loss. Psychoanalytically, we might imagine the loss of an autonomous self, the fantasy of merging with another, the blurring of boundaries. Of affect, sensation, reflective narrative. What happens when we fail?

> Love of life.
> I promise to remember you
>
> Each time we meet is the last[2]

And even now. I'm not talking about it. Not really. The body of it. The bodies of us. Together. Alone in the dark.

<p style="text-align:center">⤜</p>

A SUMMER NIGHT, warm, even with the little bit of breeze coming through the open window on top of the hill. There's a sheet pulled halfway up our naked postsex bodies. We were rough with each other in ways that usually work, the muscularity of struggle and strain. Erotic as a reminder of aliveness. Arms pinned. Knees bruising the inside of a thigh. Hard teeth against the back of a neck. When it doesn't work, we pull away, annoyed. Without words.

We're both irritable, trying to settle into sweetness. Cory is unbraiding and rebraiding my hair. He tugs the loose strands down, tucking them into the braid, and I flip the braid back up, away from my neck in the heat. We had stopped at the hospital on the way home. Robert has been admitted again. Wade was there, hanging out with Gabe, keeping him company, but Wade didn't look much better than Robert. Robert stayed asleep the whole time we were there. None of us said much. Gabe and I held hands. Cory sat on the side of Robert's bed with Wade. Wade looked like he was fading, so I rubbed the knots that I could from the tight sinew of his neck. "Save your energy for him," Wade murmured, though it didn't occur to me until later that I didn't know which of the other hims Wade meant. Gabe eventually shooed us away, saying that he was going to spend the night and we should go home to rest. Cory and I walked out with Wade and kissed him good night before heading home.

Now here we were. In bed, talking about Wade and Robert.

"Will he get better?" I ask Cory.

"Who, Robert? Or Wade?"

"Well"—I consider the question—"either. Both."

"Yeah, they'll get better. A little, for a while. But you do know it will get worse."

"How much worse?" I couldn't imagine it.

"We're nowhere near the end."

I'm quiet, thinking about Robert, already in pain, already getting a little confused, Wade looking too thin and pale, his brown hair falling limply around his eyes. And Cory isn't feeling well. He won't talk about it, not really, but he's a little out of breath, a little tired, and has had a headache for a few days. He skipped a committee meeting that he had said he was coming to and snapped at me that he had gotten busy when I asked about it.

In our restlessness, he gets up and fusses with the stereo. He has a Diamanda Galás cassette playing loud. He gets back into bed. She's too much

for my nervous system, and I'm having an even harder time settling. After a few minutes I get out of bed and turn her off. I fiddle around with the radio until I find the jazz station, and Ella Fitzgerald singing "I've Got You Under My Skin." We both hum along with her a little.

"Hey," Cory starts, softly, tracing the side of my face with his fingers.

"You want me to switch the music?" I ask and start to get up.

"No, stay. I like her."

"OK. What?"

"I want to show you something. I mean, I want to tell you about something. But I don't know if you"—he takes a slow breath, lets it out—"if you want to know."

I turn and look at him.

"The pills. I want to show you where they are."

I don't understand what he's talking about. "Pills? Your meds? I know where your meds are. Do you need me to get something for you?"

"Not those pills. The other pills." He looks at me, waiting for me to catch on.

I feel a glimmer of recognition, then it slips away. I shake my head.

"You know, the pills. The ones. Enough of them."

"Oh." I stare at him, trying to find words.

"You don't know how bad it gets. Can get. Will get. You haven't seen it," he says, sitting up in bed. "I don't want that. I don't want to be stuck in the hospital. I don't want to not have control over what happens. I want to make my own decisions."

"And one of those decisions . . ."

"Yes."

I nod, slowly. "And you want me to . . . ?"

"Help me." Cory takes my hand.

"How will I know?"

"You won't have to. I'll know."

"Then what will you need me for?"

"Not to be alone."

"You're not alone."

"What?"

"You're not alone." I take a breath. I can feel my heart start to race, the edge of beginning panic. Wanting to convince him of something.

"What do I have? Who do I have?" He looks at me warily, like he's tired and disappointed.

"What about the story you told me? That you all borrow each other's T-cells whenever someone has something important to do and needs a little extra boost? Just that checking in on each other. Doesn't that account for something? Everyone loves you. And you have me." I'm talking faster in my panic. From a distance I feel my body pulling farther back from his body.

"That's what I'm asking. If I have you." He looks at me steadily. We're both quiet for a minute.

I try to slow myself down. "How will I know that you'll be right? How will you know?"

Cory looks away from me. "I'll just know."

"But how?" I insist. I can feel myself starting to panic again, starting to argue.

"I just will. You won't have to. I will." I let go of his hand and cross my arms so he won't feel me shaking.

We argue about it a little more.

"You want me to decide," I say flatly.

"No."

"How is it anything else?"

"I want you to help me. I don't want to be alone."

I close my eyes. "Not yet," I whisper.

He takes my hand back. "Not yet." He repeats my words back, as though they should soothe me. "When it's time. It isn't time yet."

I exhale, my breath shaking. I can't imagine it being time. I can't imagine it feeling clear.

"You want to love me? This is what it means to love me." I hear him say it, and I don't know how to reconcile it. I think I understand how it is love, but I can't imagine that it will feel like love. I feel my love for him as the desire to hold him close always, safe. To never let go. I let go of his hand. Then I get up and start pacing.

"Come sit," he says. I sit back on the bed, then pick up my clothes from the floor and stand up to put them back on. He sighs and gets up and pulls on his jeans and an INFECTED FAGGOT T-shirt. "Come on."

"Where are we going?"

"Walking."

I follow him down the long stairway back out onto Echo Park Avenue. We start walking toward the lake. We're silent, listening to the sounds of the urban park at night. As we approach the park, I hear the sound of water moving though the filter system of the man-made lake. We walk around the lake. I see the silhouettes of ducks and geese in sleep poses on the steep-lawned banks.

I've never been in this park after dark. When I was a little kid, my parents used to bring me here. We'd bring any leftover bread uneaten from the week and feed the ducks at the lake's edge. I'd laugh as they swarmed around us, trying to steal the bits of bread from my little hands. The pedal boats are tied to the docks of the boathouse. Sometimes we'd rent a boat for an hour and cruise around the lake. I close my eyes and remember the first time I was old enough to reach the pedals.

We walk toward the northern edge of the lake. Toward the lotus in the moonlight. But moonlight is strange in Los Angeles. We want to think it's moonlight. That's the story we tell ourselves. But it isn't the moon. It's houses. The streetlamps glaring down on us, catching us in the cross fire as they mean to illuminate the junkies and the sex workers, to discourage nighttime cruising and sex in the bushes.

We sit in silence by the path at the edge of the lake. Behind us is a large patch of bushes, and beyond that, the bridge onto the small island at the northeastern side of the lake, lined with tall reeds and trees. As we sit in our silence, I begin to tune in to the sounds around us. To really listen to them. *For* them. In urban Echo Park, when we hear rustling in the bushes near us, we don't think of bear, or cougar, or even the coyotes, who come down from the dry hills late at night searching for food, for water. We think sex, we think cruising, we think of not having other places to go, or wanting the internal feel of risk amplified or matched by the external risk of violence.

"If you don't want to, then say no," Cory says. "Say it out loud. Don't just nod and hope it doesn't come to it. It will come to it."

I turn my attention away from the tall reeds and back toward him. "What if it doesn't?"

"Don't do that."

"What?"

"Make me take care of you."

"How am I making you take care of me?"

"By making me pretend that it will be all right."

There's nothing left for me to say. There is everything left to say, but no words come. I reach for his hand again, and we sit together, quietly. Gradually our stiff bodies soften toward each other again, and we lean shoulder to shoulder. Finally, the breeze is starting to cool the air.

We listen to the sounds of intimacies around us and feel closer in their wake. And in our closeness, I feel the impossible distance between his story and mine. It's the strangest of queer intimacies, this blurring of desire and

death and negotiation of risk. Not the cruising around us but the risk of having to let go.

Under the gritty yellowed light, the lotus blossoms glow. There's a moan and a quick hush from the darkness behind us. We listen to the kinds of joy that still remain possible. Even in what we grow up thinking are the darkest places.

WHERE WERE MY PARENTS? This is both a complicated and a simple part of the story: once trust has been earned, good kids can get away with almost anything, including secrets.

Susan and I were both good kids. Most of our crew of student organizers went to school and did our homework. We got good grades. We were home most nights for family dinner. Or we studied together after school and into the evening, having dinner and spending the night at each other's houses, waking early to finish homework and get across town to our different schools. *I'll be at Susan's . . . I'll be at Diana's . . . I'll be at Leah's tonight, I'll be home tomorrow . . .* Some weeknights I had an early dinner with my parents, then left them home watching Jeopardy!, and my mother painting or baking and my father in his music studio, and I went out to an ACT UP committee meeting, or to see Cory. Sometimes, on Friday nights, after my parents and I had dinner with my grandmother, a friend from Queer Nation who lived in Long Beach and didn't have a car would take the bus up to meet me. We would go out to Friday Night Fundies or whatever else was happening, and then he would spend the night on the couch. When I stumbled into the kitchen on Saturday mornings, he would be having coffee and reading the paper with my parents, waiting for me to get up.

When I was in elementary school and sorting the mail one afternoon, I held up an envelope from Amnesty International and asked, "What does *amnesty* mean?" They explained about displacement, refugees, silencing. I already knew about my family's wartime incarceration. A few years later, I joined a student chapter of Amnesty International in my junior high school. But at an Amnesty International conference I went to with student-organizer friends, there were long debates about whether it was right to ask all countries to respect the same idea of human rights, and if homosexuality was illegal in some countries because it was antithetical to historical cultural values there, how could Amnesty International consider people imprisoned there because of their queerness to be political prisoners?

At the conference I listened to testimony from gay and lesbian political prisoners who had been supported by Amnesty International and who had escaped their families, communities, and countries in order to keep their whole selves true. I wondered if parts of the self are always used to justify violence and are therefore often disavowed in order to survive. What parts of my family were left behind in detention camps? How much of queer assimilation is a desire for the myth of invisibility as a guarantee of survival? Is that the

same thing as postinternment model-minority assimilative hopes for invisibility as a form of protection? My parents walked a breath-holding tightrope of advocating for others while hoping to go unnoticed. Even then, I had some growing awareness of my queerness. I wondered what parts of myself and my relationships I would need to leave out, even if they were in plain sight.

What my parents didn't see was because they couldn't imagine it.

My parents got to know Cory over the years. Enough so that my statements of "Cory's not feeling great, I'm going to head over, I might crash there" were taken as simply and easily as I tossed them out. As easily as "I'm staying at Susan's, see you tomorrow." Enough so that Cory, when he moved to Germany to be with his husband, left rolls of unused blank canvas with my mother. Enough so that they didn't question a year later when I said Cory was coming home to die, and I flew home from college. But I'm getting ahead of myself. Before we could come back, we had to leave.

an archive of impending loss

"ARE YOU SURE YOU WANT TO DO THIS TODAY?" Sonia asked. She was packing up her camera. Sonia was home for summer break from her first year at an East Coast college. We had been a part of the Student Coalition together and were savoring a summer of relaxed hanging out after nine months of letters and postcards. I had brought her to several ACT UP and Queer Nation events, introducing her to my new friends. She and Cory had immediately adored each other. We were on our way to pick him up. Sonia was developing her photography practice and wanted to shoot us in Elysian Park.

"Why wouldn't I want to do this?" I asked, pulling a hairband out of my hair and brushing the tangles. Los Angeles summertime, hot, dry, punctuated by occasional bursts of warm, dry breeze.

"You seem upset," she said, taking the hairband I had just pulled out of my hair and using it to pile her long hair on top of her head. "What's wrong? Did you and Cory have a fight?"

"Not exactly," I said.

"What does that mean?"

"Nothing." I hesitated, and she watched me. I wanted to tell her about the conversation about the pills two days earlier, but somehow I couldn't. "We just had a hot, cranky night. We took the day away from each other yesterday. But I want to do this."

When we picked up Cory, he was all smiles and hugs. He sat in the back seat of my car, gently catching the ends of my hair as it blew in his face from the open windows and the wind. We stopped in a part of the park with a wide-open field surrounded by a thick stand of trees.

"Just be yourselves," Sonia said.

"Which selves?" Cory asked.

"All of them," Sonia said.

Cory was wearing beat-up faded jeans and a white T-shirt that said QUEER NATION in big block letters on the front. I was wearing cutoff jeans and a plain white T-shirt. He took my hand and led me through the field. As we walked, I could feel the tension falling away. He grabbed my other hand and swung me around. We gripped each other's hands hard, spinning until our fingers ached, spinning until we were too dizzy to stand. Sonia just out of our focus, snapping photos. When we let go, we both crashed to the ground, laughing as the world spun around.

After that, the feeling eased back into play. Sonia stuck a Queer Nation FAG sticker on Cory's forehead and a DYKE sticker on mine. Cheek to cheek, serious faces looking into the camera, then away, endless stillness. In one wardrobe change, Cory pulled off his T-shirt and slipped into a pale blue sheer dress, voluminous pleats floating around him. We darted through the trees, chasing each other. He tackled me, and we rolled in the grass, laughing. Then kneeling, face to face, holding hands, gentle kisses, Sonia zooming in, and then back out wide—us in a wider and wider frame—more and more of the world looming over us.

Under my T-shirt I had on a white lace camisole, and in the overexposed proof sheet Sonia sent me later, we're both ethereal, our clothing and pale skin fading into each other, fading into the air around us, dark punctuations of my hair, Cory's eyebrows, my lips and eyelashes, the shadows in the hollows under Cory's eyes and cheekbones.

"You're feeling better," I said, when we paused to catch our breath. I passed him a bottle of water.

He drank, then passed back the bottle. "I borrowed a few T-cells," he said.

Out on the road, a car slowed to watch us, to see if we were people they should pay attention to. Photo shoots are a common sight in LA. We weren't what they were looking for, and they kept driving.

"I'm sorry," Cory said, taking my hand.

"For what?"

"I shouldn't have asked."

"No. I'm glad you did. I mean, you know I don't like to think about it. That it may come to that someday."

"I know, I'm sorry . . ."

"No. Let me finish." I took a breath. "Yes. If it comes to that, then yes. I'll help you. I'm glad you trust me that much. Whatever you need. Always."

"Are you sure?"

"I love you."

"I love you."

"And so, yes."

I bent to put down the bottle, took a deep breath, and kept my head tilted and eyes closed so he wouldn't see my tears. Cory moved behind me and wrapped his arms around me. He looked into the distance over my head, my hair blowing and catching in the stubble of his two-day beard and shaved head. Sonia caught that moment.

▲

THE FIRST ISSUE OF *Infected Faggot Perspectives* (IFP) came out in September 1991, "Dedicated to Keeping the Realities of Faggots Living with AIDS and HIV Disease IN YOUR FACE until the Plague is OVER!!!" The 'zine was the love child of Cory and Wayne. They both wanted to be in charge, and they both wanted titles that showed their collaboration and didn't allow either one of them to top the other. Wayne became "The Conceptual Control Queen of the Universe" and Cory "The fierce ruling pansy-ass faggot." From the first issue, the mission of the 'zine was clear. Opening the first issue was a poem by Wayne:

AIDS-PHOBES MAKE ME PUKE

You have kissed me on the lips for 10 years but three days of hospital and PCP and your lips can barely touch my cheek. (Don't even bother—it would be LESS offensive.)

I tell you about the ongoing battle with County, State and Federal Governments over funding for AIDS and HIV related issues and you tell me "I'm not into politics." (Are you into LIFE? I don't think so. GO FUCK YOURSELF!)[1]

The production of the 'zine was an embodiment of the 'zine's manifesto. Cory and Wayne started it but needed help from all of us. It was manifest practice of our questions in Gender Queeries. How did we listen to each other? Whose labor was engaged in service of whose voice? Cory and Wayne were listening to the voices—the dead who hadn't had a venue to speak and the voices inside their own heads. What was the role of those of us who were seronegative? What did it mean to stand back in solidarity? To come forward in solidarity? Even when, or especially when, we were the ones being called to action?

Depending on who was sick, and how sick, or what demonstrations and actions were being planned, IFP planning might happen in the living room of Queer Acres, the house shared by Patt, Wayne, and Wayne's lovers Marco and Christian. Or the planning and writing might happen sitting on the wood floor of Cory's cottage a few blocks away. Questions came up early on about what it meant to be an infected faggot. It was a literal, embodied, viral location—Cory, Wayne, Pete, Kirk, Steven, Ron, Ferd. But was it also an exclusively gendered one? Mary wrote for a few issues, as the HIV-positive bulldagger. And then Kate wrote a funny love letter to Cory in issue 3, and

Patt wrote a piece about queer family and what it means for her when Wayne is sick. Was *infected faggot* not only a specific embodied location? Was it a signifier of bodies? A signifier of the bodies we loved? A signifier of relationship to queer respectability?

In the writing in IFP, no distinction is made between "verifiable fact" and "felt experience." The writing in the 'zine was the translation of body experience into narrative others might relate to. The translation of plague into felt sense. And it was also a literal description of the keening of pain and suffering, as well as the desire and sex and ecstasy, of their declining T-celled bodies.

For the release of every issue, whoever was able would make the late-night trek to the local Kinko's and spend a few hours copying, collating, and stapling the neon yellow pages.

One of the voices that emerged early into IFP was an advice column written under the pen name Crypta la Cockus. Says Crypta, "Advice is never easy to give, nor should it be free. I never give advice (though I am hounded for my wisdom), but I will give you my opinion."[2] And Crypta had opinions: from tearing apart medical researchers exploiting PWAs to self-hating faggots, or HIV-negative lovers who wanted to be safe and protected from loss or harm, she was the cranky, bitchy, campy queen telling everyone to stand up for themselves and not take everything so seriously, and that they didn't owe anyone anything.

Then, in issue 4, Crypta dies:

> Her last words were "where's the riot, I want to go!" and something about Senator Ed Davis and a dildo. Crypta worked hard to educate the infected about their rights. Especially their right to fuck. She remained sexually active to the end. Crypta co-authored "Dick and Dying" and "Post-Penetration Guidebooks for Queens with AIDS" dealing with such subjects as how to prepare before and after getting laid and how to safeguard against anything you might catch from your partner(s).[3]

When Crypta died, it reminded us all of the mortality of voices of camp. But even in death, she wouldn't shut up, or give up her gallows humor and glee. After she died in issue 4, she reemerged in issue 5 to begin, again, giving opinions and commentary as "Crypta from the Crypt." In issue 5, "Crypta Speaks (Scribed by Lesions)," she says:

> I know you infected queens were looking for some answers, but you'll have them soon enough . . . a few of you within the hour! The only thing

I can tell you is when you get through ignore the white light, bear to the left about sixty-six paces and you'll be in the red light district! (The folks near the white light are all vanilla anyway!)[4]

At the beginning or end of every issue, in the call for ads and submissions and donations to keep the 'zine running, was a reminder that the 'zine was run by dying queens, and any issue could be the last. But until then, or maybe even past the grave, they would keep going. In one issue, Richard bought ad space to write, "Infection demands we become excellent friends now. GET CLOSE. Scared? Who isn't? Listen, learn, ask questions. Read Infected Faggot Perspectives."[5]

▶

WE WERE PRESSURING Governor Wilson to sign AB-101, the California equal housing and job protection bill. Rob Roberts went on hunger strike to gather support and media attention for the bill. We took turns keeping watch over Queer Village, the intersection of Santa Monica Boulevard and Crescent Heights Boulevard, where he was on strike.

(A few years earlier, in the same intersection, Wayne had been part of a hunger strike with other PWAs demanding parallel-track testing, a system of AIDS drug testing and distribution where experimental drugs would be made available simultaneous to clinical trials, for patients for whom other approved drugs were no longer effective or tolerated. Wayne and the other hunger strikers on that campaign had been successful in pushing the release of DDI [didanosine]. In later years, DDI would be a part of the magical HAART [highly active antiretroviral therapy] drug lineup that would extend the lives of many who were left in the community. However, especially in the early years, and with unstable dosing, side effects such as diarrhea, nausea, vomiting, optic neuritis, and alarming rates of peripheral neuropathy were rampant. Which were the stakes and negotiated side effects of survival.)

And so, at Queer Village, in the middle of West Hollywood, we came up with things to do to entertain Rob and each other:

Quiet midmornings we read to each other. The latest news reported in the gay rags by Karen Ocamb, our most trusted reporter and community member, and then the counternews in the *LA Times*.

Or we read poetry and fragments from the latest book by Paul Monette, who once, though he was himself very sick at the time, stopped by the hunger strike to sit for a few minutes with Rob.

There were late-afternoon drag shows.

Wayne showed up in full drag as a ranting and demented Kimberly Bergalis, chain-smoking and lecturing about sin until we all ran out of breath from laughing.

At night, we paced, keeping warm and keeping watch.

Governor Wilson vetoed AB-101 while most of ACT UP/LA was at a national action in DC fighting for universal health care. Pete, along with a dozen other ACT UP folks, was arrested in DC. While in jail, he was diagnosed with meningitis. When people asked what they could do for him, what he needed, he just said, "Get me more stickers," which he usually used to cover so much of his clothing you couldn't tell what color the cloth was under the neon crack-and-peel.

Meanwhile, in LA, as the first demonstrations erupted, I was hit by the flu. Feverish from the late nights of patrolling the hunger strike, I wasn't in the streets the first few nights. Frustrated, I monitored the news, fielded phone calls, and called reporters and lawyers.

Then Cory called. He had been arrested and beaten. He was home and wanted me.

A few nights after Cory's arrest, pissed off and shaken and still exhausted, I got out of the house for the demonstrations, connecting with the ACT UP crew who were finally back from their East Coast junket. As the march bottlenecked and paused, Lee, an ACT UP member back from DC, pulled up on his motorcycle at the side of the march.

"Look at it," he said, shaking his head with equal parts concern, awe, and mischief. The march spanned blocks in each direction as angry, loud gays and lesbians who had always thought the system worked for them joined those of us who had always known otherwise.

The marches were unplanned and unformed, with people spilling into the streets. The front of the marches used the adrenaline of their anger to pick up the pace. Anyone who has been to a large march understands the unpredictable spatial relations of crowds. The more people, the more adrenaline, the faster the front goes, the slower the back goes, the longer the march, the more opportunities there are for the police to pull off parts of the crowd.

There were cops on all sides. There was no one steering the crowd, which was its strength and our concern. It was energized and on the verge of eruption. Also, in danger of people being divided and penned by the police. There were a handful of motorcycles flanking the crowd.

"Get on," Lee said, handing me his extra helmet. We rode the perimeter of the demonstration. From front to back, like herding horses or sheep, not demanding or steering but watching. Keeping track of people, trying to pace the crowd so everyone stayed connected. Riding to the front to cue temporary march leaders about the scope of the crowd stretched behind them. Then we rode back to the end, to cue the people trying to keep enough critical mass to keep the police from splitting people off, to tell them where it seemed like they were headed.

On the back of Lee's motorcycle, I learned a new physics of crowds and angles and speed. The turn and torque of the bike. The lean. Like the way I'd pivot and turn my shoulders and hips to move through the crowded demonstration when on my feet. My hands were tight around Lee's waist,

my hands slipped under Lee's jacket to keep them warm, the metal teeth of the zipper biting into my palms. Lee, the bike, me, turning as one. Back and forth, from the front of the march to the rear, all the way across town.

At another demonstration, this time at the Ronald Reagan State Building, flags burned. Then Wayne was at the front of the crush of the crowd that rushed the heavy glass doors of the building. Roaring with rage, shaking the metal bar of the front door to the State Building. The bar broke off. Metal in Wayne's hand. He swung hard, glass shattering all around the crowd and glittering on the floor.

Five months later, in issue 8 of IFP, Wayne would write:

> Karr appeared in court looking fabulous on March 10th where he was ultimately charged with Malicious Mischief (which Karr said he will adopt as a new drag name) and the state of California required he pay $563.00 to replace the window. In addition, Karr was placed on 1 year summary probation and is prohibited from any further door smashings for a period of 1 year.
> "... Shit ... if we had known this is all that was going to happen we could have taken down the whole fucking building! Fuck Bush, fuck Wilson, fuck Ed Davis, Fuck 'em all! This queen is pissed as hell and he ain't gonna take it anymore ..." Karr's last words as he left the Court building was "So what are they gonna do ... Kill me??" and he broke off into hysterical maniacal laughter as he jumped on his motorcycle and sped off into the further mysteries and adventures of Los Angeles.[6]

Richard made us talismans—pins to mark us and make us visible to each other and, in the absence of recognition, to keep us safe. Scraps of burned flags. Shards of State Building door glass like stars or diamonds. We could cut through anything.

↗

AFTER THE FIRST SHOCK WAVE OF AB-101 rebellion. After closing the police-inflicted cuts in Cory's arms with my bare fingers. After waking with blood on my hands and my chest and my face. He'd slept through the whole thing. The morning after, he woke sore, stiff, bruised, cranky.

"What happened last night?" he asked.

"What do you remember?"

"I remember you getting here. Bandaging me. I don't remember going to sleep. But I think I woke up once. Did you get up in the middle of the night? Did I?" He looked around the bedroom; there was still a wrapped bag of bloody gauze and tape on the floor.

"I rewrapped your arm, you were still bleeding." He looked at me. I looked at him, steadily. "How is your arm now?" We both looked at his arm. The bandages white and clean, at least at the outer, visible layers.

Now, a few weeks later, I'm sitting in a little consultation room of the anonymous testing clinic at the Gay and Lesbian Center. The test counselor looks familiar to me. Latino, short hair, a bit of a tattoo around his neck peeking out from under the back of his button-down shirt. He might be in his early twenties. Have we seen each other at the bookstore? At the antiwar demonstrations? At any of the hopeful pre-veto AB-101 rallies or the throbbing rage-fueled demonstrations that came later? He's already gone through his list of questions, asking me if understand how the virus is contracted and how it isn't, if I know anyone who is HIV positive, and if I have people I could talk to for support if my test results are positive. "Do you have reason to believe you've been exposed?" he asks me.

I hesitate. There is no good way to answer this. The testing is anonymous. But still. Cory is well known in the community for IFP. He's an HIV-positive fag. I'm an underage dyke. A girl. We're in the middle of planning a demonstration against a proposed California Senate bill that would criminalize sex for people who are HIV positive. Even without the bill, I worry about protecting him. He worries about protecting me virally. But sex is the easy part. He has no idea about the blood. I can't remember the age cutoff for mandated reporting of sex between legal minors and legal adults. I hesitate, realizing that I didn't check to see if this young man, not much older than me, is a mandated reporter. And besides, what would he report? The real risk, the exposure, was the result of a police beating. And I wouldn't have done it any other way. But still.

I meet the kind eyes of the test counselor directly. "It's a good habit, isn't it? Getting tested regularly?"

He nods, scrutinizing me. Knowing there is more to the story. But isn't there always more to the story than we're willing to tell?

WE GOT TO BE VERY GOOD at Republican drag. Sometimes it was to infiltrate Operation Rescue meetings to find out which women's health clinics they were going to try to close so we could get there first and build a human wall to keep them open. Sometimes, like this time, it was to scope out the site of an upcoming demonstration. For this stealth queer field trip, I had dressed in a simple black skirt and white sweater, the most conservative outfit I could put together. The one pair of shoes I had that weren't Birkenstocks, running shoes, or bright purple Dr. Martens boots. My hair in a long French braid. I was with Michael, one of the ACT UP fags from my affinity group, who was not tattooed lower on his arms than his shirt sleeves and who had taken out his facial piercings. Another team had already scoped out the hotel and the surrounding grounds a few days earlier. We were doing one more pass before the demonstration.

We drove out to the hotel on a weekday afternoon, walked into the hotel lobby holding hands and smiled at the front-desk clerk, and then took the elevator up a couple of floors. We walked around the halls gauging which rooms would have windows that looked out onto the street where the rest of the demonstration would happen, which rooms would be easiest for us to get in and out of, which were closest to the elevators, how long it took for a called elevator to arrive, and then how long it took to get back down to the lobby. When we got back down to the lobby, a different clerk was at the front desk, by himself, busy answering phones. We sat for a few minutes, taking notes, looking like two conservative straight people on a date.

I was watching the lobby, distracted from our conversation about logistics and tactics, thinking about surveillance.

"What's wrong?" Michael asked.

"What do you mean?"

"You're wound up."

"Um, we're preparing to disrupt this place, and it's going to be secured like a fortress. Besides that?"

"Yes," he said, laughing, "besides that."

The dinner we were planning to disrupt was a birthday fundraiser for California State senator Ed Davis, who had introduced SB-982. The proposed bill would criminalize sex for people who were HIV positive, making it a felony for anyone seropositive to have unprotected sex and mandating a one-year prison sentence for not disclosing seropositive status to a sex partner, even if having protected sex. It also proposed a possible life sentence for anyone

who knew they were seropositive and passed the virus to someone else. Governor Wilson was expected to speak at the fundraiser. It had only been a few months since his veto of AB-101, the LGBT housing and employment discrimination protection bill. We intended to disrupt their night as many times and from as many angles as we could.

Michael was still talking, but I was looking around the lobby, thinking about how I move my body through the space anticipating cameras and surveillance, even when I can't see them, about all the ways we move stealthily through the world. Michael and I are unnoticed in the lobby, which I know is because of his whiteness, my white passing, my femmeness, our assumed heterosexuality that we consciously play at by misdirected coding in the easy affection between us. With no visible signifiers of our queerness, we are only seen through the assumed shared context of the conservative hotel.

In addition to the sex criminalization bill, there was also an ongoing fight about immigration. The HIV travel ban, which sounds like an inconvenience, was barely coded xenophobia. Seropositive immigrants, since the late 1980s, had been banned from entering the United States or establishing permanent residency. The actual impact of the ban forced refugees and asylum seekers into medical and political hiding and kept people who were undocumented or in immigration-status limbo from seeking treatment or testing, so that there was no record of their serostatus. By escalating the persecution of those perceived to be seropositive, SB-982 would add to their jeopardy.

There are so many reasons to keep so many parts of our lives stealth. I was only half listening to Michael talk about media positioning and camera angles to aim for if our disruptions erupted from one part of the room or another.

"Are you listening?" he asked, his fingertips tapping the top of my hand, which was clenched around the arm of my chair.

"Oh, sorry." I was thinking about Cory and Wayne and Pete. Their radical insistence on visibility and the dismantling of shame. The INFECTED FAGGOT T-shirts and the FEAR NO QUEER stickers. Wayne had a biohazard tattoo on his arm. Pete and Mary both had SILENCE = DEATH tattooed on their forearms. Their visibility also meant that on the night of the demonstration, they would be in the guerrilla theater affinity group disrupting hotel traffic and media outside the hotel. Not only were Pete and Cory visibly queer, they also weren't white. Those of us who were part of the dinner-disruption affinity group had to be able to get into the hotel by blending into the hotel guests and scenery enough to walk, unnoticed, through the front doors. Everything

I had learned in ACT UP and Queer Nation spawned from the body-positive and sex-positive political rhetoric we held on to, led with, insisted on. And yet, in these moments, in service of our bigger picture, we forced ourselves into enacting everything counter to what we believed.

On the drive to the hotel, Michael had told me about a new guy he was dating, and how he was excited because they had easily talked about their serostatus differences on their first date, and neither of them had been worried or looked away. He asked me about my dating life. And I told him the easy answer, that I was casually dating a woman in Queer Nation. We were friends, not romantically serious, but enjoying each other. I said nothing about Cory. Everyone knew that we had become close friends and loved each other and fiercely defended each other at demonstrations and showdowns with the Los Angeles Police Department (LAPD). But no one knew, at least not explicitly, that for months we had also been sleeping together. I was thinking about SB-982. What did it mean to intentionally transmit the virus? My tests had continued to come back seronegative. But what if they didn't? I was less concerned about what that might mean for my health than what it might mean for Cory's safety. I was seventeen, and he was a loud, radical fag in his late twenties. I was less concerned about sex, which had always been safe, than the night I ended up covered in his blood from the open wounds and cuts of the beating by the LAPD.

I didn't know how to answer Michael. I didn't tell him. What would I tell him? What do we keep under cover? What do we hide from each other? We got so good at it. So skilled.

"Sorry," I said, pulling myself back into our conversation about photo angles, noise echoes, and the size of the room. "What do you think about that alcove?" We talked it through as we looked over each other's shoulders, watching out for ordinary surveillance. Imagining how it would be amped up the night of the dinner. We wondered where other security and police, on the night of the fundraiser, were likely to be stationed. Would we have time to get from the elevators to the lobby? Would we have time to get from the lobby into the ballroom to disrupt the dinner? Would there be cameras to aim for, or would it be a singular focus on disrupting Wilson and Davis?

The night of the demo is a blur. We arrive at the hotel in pairs. Hours earlier, other members of our affinity group checked into the hotel room. We do our best to look casual, and we're back in our Republican drag, with our ACT UP T-shirts tucked away in small suitcases and bags.

Outside the hotel, the Sex Police brigade, a guerilla theater affinity group coalesced for this action, is putting on a show for several hundred protesters. The Sex Police, including Pete, Cory, Miles, Jeff, Kate, and a handful of other Queer Nation and ACT UP members, have dressed in white face paint with bright lips and eyes. Some people are dressed as sex criminals and some as grotesque officers who mime attacking and dragging them away as they mime sex. Over and over. Several hundred police on foot and horseback are surveilling and surrounding the demonstration.

From inside, we hear it, and we can feel the tension of it from up in our hotel room as we gauge the best time to go down to disrupt the benefit in the lobby. We're pacing, watching the news, the TV volume turned low, going over our plans and contingencies. Susan and I are the only minors in ACT UP, and this will be our last arrest together before we turn eighteen. We need to stay together, and we know we'll be separated from the rest of the group. Robin is assigned to keep track of us and make sure we're safe and, eventually, released.

Once we get the signal, we leave the hotel room and walk down the hall toward the elevator, hoping we don't run into dinner guests on the way down who will tip off security that we're coming. The elevator door opens. There's a middle-aged white couple dressed up for the benefit, staring at us as the door opens. He's wearing a dark suit. She wears gleaming white pearls above the neckline of her black dress. We all hold our breath. No one says anything. No one moves. The door closes, and the elevator continues on its path.

Then we're nervous, moving faster. Another elevator door opens, this time empty. We get into it and hope it doesn't stop on the way down to the lobby. It doesn't. Somehow the other elevator must have stopped because we get there before the couple. We get far enough into the lobby to disrupt the event. We're chanting "AIDS phobia, homophobia, genocide" and "Ed Davis is a slime, HIV is not a crime."

Everything stops moving around us. People are staring. The media have paused their photography of the party and are snapping shots of us. We're knocked to the ground as police swoop in and start cuffing us. The wandering string players have walked over to where we are, and the violinist is playing over us as the police continue cuffing us, wrenching our shoulders behind us in hard plastic ties.

Later, Susan will reflect on what she remembers from that arrest:

That moment of the strings playing over us as the police were grabbing us is etched in my memory forever. So surreal. And I always wondered what

those musicians felt as they were told to come and play right over that. There was one woman in particular I remember playing the violin over us. I remember giving her a look like, "Really?"

The friction of the heavy rubber gloves the police wear whenever dealing with ACT UP rubs against our wrists and arms. The cops have covered their badge numbers and are wearing face masks so we can't identify them, and because, in their AIDS phobia, they fear breathing our same air.

With all the chaos of multiple affinity groups launching almost-simultaneous actions, I can't see or hear how the other groups are doing or tell whether anyone is hurt. The sound is overwhelming—crowd chanting, police bull-horns, the occasional scream. I know we have a legal team shadowing us, but the other affinity groups won't know how our action has unfolded until we're all able to debrief late in the night, after, we hope, we have all been released from jail.

Years later, when I ask Jeff what he remembers, he says:

I was a sex criminal along with eight other men and Kate. I remember this because one of the cops yelled to the other cop (as we were being chained inside the bus), "I got ten guys here, and one of them claims to be a chick."

Pete, Luz, Cory were the sex (mock) police. Some people were inside the hotel posing as Republicans. (They got arrested.) Sex criminals had on HIV-positive and -negative T-shirts. Blocked the street . . . simulating/ sort of/more of a kiss-in/sex direct protest of SB-982.

I remember weeks before the action, Cory and Neil working very hard on the informational flyer. We were all at the hospital with someone. Cory didn't feel well but kept working on it. I don't remember who was in the hospital. He just kept working. We all did.

As we're led outside to the police vans that will take us away, we see some of what has happened to the demonstration outside the hotel. We're exiting just as someone from ACT UP is screaming, being hog-tied by the police and lifted up by his arms, which are tied to his feet. No part of his body is touching the ground.

Because we're still minors, Susan and I are separated from the rest of the arrestees and put on a separate bus. The night is cold, and the adrenaline of the arrest is wearing off. We're shivering, wondering how far they'll take us from everyone else in our affinity group. When the bus starts moving, it's

away from the rest of the demonstration, and we can see that we're being taken in the opposite direction of the other arrestees. We can barely see out the windows. The bus lurches forward, and we can make out that we're running red lights. Maybe we're driving in a circle? We look behind and out the window. It takes a minute to focus on the car following us. Robin is in the car. She's making sure that she doesn't lose track of us, that the police can't lose us in the system for the night. It's Friday night, and it would be easy for the police to book us into juvie and lose track of us for the weekend. The bus runs another light. Robin's car runs it behind us.

Jeff continues:

Pete took his boom box and played disco music outside of the jail. He had on Miles's "Republican wig" and had a remade sign that said, "Let my people go!" A big crowd waited outside for us.

We're taken to the same station as the rest of the ACT UP arrestees. When we're finally released, and as the other members of ACT UP are being released, we join the party on the steps of the police station, where everyone is waiting for us. We're not yet done with Governor Wilson or Senator Davis or SB-982, but for the rest of the night, Pete's boom box is loud, and everyone is dancing together. No one is too badly hurt. Everyone will be released. We won't leave until everyone is out. Until then, we dance to stay warm.

IT'S A COLD FRIDAY NIGHT, and we get back to Cory's cottage late. We started at the hospital with Robert, but Cory wasn't feeling well, so after we left the hospital, Cory went to Wayne's house to work on an issue of IFP. I was restless and couldn't focus on editing the 'zine, so I went back to the hospital for another hour. Finally, at around midnight, I went back to Wayne's and looked at the articles they were laying out for the next issue. Then Cory and I drove back down the block to his cottage.

We got ready for bed. Cory fell asleep immediately. I tossed and turned, listening to his breathing. Eventually, I fell asleep.

I woke up alone in bed, in the confused dark. Cory had rolled out of bed.

These are the things I'm not supposed to tell. The places where language matters. Specificity.

He didn't roll out of bed. Casually. He fell out of bed. Was flung. Flung himself. Propelled. He is half awake, maybe. Talking, but I can't understand the words. No. Not talking. Moaning. Keening. Chattering quick, urgent, unknowable language. Shaking. No, more than shaking. Was it a seizure? I can see his trembling outline through the lights coming from outside the windows.

"Cory." I say his name.

No response. He keeps talking in a language I can't understand. High pitched, frantic.

"Cory," I say louder.

He stops talking. Then he groans.

"Can you get up?" I ask him, reaching to touch his shoulder.

"I think so." He has stopped shaking. His voice is small.

I turn on one small light in the corner.

"Oh, don't, I don't know what . . . I don't want you to . . . I can . . ." He is struggling to get up, trying to turn away from me. My eyes adjust to the half-light. He has shit himself. And urine spreads through his sweatpants.

"Let me help you." I reach my hand toward him.

"No." He tries to pull away from me.

"Can you stand?" I take a breath, trying to stay calm, feeling my breath rattle.

"I think so." He lets me help him stand. Then he sits down on the bed and pulls me to sit with him. The long minutes it takes us to both catch our breath. Assessing. Looking at each other. Not looking at each other.

I help him to the bathroom. His arm heavy across my shoulders, my arm around his waist, him leaning his hip into mine. I help him to the toilet and pull his pants off of him, tossing them in a corner to deal with later. He is out of breath. Not breathing heavily but shallow. Both shallow and gasping. Staring into the space beyond my head.

"Cory," I say, gently, quietly.

He keeps looking. He isn't blinking.

"Cory," I say again, a little louder. "Cory, love." My hand pressing against his chest, then harder, my thumb rubbing circles over his heart.

He takes a deeper, gasping breath, brings the focus of his eyes to mine, blinking, looking at me.

"Love?" I look into his eyes, watching as I come into focus and his pupils pulse and steady.

"Leave me here a minute."

"Are you sure?"

"Yes, give me a minute. Alone."

I hesitate. "Don't get up, you might fall."

"I'm fine," he barks at me, annoyed.

"Don't get up. Please." I can feel the panic creeping into my voice. I try to calm myself.

I go back to the bedroom, then the kitchen, finding gloves, rags, and a bucket. I turn on the bright lights in the bedroom and clean up the floor the best I can, and then change the soaked-through sheets. I tie my hair up in a knot on top of my head. Biting my lip, trying to take slow, deep breaths to quell the rising panic.

I hear him throw up in the other room.

"Love? Do you want me to come in?"

"I don't know. No . . . Yes."

He is sitting on the floor, leaning over the toilet bowl. I kneel next to him and put my hands on his back. "Love, you're freezing. Let's get you up."

"Shower?" He looks over his shoulder at me, and at the bathtub behind me.

"Can you stand?"

"Help me?"

I help him into the shower, and he leans against the shower wall while I turn the water on and adjust the temperature. He stands under the shower-head and reaches his arm out to me. "Help me?"

I strip off my clothes and get into the shower behind him, my arms around his hips and waist. I'm half holding him up. His thin frame is heavy in my

arms, slippery from the water, from the soap I'm using to clean him. I'm struggling to hold us both upright.

"The water feels good," he says, and I can feel his skin warming, the muscles relaxing a little under the hot spray. He gets easier to hold as he relaxes. Heavier, but pliable. Less slippery. We stand there for a few minutes, trying to breathe, and then I finish cleaning him up the best I can while he leans into the wall. The hot water runs over both of us.

I wrap a towel around him and help him get out of the shower. He's weak and leaning heavily on me.

"Do you want to go to the hospital?"

"No," he says, but his breath is getting ragged again. He leans over the toilet and throws up again.

I keep one hand on his back and grab a towel with my other hand, trying to cover myself. I wrap him in another towel. "Are you sure?"

He's sitting back, catching his breath. "No hospital. Bed."

I hesitate, then figure that even if we do end up going to the hospital, there is no way he can walk all the way down the stairs and back onto Echo Park Avenue to the car without resting first. And I know I can't carry him.

I help him across the small cottage and back into the newly made bed. He's shivering again. I cover him with the blankets and feel for fever. His whole body is cold and clammy. I bring him a bucket and put it on the floor next to the bed.

He closes his eyes, taking a breath, and another. Reaching for my hand.

"You don't have to stay." His voice is thin.

"Yes, I do." I make my voice clear, calm, but I'm still trembling a little.

He nods off for a minute, then wakes up panicking. Hyperventilating, looking around the room like he's trapped. He tries to get out of bed. I put my hand back on his chest. "Slow down, love. What's wrong?"

"I can't do this anymore." His breath is high and tight.

"Do what?" I can feel my own escalating heartbeat.

"This," he says, looking around.

"What do you need?"

"I don't know. Stay with me."

"I'm right here, love."

"I can't, I . . ."

"Breathe," I say, one hand against his chest. "Slow down, baby."

"I can't." There are tears starting to fall down his face, shining in the faint light.

"Do you want me to call Wayne? Do you want Pete?"

"No. Not . . . no . . ."

"Are you sure?"

"Yes."

"Do you want to go the hospital? Are you in pain?"

"No hospital."

"Rest, then, please." I keep my hands on his chest and cheek. He takes a deep breath. Another. And slips into sleep. I watch him, my own breath still shallow. I can feel my own panic close by.

His breathing stays steady. I get up from the bed and pace around the cottage. I don't know what I'm supposed to do. I walk to the phone and pick up the receiver. Do I call Wayne? Do I call Pete? Would Nancy tell me what to do? The receiver starts beeping because I've held it off the cradle for too long. I put it back down, hesitating. Then I hear Cory from the other room.

"Pills. Bring them," he calls out. I walk to the bedroom door to talk to him.

"What? Which pills? Do you want aspirin? Did you miss a dose of something?" I can hear my speech quickening. I'm scared.

"No." He's impatient, breathless. "The pills. Get them."

I feel a wave of nausea, understanding what he's saying. Then a dug-in resistance. Something hardening in me. "Get them yourself."

"You promised."

"You can walk. You get them," I say.

"You promised." He's out of breath and looks right into my eyes as he says it.

"And you promised not to make it my decision." I'm trying not to cry, not to panic. "You'll be OK. This is food poisoning, or it's flu, or I don't know what. But you'll be fine in the morning. I promise."

"Don't try to make this go away," he yells, his voice cracking. "This is what happens." He's struggling to catch his breath after yelling.

"No." I shake my head at him, taking a step back away from the bed. "I mean, maybe. And what if it isn't?"

"I knew you wouldn't understand."

"I can't." I'm whispering, dizzy, trying to breathe.

He's crying, and from the way his breath pauses and catches, I can see the wave of pain wash over him, but I don't know what's causing it. I'd give anything to fix it. I can't fix it.

"Why won't you help me?" Angry and hurt tears. Panic.

I get up and start pacing.

"I need it to stop."

"I don't believe you. This isn't how it was supposed to go. Not this fast. I can't."

"This is how it's going." He's crying. "I can't anymore."

Something in me breaks, pulls back, cold. "I won't kill you. I won't." I come back to the bed and sit next to him. Quieting as I say it.

"I can't take this." Now he's in full panic. Hyperventilating. Louder in response to my quiet. "I can't."

"You can. I'm right here. I won't leave." But even as I say it, I get up and start pacing again.

He's sobbing. "It hurts."

"What hurts?"

"Everything."

"Let me take you to the hospital." I sit down on the bed with him again, reaching for his hands.

"No. No hospitals. No machines." He pulls his hands away from me.

"Can I call Wayne?"

"No. Just us. I can't. Can you at least do that? No one else. Not now." He reaches for me again, and I sit at the top of the bed with him. He grabs onto my arms, his face against my shoulder.

We keep arguing. I don't know how long. It could be minutes, hours, days. He tells me I don't understand pain. Maybe he's right. But I can feel his panic. And I can feel my own. I could call Wayne anyway. But what if he agreed with Cory? What if he came over and . . . And what? Gave him the pills? Helped him. Isn't that what Cory wants? But he won't let me call him. I want to take him to the hospital, but I know I can't get him down the stairs. I could call 911. But I also know that emergency rooms aren't kind places for brown queer men with AIDS. In the middle of the night. I flash on my parents a mile up the hill. I could call them. But they don't have any idea what's happening, and the idea of explaining feels too exhausting. And too risky for both of us.

"You promised you wouldn't make me decide," I cry at him.

"My decision," he says.

"I don't trust your decision. You're in pain. You're panicking."

"I can't anymore." He's too weak to yell loudly, but the feeling is clear. He's angry. I'm angry. I'm afraid.

I'm crying. I'd had a different idea. Something about a plan, some romantic notion of bravery and nobility and something thought-through. Ritual. Precision. I didn't think we'd be alone. Not panic and improvisation and us alone in the middle of a delirious night.

"You didn't expect to have to do what you agreed to do." He pushes me away, but I don't get out of the bed. We're silent, breathing hard. Angry and terrified and in pain.

He reaches for me and pulls me close. Then he pushes me away again. Eventually his breathing calms down. He passes out or falls asleep and, in his sleep, reaches for my hand. His skin has warmed up, and the deep tremor has calmed.

We stay in bed like that for a while. He sleeps. I'm scared. Wide awake. I keep checking his pulse and his breathing, the temperature and texture of his skin against mine. I still think I should do something, but I don't know what to do. Eventually he lets go of my body and rolls over to face away from me in his sleep. I pull the covers over his body and get out of bed. I sit in a chair in the living room, turn on a small light, and pick up a book, waiting for morning.

IN THE ORDINARY ALMOST-LIGHT of early-winter morning, Cory was just Cory again. From my perch by the living room window, I could see into his room where I'd left the door open. His chest was rising and falling evenly, his hands loose at his sides, not twitching. His body looked relaxed. I was stiff from sitting up all night in the winter chill. I walked to the doorway of his room and stood there for a few minutes, convincing myself that he seemed fine, then I stood under the hot shower, trying to wake up, trying to relax.

When I walked out of the bathroom, zipping my sweatshirt against the chill, he was sitting up in his bed. "Good morning," he said. "When did you get up?"

"Um, not that long ago." He didn't need to know I hadn't ever come back to bed.

He looked at his clock. 6:30. "Don't you need to go?"

"What?"

"Clinic defense. Isn't that today? Weren't we going?"

"You're not . . ."

"No. I'm tired. But you should go. Go fight the fundies for me."

I wanted to get out of the house. And I didn't want to leave him. I went and sat on his bed and leaned against the wall. I was feeling my fatigue in my rubbery legs and cold skin.

"What about you? What are your plans?"

"Working on IFP with Wayne."

I had promised Wade and Pete that I would meet them at clinic defense. I could easily call someone and tell them I wasn't going. Probably a few people hadn't left their houses yet. But I also wanted to go, wanted to face off with Operation Rescue and yell, wanted to run away from this cottage where Cory was lounging in his bed as though nothing had happened. "Do you want breakfast?"

"No. I said I'm fine." Cory reached over the side of the bed and picked up a sweatshirt from the floor and pulled it over his head. "Stop fussing over me." He rolled his eyes at me.

"Excuse me?" I snapped back.

"You're hovering. Go yell at the fundies. I'll see you later." He swung his legs over the side of the bed. "I'm fine. Go."

As he got out of bed, I looked at the soft pillows, where I wanted to crawl back in and forget the past eight hours. I looked at the other side of the room, at a crumpled latex glove that must have fallen out of my arms when I took

out the trash in the night. After cleaning up. After cleaning him up. Hovering? He had no idea.

"Fine." I could hear the stiffness in my voice. Escape. Why was it even harder with permission?

"Great. See you later." His voice was equally stiff.

(Now, when I ask, everyone remembers the day differently. Or maybe there were so many mornings like this that they all blur together. Everyone tells a different story: Tim says, "Weren't we in Torrance? I remember driving my weird little Toyota painted like a cow and getting stopped by the police on the way back . . ." Nancy says she wasn't there but remembers hearing about a clinic defense action where Mary and Connie flashed their tits at the fundies and Dwayne mooned Operation Rescue and they all almost got arrested . . . Mary says, "No, I think we were in East LA . . ." Wendell thinks we were south of LA, somewhere in Orange County, near Calvary Chapel . . . Jansen says, "Crap. I had to work and missed all the good stuff.")

Here's what I remember:

When I got to the clinic, the confrontation had already started. A thick row of queers and feminists were linked arm in arm around the front of the clinic and the perimeter of the walkway, leaving space behind the line for escorts from inside the clinic to step out to guide patients into the clinic. Members of Operation Rescue were clustered as close as they could get, yelling "Sinner!" and "Shame!" and carrying huge photoshopped posters of bloody babies. A cluster of LA County police officers stood across the street, watching.

I spotted a section of the defense lineup layered with friends and slipped into the front row of the lineup with Pete and Wade on one side of me and Jim on the other. Another row of ACT UP members and Queer Nationals assembled behind us as more people arrived. Operation Rescue's numbers continued to grow as well.

Operation Rescue teams would rush at us, trying to break through our lines, trying to get to the doors of the clinic to shut it down. It was so loud, both sides yelling. Chanting on our side: "Women's rights under attack! What do we do? ACT UP! Fight back!" We kept our arms linked tightly together, Pete standing tall, feet planted firmly, such a solid wall that the fundies seemed to bounce off of him. Wade and I were smaller, Wade so sick by then but determined to stay and fight for the clinic. He leaned on Pete and on me. I kept my body turned slightly toward Wade, partially to be able to step in front of him to deflect the rushing fundies, and partially because I had better traction to stay standing and not get knocked off balance as men from Operation Rescue pushed against us. I could feel David, Steven,

Robert, and a few others behind us, supporting us, keeping us upright. The fundies backed off and retreated across the street from us. We loosened our grip on each other a little, catching our breath. We had one eye on the police and one eye on the fundies, unsure who would come at us next.

"Are you OK?" Wade asked me. "You look tired." I looked at Wade, thin, pale, leaning heavily on Pete, fighting for the health clinic on a cold winter morning even though he should probably have been in bed.

"You're worried about me?"

"Why shouldn't I worry about you? Just because you're not sick doesn't mean you're fine."

I took a shaky breath, shook my head, trying to brush him off.

"Cory had a bad night?" Wade asked.

My eyes welled up, and I nodded my head.

"It's OK," he said, and put his arm around me, then gently kissed my forehead. Before I could respond to Wade, the fundies rushed at us again.

"Save the babies! Kill the faggots! Fucking faggots deserve to die!" A large man carrying a poster of what was supposed to look like an aborted fetus was marching toward us, yelling.

Without thinking, I pulled my arms out from Wade and Jim, and my hands were in fists, and I was screaming "Fuck you!" and lunging forward toward the fundie. Before I could get far, I felt an arm around my waist from behind and another pulling my arm back. I was launched airborne and backward into the body pulling me. Pete. I struggled to get out of his grip. "You're stopping me?! You're always the first one arrested. Let me go!"

"Cool it," he said as I struggled against his grip. "I mean it. Stop." He tipped his head toward the other side of the street, where the police were putting on gloves, the first step in their rituals of preparation for coming after ACT UP with batons and handcuffs. Steven had stepped into my place next to Wade and had body-blocked the man with the poster. Steven, tall, dark-skinned, dreadlocks sprouting from the top of his head, the sides of his head shaved, jeans, dark sweatshirt snug against his broad shoulders and biceps. I saw two of the cops zero their gaze in on Steven, the only Black member of our contingent that day.

I turned back to Pete. "I can't keep you safe," he said. "You can't get arrested today."

"But," I started to argue.

"No. You're the only one. We can't lose you."

That stopped me. I was still a few months away from my eighteenth birthday, and Susan wasn't with us that morning. Shit. Pete was right. Pete looked

from me to the cops and saw their gaze on Steven. Between the cops and us, the fundies looked like they were ready to push forward again. I saw what Pete saw and looked over my shoulder at Steven.

"Get him out of here," Pete whispered to me. Then Pete held his hand out to Steven and called him to us. "Get her out of here," Pete said of me, to Steven.

I shook my head at Pete. He was protecting both of us. He read my look. "We're fine," Pete said. "We've got this."

"Wade?" I asked. Pete and I looked over at him, frail, leaning into Jim.

"I've got him," Pete said. "Go."

Jim and Robert had already filled in the space Steven and I had occupied. Steven and I walked to the side parking lot of the clinic, where we could still see what was happening but were out of the direct line of sight of the police.

We paced, Steven and I, our bodies tense as we watched, bouncing on the balls of our feet, quads and necks tight, ready to run back if the cops really came for Pete and Wade. We were humoring Pete, but we knew if there was danger, we wouldn't stay away. From where we stood we could see the backs of our friends standing tall and strong, arms linked, preparing. Facing them, the fundies were regrouping in a circle, we imagined preparing to push forward again. And across the street, behind the fundies, the police, some of whom were still nervously pulling gloves tight against their wrists. The fundies looked over their shoulders, back at the police. Ah, they were also worried about being arrested. Suddenly they spread back into a line, and they began walking in a circle, chanting, waving their posters, but no longer lunging at our crew. The police also backed up. We watched our friends from a distance, their bodies visibly relaxing as the threat of impending confrontation seemed to dissipate into the cold air.

Steven and I took deep breaths, tension leaving our bodies in small increments. We turned to face each other. The winter sun behind his head made his dreadlocks glow and dance in shadows on the sidewalk between us. We had been in ACT UP meetings together for months and had been at a few of the same demonstrations. We had crossed paths pacing in the hallway outside of Robert's hospital room, at Club Fuck! on Sunday nights, and we had backed each other on the floor of an ACT UP meeting a few weeks earlier as the People of Color Caucus, of which we were both members, put forth a proposal. I knew he was a novelist and a writing teacher. But we hadn't ever talked, just the two of us.

I looked away from him and back at Pete, who was now laughing, his head tipped down toward Wade, who looked from behind like he was also

laughing, both of their postures relaxed. Pete looked over his shoulder at us, caught my eye, and blew me a kiss. "I think it's OK now," I said, looking at Steven again.

He nodded. "For now. Looks like it." He looked at me, his head tilted, assessing.

"What?" I felt like I had been under surveillance all morning.

"You look tired," Steven observed.

"Why does everyone keep saying that?" I snapped back. "It's early. Demonstrations shouldn't start before 7 a.m." I closed my eyes and took a deep breath. I was tired. I was starting to feel the winter chill and ache.

"He had a bad night, didn't he?" Steven asked, taking a step toward me and closing the space between us.

"What are you talking about?"

"Cory. I've seen you two together. I know—" he started cautiously.

"You know what?" I interrupted him, warily.

"I ran into him yesterday. He didn't look well."

"He's fine." I looked away from Steven and stared at the back of Pete's head. Steven was still looking at me, I could feel him. He wasn't looking away. And I could feel tears pooling in the corners of my eyes again, threatening to spill. "Yeah," I finally said, "it was a bad night." I looked up at him, his kind eyes, crinkling at their edges, a sad smile on his lips. "He's not fine."

"Yeah," he said, "I'm sorry."

I just nodded. "He's better this morning. Otherwise I wouldn't be here. But I needed . . ." I couldn't finish.

"To pick a fight?"

"Something like that."

"I get that. So, what did you do?"

"When? What do you mean?"

"Last night. You didn't sleep. You kept vigil. So, what did you do?"

I smiled at him. "I read."

"All night?"

"Yeah."

"What were you reading?"

"*Fact of a Doorframe*. Adrienne Rich."

He smiled. "You're a poet, then?"

"No. A reader. You know Rich?"

"Of course I know Rich. And yes, you are. No one reads Rich all night who isn't also a writer. Even if you haven't written it yet."

"Written what yet?"

"Your story."

"Which is what?"

He cocked his head sideways and looked at me, smiling again. "I don't know yet. Do you?"

I shook my head, looking around. Pete was still by the front doors of the clinic with Wade and Jim. The tight rows they had formed to protect the walkway had relaxed as the fundies moved even farther away. I shivered. The fatigue was finally taking over my bones.

"Cold?" Steven asked.

I nodded. He stood behind me and wrapped his arms around me. Slowly I relaxed into the warmth and safety of his body. I could almost have fallen asleep, standing there in the circle of his arms. He folded my hands under his own larger, warmer hands and held them tight against my sternum. Then I heard him, speaking so quietly under his breath that it took me a moment to realize I was hearing him. "What?"

He brought his mouth closer to my ear and kept whispering, and finally I began to recognize the words.

"What is that?" I whispered.

"You know what it is, you were reading it last night."

I smiled to myself, hearing the writing teacher in his voice. Then I turned the phrases over in my mind. "'Diving into the Wreck'? It sounds different out loud than in my head."

"That's the point. You have to read poetry out loud. It's like music. That's how you know when to breathe, when the poet wants you to breathe. Breath tells you as much as the words."

I tilted my head back against his chest as he spoke, listening to his words and feeling the rhythm of his breathing, a gentle tide. We stood like that, quietly but not silent, folded into a shared and separate reverie, the cold morning, our friends nearby, everyone all right for the moment, the words lingering in the small space of air between us.

◢◣

JOHN COLTRANE'S *MY FAVORITE THINGS* was playing through the stereo system at the Onyx Coffeehouse when I walked up to the counter to order a mocha. Susan and I sometimes studied at the Onyx or stopped in for tea after browsing through Skylight Books just down the block. But I wasn't waiting for Susan. I was waiting for Steven.

A few days after that clinic defense morning, Steven and I ran into each other at a Monday night ACT UP meeting. At the break I was standing in the courtyard with Cory, Wade, Sister X, and Wayne, while Wayne smoked a cigarette, and Steven walked by us, pausing to kiss each of us hello.

"How's the Rich?" he asked me.

"Still working on it." I smiled at him.

"Working on it is eternal with her. I want to hear your thoughts."

"Sure." I laughed.

"Really, I do." Steven smiled. "Meet me for coffee."

"When?"

"Wednesday afternoon, the Onyx?"

"OK, see you then."

The next day after school, Susan and I took a break from studying and meetings and wandered over to A Different Light Books. At the magazine rack I saw him. Steven. On the cover of *BLK*, a Black lesbian and gay magazine.

Susan looked over my shoulder. "Is that him?"

I stood in front of the magazine rack and quickly scanned the interview, smiling as he talked about finding James Baldwin and Toni Morrison. Then, a few pages into the interview, the interviewer says, "On the general subject of AIDS: You're HIV positive."[7]

My breath catches in my throat.

Susan looks up at me from down the aisle, where she's holding a book by Audre Lorde. "What's wrong?"

"Nothing."

She walks over to me and looks at the page in my hand, reading over my shoulder.

"You didn't know he was positive?"

"No. But it isn't like I thought he wasn't."

But still. I buy the magazine and read the interview slowly before bed. I smile at the sections where he talks about dealing with racism in the queer

community and where he talks about claiming the term *queer*. But I keep turning back to that page. All night I read him saying yes, he is positive.

The afternoon is chilly, but I find a table outside on the sidewalk, warming my hands with my mocha, waiting for Steven to arrive. I see him walking up the sidewalk before he sees me. He's wearing a black sweatshirt with the hood pulled up over the shaved back of his head for warmth. He looks up toward me, and I'm about to wave hello when a white woman walking down the sidewalk between us, toward him, grabs her purse with both hands, looks quickly away from him, and crosses the street, dodging between moving cars. She looks back at him, still clutching her purse, and almost runs down the street. I'm still watching her scurrying away when Steven gets to the table I have staked out for us. I look up at him, stunned. "Happens every day, Babygirl," he says, as I stand to kiss him hello and he lifts me off of my feet, swinging me around. He walks inside to get a cup of tea, then joins me at the table.

He comes back with his tea and looks through the books I've laid out on the table in front of me. Rich's *Atlas of a Difficult World* and *Diving into the Wreck*. "So?" he asks.

"So, what?" I tilt my head at him.

"Are you sleeping any better?"

"I thought you were asking about Rich?" I bite down on my lip and look at him through narrowed eyes. "And sleeping better than what?"

"You know what I'm asking."

I raise my eyebrows.

"Cory. Is he better?"

"You saw him on Monday." I shrug. "He says he's fine. He is . . . better at least. Rich is what's keeping me up nights."

"OK. Fair enough." He nods. "So tell me."

The night before, unable to sleep, I memorized the last stanza of "Diving into the Wreck," turning it over and over in my mouth, playing with my breath and Rich's line breaks, feeling my deep uneasiness at where the poem ends with what feels like erasure or invisibility paired with the burden of memory. I take a breath and say the words out loud to Steven.

"Gorgeous, isn't it?" he asks, watching me as I finish reciting.

I'm quiet, studying him. His hands are wrapped around his mug of tea for warmth. He's pushed his hood down around his neck, and the back of his head is exposed to the chilly air. He takes his hands from his mug and runs them across the back of his head and twists his dreadlocks between his fingers.

"Yeah, of course it's gorgeous. But it scares me."

"Why?"

"Are we always going to be erased?"

"No, Babygirl. The trace of us will be inscribed by us. We will be there."
Steven repeats the lines back to me.

I'm thinking about the line, and about erasure and presence. I stare at him across the table.

"What?" he asks me.

"But it's all still a war zone."

"And you're not used to that."

"No."

"I get that. Some of us are used to it."

"I know that. But still . . ." I look away from him and down into the sludgy remains of my mocha.

"What?" he asks, furrowing his eyebrows.

I take a deep breath. "Nice interview." We make eye contact for a second. Then I break it, looking out toward the street.

"Ah," he says. "You didn't know I'm positive."

"No, but . . ." I'm silent, thinking about it. What had I known? It seems like everyone else is. So why was I so shocked and panicked to read about his status?

"Hey." He reaches across the table and takes my hand in his.

I pull myself back to the present, look up at his smiling face across from me, and I don't want him to comfort me. "So, the interview," I start.

"Yeah?" He's rubbing my fingers in his, warming them against my shiver, which is partly from cold and partly from feeling.

"Do you really think that some people will survive?"

"Yeah, Babygirl, I do."

I take another deep breath. "What does survival mean? I mean, what does it literally mean? Live through it? Do you mean that metaphorically? Live through as in *remembered*. That those who are left will remember?"

"Daunting? To think about being cursed with memory?" he asks.

I nod.

"All of it. I think some people will live through it. Quite literally. Some of us will survive. I don't know why or how. If there will ever be a cure, or if we'll just, somehow . . . Some of us just will."

"I don't know if . . ."

"You don't know if you can what? Survive it? All of it?"

"Yeah."

"You haven't lost anyone yet."

I shake my head. "No. Not yet."

"But you thought you were going to, that night, when Cory had a bad night and you were alone with him."

"How did you know about that night?"

"I guessed. I know that look. I saw it in you at clinic defense."

"In that interview you talked about your boyfriend, the one . . ."

"The one who died." Steven's eyes fill, but he keeps eye contact with me.

"How did you go on?"

"For a while I didn't. And then you just do. There are people to love. And there is art. There are stories to tell. Remembering has its own energy and inertia. Its own demands."

"And that was the last book?"

"Yeah. That was that book."

"What will you write next?"

"I don't know what the next book is quite yet."

"You don't?" I don't know why this surprises me.

"It will never not have happened. We may have to reimagine what *after* means." Steven smiles at me, more light behind his eyes, and a little mischief.

"What will you do?"

"I don't know. I can't imagine it. I don't have a queerness before. I didn't have any life before, so I can't imagine what queerness after would be. What life could be."

"Do you read Audre Lorde?" Steven asks.

"Of course."

He laughs. "I love your assumption that it is an 'of course' kind of question. It should be. But it isn't." He begins to perform "A Litany for Survival," a poem Susan and I have read out loud to each other many times, always challenged as much as we are soothed. I close my eyes and listen to him recite Lorde's incantation of speaking and relentless love in the face of fear and loss.

The words hang in the air between us, reverberating in my chest like music.

"That's the answer, Babygirl. We tell the story. Relentlessly. You have to. You have to find yours."

"Why are you so fixated on me telling it?"

"Because you were meant to survive."

"Because I'm negative?"

"Because you're negative. Because you're the next generation. And something else I can't name yet. You just are." Steven finishes the last of his tea.

"It's also the answer to your question about Rich's poem."

"What is the answer to my question?"

"We make our names appear. Each other's names. We'll remember together. And those of us who survive will remember for those who don't."

"You seem so sure." I'm rolling my empty coffee cup between my hands, squeezing hard, my knuckles whitening.

Steven reaches across the table and places his hand over mine, smiling. "You'll have to tell it. What other choices do we have?"

Steven makes a deal with me that day. We meet almost weekly for the rest of the spring. Sometimes more than once a week. Sometimes Cory joins us. Some weeks we drive to the hospital to visit Robert or Wade or Wayne or Pete. But mostly we sit at the Onyx, where the afternoon barista is fixated on John Coltrane, or we sit in Steven's living room, with Billie Holiday or Sarah Vaughan reverberating through the air around us. And he makes notes on his stories or reads and makes notes on his students' stories. I study for my exams. We sing quietly along with the music, harmonizing with each other, sometimes conscious of our voices, sometimes not, even as we're working side by side on different projects. Then we read to each other. He reads Audre Lorde's *The Black Unicorn* to me, and Adrienne Rich's *Fact of a Doorframe*. I read them out loud as well, and we read from Paul Monette and Lucille Clifton. Because, he says, poetry is a collective experience. Even when or even though it is written in solitude. It comes from where we are connected and where we aren't. It comes from breath. Just like music.

I love those afternoons. I know they won't last. But I sit in the sunlit spring and drink in the sound of him.

SOMETIMES I STOPPED BY Being Alive, the AIDS service organization where Nancy worked, to visit her on my way home from school. A few blocks farther east on Sunset Boulevard from the ACT UP office, A Different Light Books, and Club Fuck! Nancy and Mary arrived at ACT UP together when they were first a couple. When they met, Mary was already HIV positive. No one knew what to tell them, or how to help. Not only was all safer-sex education aimed at gay men, so were drug trials and treatments. Part of the work of ACT UP, under the leadership of the Women's Caucus of ACT UP, was about making safer-sex information available to women, writing lesbian-specific safer-sex information, working with HIV-positive women in prisons, and fighting to have women included in drug treatment trials. One of the major projects of ACT UP nationally was pressuring the CDC to change the definition of AIDS to include opportunistic infections specific to women, so that women would be able to access HIV-appropriate care.

I'd show up at Being Alive in the afternoon. Nancy would take a break from whatever she was doing, or she wouldn't, and I'd tuck myself into a little corner of her tiny office, just to be with her. Eventually, she'd decide she needed a smoke break. We'd sit on the patio and run through the usual litany of questions: *How's Ferd? How's Connie? How's Cory? How's Mary?*

Sometimes answers spilled out of us, full of disclosures and worry. Sometimes answers were short, easy on the surface. Even then, both of us always listening for the subtext. Most of the space between us subtext and metaphor.

Some of the story I'd tell her, and some of the story I always left out. Nancy and Mary spent a few years chasing their friends off of me, hot older butches who I'd flirt with at parties until Mary or Nancy (it was usually Mary) noticed and scolded them away from me with a wink and a nod. It would be more than twenty years until I told them the truth about me and Cory. Or maybe they always knew. But we never said it out loud. Just like so many other things we never said out loud. Some, to pretend they never happened. Some, to maintain a fantasy about the possibility of safety, the possibility of survival.

Sometimes, when I'd stop at Being Alive, Mary was there also, and with whoever else was around we would work on the latest safer-sex info campaign or graphic, or the press release for the latest fight with the CDC, or for rights for prisoners with HIV. The thing about these fights and these graphics

is that they were the embodiment of our hope simplified. The fantasy that there was an answer, a way to mitigate risk. A way to mitigate loss. How many of our political and emotional strategies were about holding on to the fantasy of safety and survival? Even when there were big stories we weren't telling each other.

A few weeks after the horrible night with Cory, I stopped by Being Alive on my way home from the anonymous HIV testing center. The questions the test counselor asked were the same questions we used to organize safer-sex campaigns. They're good questions, an attempt to understand without judgment a large range of desires and sexualities. I answered his questions. And then he asked why I thought I might have been exposed, because nowhere in the narrative of my recent sexual history was there much possibility of infection. I didn't know how to answer that question. What are the questions we don't ask? The ones that leave out most of the experience of our bodies in relationship to each other? The stories we don't tell each other. What does exposure really mean? Bodily, emotionally. What do we leave ourselves vulnerable to? What is the liminal space between wondering and telling, between touch and contamination, between exposure and infection?

How neat and tidy it sounds to talk about universal precautions. To talk about safe sex. As though bodies are only exposed during sex. As though sex was the only space of risk. Mostly, sex is containable. Condoms. Dental dams. Gloves. Those were the easy parts. Vulnerability. Containment. We don't mention blood. The IVs ripped out in frustration, blood splatter across walls. Soaked sheets. Shit. Midnight delirium. Vomiting. Coughing blood. And still, our refusal to let each other slip beyond the reach of contact. Our refusal to let each other slip beyond the warmth and softness of unbarriered skin.

Did we really tell the truth when we talked about the intersections of bodies and longings? Mostly, maybe. But what do we leave out? We knew how to ritualize desire, how to incorporate latex into a scene, or how to slide on gloves so matter-of-factly and silently while talking quietly to mask the slight sound of the snapping glove wrist that the beloved sick in bed didn't notice. But what about the dailiness of queer domesticities? Queer domesticities, like other war zones, aren't always tranquil, aren't always limited to a private sphere, aren't always protected from the intrusion of the police state. How many times did we lean in to pull each other back from the reach of riot police? How many times did we pick each other up off the ground after

a beating? How many times did we wake up at night to help our loved one to the bathroom, to change the ruined sheets, to run the shower, to get into the shower with them to hold them up? To wipe the vomit off their face, the blood from their cracked lips? Did we really reach for gloves? Every time? What other risks did we take in the nonsymbolic dailiness of our plague-framed embodied queer lives?

"STOP BEING SO FUCKING CAREFUL," Cory says, angry, getting out of bed, knocking the gloves and condoms from the bedside. I sit up, reach down, pick them up again. He's right. I've watched him strut and play at Fuck! and at the Queer Nation parties that run late into the night in underlit living rooms. But I've been cautious, hesitant, since he was beaten. At first I was being careful of his bruises, the swollen joints and broken skin just barely holding together. But he's been mostly healed for months. Also, since the pills. *He could be gone by now*, is what I think. I think about my anxiety about his fragility, all a projection, the fragile body and not-fragile spirit that pushes it forward. How do I distinguish? Are they the same?

"Stop treating me like I'm dying." He pulls on torn jeans, a white T-shirt. "I'm not."

"You are."

Looking at him, thinking about my body, about his, I think words like *cupped*—I'd cupped my hand gently against his cheek. *Tapped. Brushed.* I'd brushed the grass away from his face and neck when we got up from our nap in the dried grass. Delicate words, feathery touches. But these are not all that the robust living body needs. Maybe at the beginning of life and the very end. But maybe not even then. A fallacy of assuming delicacy and fragility, when maybe, mostly, there is more resilience than that. Bodies need firmer touch. *Press. Pull. Collide.* The words of passion that are really about feeling solid, steady, a collision of bodies in space and time, trusting in the self that its cells stay connected in the ways they are supposed to. That the self stays intact, his and mine. (*We do not always stay intact . . .* writes Butler.)[8]

But this is the thought that comes later. The understanding. The articulation.

Instead, I think the only wounded body is his.

Instead, I think the only danger is his.

Instead, because it's Sunday night, we leave the cottage in our frustration and drive up Sunset to Fuck! We walk into the club, where we meet up with friends from ACT UP and Queer Nation, playmates from those underlit living rooms. Tattooed queers in leather and piercings are dancing on platforms. During a break in the music, there are live demos and performances on the small stages.

Who was onstage that night? Was it different from any other night? I don't remember. What I remember is that on any given Sunday night Ron Athey might be working out a fragment of new performance, with or without blood,

needles, body parts sewn and laced, demonstrations with his collaborators. His collaborators, some of them friends of ours, or other performers, might be exploring relationships between pain and performance, the amplification of affect through myth and body memory. People who came as tourists to Fuck! for the spectacle of fetish and body performance stepped back and away at the up-close sight and smell of blood, of bodies, and the unstaged explorations of boundaries of skin, psyche, breath. People who came to Fuck! weekly, who knew the performers or had been on the stages, had a different relationship to the bodies displayed for us. We think about the externalization of experience, about vitality and how the bodies on the stages offered us relief, a projected moment of making our internal worlds visible, if only to us. To each other. Feeling symbolized. Affect distilled. What are the marks we are willing to leave on each other's bodies? On our own? *Press. Pull. Collide.* And also, making visible the separation of bodies, the individuation, the ways we are not each other. The myth of attunement—that knowing, as we become aware of our own witnessing, that the empathic resonance of somatic experience is not the same thing as sameness. Translation through bodies, through sound, through projection. Sometimes we get it right. Sometimes we miss each other. Sometimes it doesn't matter.

The music thumps so loudly and rhythmically that I lose track of my own independent heartbeat. Cory and I find other people we're occasionally sleeping with, always family with, all of us moving together through the space. Cory dances. We move away and toward and away again. Cory and I leave separate from each other, with people we tell ourselves are less complicated.

MARGINALIA 1992

Eighth International AIDS conference moved from Boston to Amsterdam because of US travel restrictions on people living with HIV.

Michigan court revokes Dr. Jack Kevorkian's medical license, attempting to prohibit him from assisting in suicides of terminally ill patients.

Manzanar designated a national historic site.

what love is

"I DON'T WANT TO GO," I said. I could feel the set of my jaw, hard, stubborn. I felt like a little kid about to have a temper tantrum.

"But you will." Steven didn't even look up from the short story he was reading, turning the typewritten page and chewing on the end of his red pen.

"What if I don't?" I could imagine it, instead of going to college a thousand miles away in Oregon. Staying. Monday night ACT UP meetings. Afternoons reading and writing together. Helping Cory and Wayne with *Infected Faggot Perspectives*. A job somewhere. Maybe Nancy could find something for me to do with her at Being Alive.

"Stop it. I thought we were done with this conversation two months ago," he said, still not looking up at me.

I shook my head, silent.

In that moment I looked at him and even in my anger and panic was reminded of the man I met just a few months ago. Why did we feel like such different people now? Or maybe he wasn't different, but I was. It had only been a few months. That first coffee date, sitting in this same café, at this same table against the wall, the table sticky with almost-dried coffee that grabbed onto the napkins we laid out to protect the covers of our books. Everything had been different that day.

And of course it hadn't. But that day everyone was still alive, and I believed they would stay alive. I still thought we had time. And maybe we still did. But everything felt more precarious. And leaving felt wrong.

"You know it will be OK." He finally looked up at me.

My eyes filled with tears. "We don't know that. You don't know that. It won't be OK. Robert . . ." I couldn't finish. Steven's eyes filled also. Robert wouldn't make it until I came back. Probably Robert wouldn't make it until I left.

"You're so young," he said.

"What does that mean?"

"You know what I mean. You should have had more time. Before this. You should be able to be young, to fall in love without hospitals, without those damn dark circles under your eyes. Did you sleep last night?"

"Not so much, no. And don't change the subject. This is what I have. And come on, have a little historical perspective, he-who-writes-about-black-queer-histories," I snarled at him. "Do you really think any of this would have been easy anyway? The histories of our families haven't exactly been a cakewalk. Don't do that."

"Don't go all historical context on me now. That doesn't help. And I'm not changing the subject. Why didn't you sleep last night?"

"Robert. Gabe needed a break. He wanted to go to the Legal and Agitating Committee meeting, so I was hanging out with Robert. Then I couldn't sleep."

"This is exactly what I'm talking about. What you shouldn't ever have had to do."

"Cut it out." My coffee cup rattled as I put it down hard on the table in frustration. "It doesn't work that way. And I'm not sorry. Because then I wouldn't have you. Or Cory. Or Pete and Jeff. Or Mary and Nancy. That's why this is wrong. I just found you. So why am I going? Why are you pushing me away? I don't think I can bear it." My voice cracked, and my tears began to spill. He put his pen down and looked at me.

"We'll be here." He held my gaze.

"Steven," I said, my voice trembling, shaking my head.

"I promise." He looked away, then back down at the story, the page covered in red ink.

I wanted to tell him not to promise. But more than that, I needed to believe his promise. I looked at him again, in the light of the café, noticing how he looked so much more relaxed now than he did a few months ago. His eyes creasing at the edges from smiling, from just now pushing the pile of paper a little farther away from himself and across the small table toward me, squinting just a little at the small type.

"Where were you last night? Robert wanted to talk to you. We called your house," I asked him, tilting my head sideways.

He looked up from the page and smiled. "Date."

I stared at him for a moment. Then I laughed. "Have fun?"

He smiled and laughed, not answering, which gave me his answer. And I laughed with him.

So that explained the creases around his eyes now, different from the ashen, pinched look that they used to have and that I still had after the night before with Robert. Steven was right. I did have deep circles under my eyes, and my lips had the gray tint of creeping anemia. I chewed on them to bring color into the thin skin.

"It won't be OK, though, not really, will it?"

He took a breath, about to argue with me.

"Don't. You know I'm right."

"It won't be OK either way. So you should go. Go study poetry and date cute girls and write the story of us and come home and tell me about it."

"Tell me again, why am I writing the story of us? You should. Isn't that your job?"

"You get to tell this story. All of this." He looked around the café, the table next to us piled high with magazines and empty coffee cups, the stereo playing Coltrane's "My Favorite Things," the street outside where the white woman had hustled across, darting through traffic when she saw Steven's Black body walking down the sidewalk, she thought toward her but really toward me. I took a breath and smiled, remembering.

"Don't you have exams to study for?" He nodded toward the stack of books on the table in front of me. "You do that for a bit, and let me get through this draft." He tipped his head back down to the page, crossing out a line with his red pen.

I looked across the table at him again, examining him. I could see in the man sitting across from me on this warm spring afternoon, while outside the café the kids walking up the street from the elementary school a few blocks away were laughing and yelling and not looking in the window and noticing us, the man whose narration of our life I had come to depend on. And realizing that, I loved him even more. Followed by the thought: *I can't leave.*

He felt my gaze on him. "One more page," he said, and, without needing to look up, because he always knew, even without looking, how to gauge the distance between us, brought the tips of his fingers gently to my cheek.

⬥

I WAS HOME ALONE on the Monday afternoon when the mail came with the formal details of my fall admission to the perfect little liberal arts college in the Northwest. I was supposed to arrive there in four months. I felt myself start to hyperventilate. Dizzy. Would Robert still be alive in four months? Would Cory? I still couldn't imagine leaving. Outside the kitchen window, the eucalyptus trees dropped their silvery leaves down into the yard that had been my hideout and refuge my entire life.

Would Sister X?

Would Pete?

And I knew they wouldn't let me stay. Steven wouldn't. My parents. Cory. I couldn't stay. I couldn't go.

I started pacing around the kitchen. On the counter was a large butcher knife left out from someone's breakfast or lunch-making project. I picked up the knife and ran my fingers over the sharp blade. Still dizzy, my breath coming fast. I held the knife in my right hand and ran the tip of the knife across the skin of my left wrist and forearm, drawing circles, writing names. Not hard enough to break the skin but feeling the scratch and pressure. So close. I pressed a little harder, felt the tip of the knife catch and push through the outer layer of skin. A few drops of dark red blood beaded at the surface of my skin. I took a deeper breath, a little slower, and pushed again. Another track of beads, not quite enough to drip or run. Just sitting on the skin's surface.

I don't know how long I stood there. But I was still standing there when the phone rang. I listened to the ringing, then put down the knife and answered the phone.

It was Nate, an ACT UP fag, a friend who I hadn't seen in a few weeks. We had worked together on committees organized around HIV criminalization, and he was good friends with Cory, Sister X, Jeff, and Pete. He was deeply involved in Clean Needles Now, the hybrid project of ACT UP and several harm-reduction folks who had come in specifically to work on the project. Steven worked on it with them, forming relationships in the IV drug-using communities in parks where they took their van and collected used needles, handing out packages of clean needles, gloves, condoms, and information on how to sterilize used needles.

"I heard the news," Nate said.

"Which news?"

"That you're leaving us."

I was quiet on the other end of the phone.

"Aren't you? Congratulations, right?"

"Um, yeah," I said, quiet. Flat.

"What's wrong?"

"I can't," I said.

"Leave?"

"Yes." He heard something in my voice, in the few words I was saying. "It's going to be OK. I promise."

"I wish everyone would stop saying that. It isn't going to be OK."

"How not OK are you? Right now?"

I was quiet.

"Should I come over?"

I hesitated. "I'll see you at ACT UP tonight."

"No. I'm coming over to get you now. Stay with me tonight. I'll make us late dinner after the meeting and we can talk."

"No." I said it, but I didn't mean it. He heard the hesitation in my voice. The desire to be saved.

"I'm on my way now."

"OK." I put the knife down on the counter.

At the ACT UP meeting, we sat in the back of the rowdy meeting hall with Sister X. Sister was looking pale and tired, but her spine was straight, and she smiled at us and urged us to sit with her. Before her incarnation as Sister X, the drag nun sex educator and founder of the Los Angeles Order of the Sisters of Perpetual Indulgence, she had a life as a gay man, a high school teacher from the city where I was now supposed to move. Even when she was dressed in her gay male drag and not fully manifested in her nun's habit or the Sisters' iconic airbrushed makeup, she exuded her Sister persona, and we addressed her as such.

"Sister, I can't," I said, which seemed to be all I was saying to anyone.

"Yes, you can," she said, running her fingers through my hair and tucking the loose ends into my braid.

"But what if?" I started to ask.

"*What if* will happen anyway, dear one," she gently interrupted me.

I sighed and began massaging the tight muscles of her neck. In front of us, the ACT UP meeting was in an uproar over something. I was barely listening. I was feeling the ropiness of her neck, the way her shoulder blades were more

pronounced than they had been the week before. She was losing weight from his already too-thin frame. Pete was in the middle of the uproar but turned around to wink at us, and I laughed.

"Don't make me," I whispered to Sister.

"Don't make me insist," she said.

After the ACT UP meeting, Nate and I went back to his studio apartment in a historic building near MacArthur Park, one of the sites of Clean Needles Now's needle-exchange. As he made us a very late dinner, he told me his own story of leaving and coming back.

"It's not the same, and you know it," I argued.

"No, I suppose not, but you still have to."

"The friends you left, they were going to be here when you got back, or they were having their own adventures. They weren't . . ." I hesitated, shook my head, teary and exhausted.

"Dying. They weren't dying."

"Right. They were going to be here, whether you left or not."

"And the ones who are dying won't be saved by you staying."

"Everyone keeps saying that."

"It's true. Don't think yourself so much a hero. The savior," he said, handing me a plate of spaghetti and salad.

"That's not at all what I think."

"What then?"

"I don't want to miss it. Any of it. I've just now found everyone. I can't bear to miss whatever time we all have left. And you can't tell me I'm not right about that."

He sighed. "No. You are right about that. But do it anyway."

After dinner we got ready for bed and crawled into his bed under the window. I was studying for my exams. He was at the end of grad school. He was watching me read.

"What?"

"Let me see," he said, taking my arm and pulling up the sleeve of my long-sleeved T-shirt. He ran his fingers over the shallow cuts made by the knife earlier in the day.

I pulled my arm away. "It's nothing."

"Not nothing."

"I don't want to talk about it."

We stared each other down. Finally, he relented. "Let's sleep. Tomorrow starts early."

He fell asleep quickly. I tossed and turned. The loud whir of helicopters circling the park broke over the softer sounds of radios and sidewalk conversations. Eventually I got out of bed and sat in the armchair across the room from where he lay sleeping. As dawn lit the city around us, I knew he was right. They all were. I would leave.

The week was filled with Robert back in the hospital, Cory and Wayne working on a self-imposed deadline for *Infected Faggot Perspectives* and a press release for an upcoming ACT UP benefit for the Women's Caucus. The following Monday, I met Nate at the ACT UP meeting. We both pulled into the parking lot at the same time. As he opened my car door and reached his hand to me, an LAPD car pulled into the parking lot, slowing down and cruising around us. Plummer Park, where ACT UP and Queer Nation met, is in the City of West Hollywood, not technically the jurisdiction of the LAPD general patrol. We stood next to my car watching as the cruiser slowly circled the lot, then left.

At the beginning of every ACT UP meeting, one of the facilitators would call the meeting to order, announcing:

The AIDS Coalition to Unleash Power is a nonpartisan group of diverse individuals united in anger to end the AIDS crisis through direct action.

Everyone would cheer, then settle, then someone would call for all the police, federal agents, and law enforcement to identify themselves. No one ever did, but we all felt better for having asked, having reminded each other to be careful. This week was no different. During the call for police disclosure, I looked around the room at all of the faces I knew and recognized, scanning for the new ones I didn't, to see if anyone stood out as not connected to anyone there.

After the meeting we were headed to the Wilshire Federal Building for an anti–death penalty vigil sponsored by Amnesty International. The execution of Robert Alton Harris was scheduled for just after midnight. He was going to be the first person executed by the state of California since 1967.

We drove both of our cars to Westwood and, while we were at the vigil, saw what we were convinced was the same LAPD cruiser circling the building. It made sense, we told ourselves, that the LAPD would be monitoring the vigil. We told ourselves that our COINTELPRO fantasies were just paranoia. But we kept looking over our shoulders.

We drove both of our cars back across town, and I jumped at each LAPD cruiser I passed. By the time we got back to his apartment by MacArthur

Park, not far from the LAPD Rampart station, I was rattled. As we got ready for bed, I kept going to the window, looking out toward the park, listening to all the sounds of the urban night.

"Sleep," he said to me. "We have to sleep. I know you didn't sleep last week. Tonight, you have to."

Nate was asleep right away. Helicopters circled overhead. They circled over my Echo Park hill as well, but these felt closer and sounded lower. A searchlight flashed through the window behind the bed. I got up and checked the locks on the apartment door again, then got back into bed. I had just nodded off when I heard breaking glass on the street below us. I sat upright, my heart racing.

"No," he said, "stay," pulling me back into the bed. "It sounds like this every night, you're just not used to it. Try to sleep."

I lay back down in the bed next to him. He draped one leg over my legs, and an arm across my chest, his fingers loosely latched around my wrist, pinning me to the bed. I felt secure under his weight, soothed by the force of his body. Safe. I tried to steady my breathing. Eventually, I slept.

The next morning, he walked me to my car. As soon as we turned the corner, we could see that something was wrong, the sunlight catching and reflecting off the pile of shattered glass on the street under the driver's-side window. *Shit.*

We looked through the little Honda to see what had been taken. An LAPD car drove by and slowed down. The glove compartment was open, and the car registration was on the front seat. My backpack was gone. So was all of the press material from the Robert Alton Harris vigil, the upcoming ACT UP benefit, and the notes from an ACT UP committee meeting. All of the music cassettes were gone, but the stereo system was untouched. And it didn't look like there had been any attempt to start the car or pop the hood.

The hair on the back of my neck stood up. Nate and I looked at each other, quiet for a moment.

He took a deep breath, looking around the empty street. "OK. You have to go. We can't keep you safe anymore."

"When was this ever about safety?" I asked. But I was scared. For the first time really scared. And I had a second of relief at the idea of walking away.

BILLIE HOLIDAY IS WAILING on a cassette in the warbly stereo system of my little blue Honda. Steven and I are both edgy and tired and singing along with her quietly. We can feel each other's vocal vibrations more than we hear each other's actual tone. We've been listening to her obsessively all spring, singing phrases at each other, communicating through her images and intonation when we run out of words. My right hand is resting on the gearshift. Steven's left hand is resting on mine, and he laces his fingers through my fingers.

We're driving east across Los Angeles. The sky is hazy and thick with smoke and debris. A few days before, the LAPD officers who beat Rodney King—the whole horrific attack caught on video and broadcast in an endless, nightmare loop—were acquitted. The city has risen up in response, and rebellion is taking many forms. The Coalition Against Police Brutality is having urgent and frequent community forums, which Steven, Cory, and I have participated in. Parts of the city have erupted in less formal and coordinated uprising, and a huge swath of Los Angeles is on fire not many miles south of us. The National Guard has been called in. All nonessential travel is discouraged. Even with the windows rolled up, our eyes and throats are burning from the smoke of the flaming city.

We see the flashing lights of police cars ahead of us, and the few cars that are traveling the usually busy street slow to a crawl. As we creep closer, we can see an LAPD checkpoint. Cars are pausing briefly before being waved through. None of the cars ahead of us has been pulled over. I can feel my nerves prickling as we get closer to the checkpoint. I glance at Steven. He's staring straight ahead, and his jaw is set.

When we get to the checkpoint, the cop looks through the window at me, then at Steven, then back at me, and motions for me to roll down my window. The smoke is palpable on our faces.

"Where are you going?" The cop is talking to me but narrowing his eyes and looking at Steven, who turns to look at him.

"Is there a problem, officer?" I ask, jumping in before the cop and Steven address each other. I keep my voice light and friendly, forcing myself to smile at him, trying to draw his attention away from Steven. My heart starts pounding louder and faster. I'm seeing us through his eyes: Steven's tall frame folded into my car, dreadlocks standing up on the top of his head; his body is strong and lean, and he's wearing jeans and a black ACT UP T-shirt with a neon pink triangle and white SILENCE = DEATH lettering. I'm wearing a

blue sundress with thin straps and a low neckline. My eyes are lined in thick black kohl, my lips coated in dark pink lipstick. My waist-length hair is loose and wild, floating around my head and bare shoulders and down my back. The officer can't see that my feet are clad in bright purple lace-up Dr. Martens boots that have a neon green QUEER'N'ASIAN sticker on one toe and a white ACT UP ACTION = LIFE sticker on the other toe, a photo-negative of Steven's T-shirt.

The cop looks white. He looks young. At the last Coalition Against Police Brutality meeting, we had passionate conversations about the problems that arise when police patrol communities that they aren't a part of. The cultural misattunements and misreadings of body language and affect. The ways that everyone is on guard. We know this. We live it. And it feels so much more complicated than that. How do we know which communities people partici-pate in? Where each of us belongs? The options and experiences multiply, and multiply again when we come together. Even in our segregated city, the intersecting points are multiple and endless.

We're just a few blocks from Steven's house, in a neighborhood at the base of the Hollywood Hills. Wealthy families collide with their working-class neighbors at the public school just up the block that all of their children at-tend. Most of the wealthy families are white. But not all of them. Most of the working-class families are Latino and Asian. But not all of them. We rarely see other Black people in the neighborhood.

Now, sitting in the car with Steven, the white cop staring at us, I wonder what he sees. Who are the police that could patrol anywhere Steven and I go together, with whom there might be community affiliation? Would the officers need to be Black? Asian? Mixed? Dyke? Fag? Who would not see us as outsiders a few blocks from Steven's home?

The cop motions for me to pull my car over to the curb. The stereo still on, Billie Holiday is beginning the opening lines of "Strange Fruit": "*Southern trees bearing a strange fruit / Blood on the leaves and blood at the root.*"[1] During this rebellion we've been listening to this song over and over, talking about the different affects of interpretation in the many versions of it recorded by Holiday and by other singers since. Each era of the song carries the echo of the cultural context it is recorded during. Steven takes his hand off of mine and turns up the stereo. I pull my car over, put it in neutral, pull up the emergency brake, and reach over to turn off the stereo. I don't look at Steven.

We hadn't meant to be out this late. It's still evening, still daylight, but with the thick ash, the light is struggling to get through the debris.

The cop approaches my rolled-down window again. "Where are you going?"

"Home," I say, scanning his chest, looking for an ID badge and not finding it. I can feel Steven scanning also.

"You're not supposed to be out. Where are you coming from?" he asks.

We've just left Cedars-Sinai Hospital, on the other side of the city, where we were visiting Robert. Steven and I had finally said it out loud to each other as we left the hospital: Robert is dying.

We hadn't admitted it before. But when Steven and I walked into Robert's hospital room, the curtains were pulled shut. Thinking Robert was asleep, we crept in quietly.

"Why are you so quiet? I'm not dead yet." Robert's voice rose up, wobbly, from the hospital bed.

"Hey, girl, it's dark in here," said Steven, walking to the bed and kissing Robert. I walked to the window to open the blinds. Just then, Gabe came into the room.

"Leave them," Gabe said, coming over to me and kissing me hello. "The light is a little too bright."

"Hurts my eyes. Can't take it. Makes everything swim," said Robert, stretching his hand toward me, and I bent to kiss him hello. His lips were dry and rough against mine.

"You're not missing much," I said, looking out the window through a crack in the blinds.

"Just the city in flames?"

"Just that. Just another smoggy day in the City of Angels," said Steven, sitting down on the foot of the bed.

"Gabe, you'll be late. Go," I said.

"Where are you going?" Robert looked worried, reaching his hands out for his lover.

Gabe held Robert's hands and kissed him. "Doctor's office. I'll be back in an hour. Steven and Keiko are going to hang out and keep you company. I'll be back as soon as I can."

"Oh. Right. Doctor. Did you tell me that? Are you OK?" Robert looked confused.

"I'm fine," Gabe said, carefully, patiently. "Just blood tests. I'll be back soon."

"OK." Robert took a deep breath. Steven, who was still sitting on the foot of the bed, started rubbing Robert's feet. "That feels good."

Gabe kissed Robert, then Steven, and picked up his backpack from the corner of the room. Heading toward the door, he nodded for me to come with him.

"Sweetie?" I held my hand out to Gabe, who leaned into me and let out a ragged breath.

"I don't know. He's been getting confused. Not about big things but little things. Short-term things. This morning he was so excited that you were coming. Then an hour ago he had forgotten."

I kissed Gabe. "Oh, babe. And you?"

"Tired. Scared. Fine." He shrugged. "I don't know."

"And your appointment?"

"It really is just blood work. I've been too busy to get to it. So thanks for coming to stay with him. I should be quick. Did you hit any checkpoints on the way here?"

"Checkpoints? Really? No. Just smoke and ash," I said. "Be careful. And don't rush. Do whatever you need. We'll stay."

We hugged and kissed again.

Steven was still at the foot of the bed, rubbing Robert's feet. Robert patted the bed next to him, and I crawled on top of the blankets to join him. "You look all buttoned up," Robert said, tugging at the white sweater I had on over my sundress. "Take it off."

"OK." I shrugged and pulled the sweater over my head, untwisting the straps of my sundress.

"Better," Robert said. "Now take your hair down and bring me my bag."

My hair was as I often wore it, tied up in a knot on top of my head to keep it out of my way. Robert often spent long ACT UP meetings with me sitting between his knees, braiding and brushing my hair. After one especially long meeting, I looked in the mirror to discover he had remade my hair into a beehive. I untwisted the knot and sat forward so he could run his fingers through it.

"Where's Gabe?" Robert asked, suddenly looking around the room.

Steven and I looked at each other, raising our eyebrows.

"He has an appointment, sweetie. He'll be back soon," I said.

"Oh, right. OK." Robert, still playing with my hair, untangled a knot. "Did he tell me that?"

Steven bit down on his lip and looked away from us, taking a deep breath. I reached across Robert's legs and held Steven's hand in mine.

"I like this slumber party," Robert said. "Now, let's do your makeup."

"Really?" I sighed. I rarely wore makeup unless Robert or one of the other Radical Faeries held me down and applied it.

"Yes, even with my bad eyes I can see you look terrible. Pale and tired. There's no excuse for that." He squinted as he sorted through his bag. He

found lipstick and black eyeliner and began to draw around my eyes. Steven lay across the foot of the bed and kept massaging Robert's feet, watching us.

"Where is Gabe?" Robert asked suddenly, looking at the door.

Steven and I looked at each other. "He's getting some blood tests, honey," Steven said. "He'll be back soon."

"Oh," Robert said. "Right. And how is your blood work? Are your numbers still fine?"

"I'm fine," Steven said.

"Well, you look fine, honey," Robert camped at Steven, batting his eyelashes. Then he smiled, sad and sweet, and asked Steven in a more serious tone, "But really?"

"Viral load is low, T-cells are high," Steven said, still massaging Robert's feet and calves.

"Then I guess you are the lucky one of us, aren't you?" Robert put down the eyeliner and picked up the lipstick and began coating my lips.

"Not too drag queen-y, please," I said through pursed lips, though they weren't really listening to me.

"Yeah. I guess I'm the lucky one," Steven said, and scooted up to the top of the bed, next to Robert. Finished with my makeup, Robert lay back down against the pillows and leaned his head on Steven's shoulder. He patted the pillow next to his head, and I curled up on the other side of him, my hair fanning out around us. We stayed like that, chatting, dozing, being quiet and gentle together, until Gabe came back. Then Steven and I left.

"I asked where you're going," the cop demands again. "Don't you know there's a curfew?"

"The curfew is after dark. It isn't dark yet." Steven's voice is stiff, and he's leaning forward, across me, toward the cop.

The cop looks at Steven and puts his hand on his gun. "I asked where you're going."

I turn my body toward the cop, blocking Steven and forcing a smile at the cop. "We're going home now, officer. We were visiting a friend in the hospital, and we lost track of time. Sorry, officer." I flip my hair back and feel the ends of it catch and tangle in Steven's dreadlocks. The cop is looking down the front of my dress. My heart is beating so hard I'm sure he can see it under my skin. I force myself to keep smiling, to tolerate it and not turn away. I can sense Steven seething behind me.

"Give me your driver's license," the cop says. I turn around and grab my wallet from under my sweater on the back seat and hand the cop my license.

The cop walks back to his patrol car at the intersection, talking into his radio, looking at my license.

"Sorry? You're apologizing to him? Don't fucking apologize." Steven's voice is tense and low, hard and sharp. I feel my back stiffen against him.

"Don't start with me," I whisper back, still not turning toward him or looking at him.

The cop is still looking at my license, then at me through the window, then at Steven. Steven and I are both known by the LAPD for actions with ACT UP from which we both have arrest records. I'm hoping the cop won't come back and ask for Steven's ID, revealing his address just a few blocks away.

I look up the block and assess how quickly I could pull the car out and down the street, looking for an escape route for Steven on foot. The nearest alley is a few buildings away. But I know Steven won't leave me. The cop starts walking back toward the car.

He hands the license back to me. "I don't want to see you here again," he says, looking past me at Steven. He puts his hand back on his gun.

"Yes, officer." I put my hand on the gearshift and look up at him. He's still looking down my dress. I put my car in gear and release the emergency brake, and he takes a step back. I pull my car out and start driving. I look in my rearview mirror. He's still watching.

I turn right at the next intersection and drive a few blocks out of the way, making several extra turns, check the rearview mirror, and then pull up in front of Steven's house.

As soon as I park the car and we walk into Steven's house, I'm aware of the adrenaline coursing through me. I imagine that Steven is feeling the same way. But we're not touching each other, not holding hands the way we usually are. We aren't looking at each other. Steven is pacing.

"What the fuck were you doing?" He's angry, his voice absent of all the warmth I'm used to.

"Getting us out of there." I'm shaking. My heart is racing.

"You shouldn't have done that."

"Why? It worked." We're yelling, facing each other, pacing, circling each other, still not touching. Hard and ferocious and tired.

"It might not have." He finally looks at me.

I stare back at Steven. "Then I would have done something else."

"What? What could you have done?"

I turn away from him and walk into the bathroom. I close the door and turn on the hot water, find soap, and rub a layer of Robert's black kohl from my eyes. Then I wipe off the sticky pink lipstick. I take a deep breath and look in the mirror. Without Robert's makeup I look pale and tired again. I open the door and walk back to the living room.

Steven is standing by the window, and I'm overcome by relief seeing his intact body right in front of me. And I'm angry at everything, the cop, the rebellion, the jury, and Steven.

"Right, so I'm supposed to let the white cop come after you just because he can? And I'm not supposed to stop that if I can?" Steven doesn't respond. I keep yelling. "And don't we make the perfect fucking target? Let's see . . . Black queer HIV-positive fag. Asian American just-exotic-enough femme dyke."

"That's my point," Steven yells at me.

"What? You think I don't know that? You think I wasn't aware of that every second? Distraction was the only thing I could do. What did you think was going to happen?"

"I can't let anything happen to you." He's less loud now and sits down.

"And I can't let anything happen to you." I quiet my yelling also. As I say it, I understand that this is our standoff. This will always be our standoff. "Besides, what's going to happen to me?"

"Cut the arrogance. I know you were scared."

"So what?" I gather my hair in my hands and twist it back into the knot that Robert had untied. "So what if I was scared? Don't I get to . . ." I trail off, uncertain of what I'm about to say.

"Finish it." Steven turns and finally looks at me, his eyes red-rimmed. "Don't you get to what?"

"Don't I get to save you, anyway?" As I say it out loud, I feel my legs trembling, and I sit down across from Steven.

"Save me? You think you can save me?" He laughs, bitter and sarcastic, turning away from me.

As soon as he says it, I hear the impossibility of it. My great hope. My great failure. And I can't tolerate it, so I keep going. "If there's a moment when I can, then yes."

"I won't pimp you out to do it."

"That's what you think? That you're deciding what I'm allowed to do?"

"Today, yes."

"Fucking macho ego."

"What?" He's yelling again.

"You heard me." Now I'm yelling back. "You think it's your call? How we get into or out of this? That it's all up to you? All your responsibility?" Above the house the whirling of helicopters is getting louder. Sirens getting closer. I'm vaguely aware of smelling smoke, even with the windows and doors closed.

"It's getting dark," Steven says. "You should go before it gets any worse."

I slam the front door behind me, but I can hardly hear it over the helicopter hovering above the next block. I open the car door and pull my sweater over my sundress.

Instead of driving my usual route across the hills and through the quiet residential neighborhoods, I make a sharp U-turn and gun the engine. When I near the now-busy intersection, I can see the checkpoint still operating, the cops slowing and waving through cars. I look in the rearview mirror. There are no cars behind me. My hair is tied up, Robert's makeup gone, my sweater covering my chest. It's a different cop checking traffic in this direction, but this one is also white, also young. I drive my car toward him, and he motions for me to slow down. He glances at me, glances into my passenger-less car, and waves me through.

Past the checkpoint, I turn the stereo back on. It doesn't drown out the helicopters or the sirens, but somehow Billie Holiday sings over them, with them, in mournful call-and-response.

Back in Echo Park, I wait at the light to turn left from Sunset Boulevard onto Echo Park Avenue. National Guard tanks are parked in the lot of the corner market. I look at the roof of the market and see two army green–clad men with rifles. One of them is aimed toward the houses set into the hillside above the street. My heart starts racing again. I look at the hill, then at the rifles, panicking. They're aimed at Cory's house. Behind me a car honks. The light is green, and there is no oncoming traffic. I turn left and drive the mile up Echo Park Avenue toward my house.

I pick up the phone and dial Cory as soon as I walk in the door. He answers on the first ring.

I'm shaking. I yell at him through the phone, "Why are there sharpshooters aimed at you?"

"Hello to you, too, love. Nice to hear from you. I'm fine, thanks for asking. My day was great. How was your day?" He's laughing at me.

"Cory?!? What's happening?" I'm still yelling.

"Isn't it fabulous?" He's taunting me, laughing at my panic.

I take a deep breath and slow down. "Seriously, what's going on?"

"Oh." He calms down also, sounding disappointed. "You can't see it from the street?"

"See what?"

"The banner. We put a banner on the roof that says, 'US OUT OF ECHO PARK.' That's why they're aimed at us. They don't know what else we're up to. They think we're plotting revolutionary action."

I start laughing. I can't help it. I can just see it, Cory and our friends from Queer Nation who live in the halves of the little duplex making the banner, probably an old sheet, and tying it to the roof.

"What else are you up to?" I ask.

"Nothing. Really. I just want to see how long they focus on us until they get bored and move on to something else."

"Or storm the house."

"Either way," he says. I can hear him shrugging. "Anyway, why do you sound so crazed? Honey? What happened?"

I take a deep breath and tell him about the day. About Robert and Gabe, about Steven and the checkpoint, about the fight with Steven.

"You blew it," Cory says to me at the end of my story.

"What? I'm the one who blew it?"

"Yes." He sounds like it's obvious.

"But we face off with the LAPD all the time." I can hear the edge of frustration creeping back into my voice.

"Right. We do. In coordinated actions with legal teams and photographers. Who knew where you were? Who would know to go looking for you and Steven?"

I'm silent, listening to Cory.

"Did Gabe know what route you were taking home? How long would it have taken for any of us to know something was wrong?"

"But—"

"You are the scariest form of naive. I love you, but you're reckless, and your ego is in the way. I know you love him, but you can't stop any of this, and you don't understand how bad it can actually get."

"I do know," I say, walking over to the couch and sitting down. I can see smoke in the distance and helicopters circling the next hill.

"No, you don't. You're calling me from the little cottage on a hill that you grew up in, in the neighborhood where your family blends in. You drove back through the intersection? And you didn't get stopped. You think it's your girlness that saved him? Maybe. But it's also your whiteness."

"Seriously?" I'm angry at him now. "My whiteness?"

"Yes, and don't think I don't know what I'm talking about it. It doesn't matter that you're hapa and I'm Puerto Rican. We're both light. Our people

can spot us in a crowd. We can find each other. But white people? They don't see us. Anyway, even if the cop did clock you, what did he see? Think about it. He would have seen Asian. Boring model minority. Or exotic sex toy. But no one who looks like you has been considered a threat in the cultural unconscious since your family was in internment. You didn't get stopped. Steven got stopped. Go apologize. Fix it."

"But Steven—" I start to argue.

"I don't care. You will never know what just happened for him."

I'm quiet for a few moments, listening to Cory breathe, thinking about driving back through the intersection. What was I testing? Or daring? I wasn't stopped. Cory is right. Steven was stopped. Finally, I ask Cory, "What would have happened if Steven was driving and I wasn't there?"

Cory sighs. "But it isn't just that he was stopped for being a Black man in his own neighborhood. A Black faggot, albeit a gorgeous butch one. And he could have been stopped for that. But he was stopped for being a Black man in a car with a white woman. Memory is long, and history is short. Strange fruit, love. This is what lynching looks like now. You think your white womanness saved him, and maybe it did, but it was also the bait."

I want to argue with Cory. And I know he's right.

That night I can't sleep. I toss and turn and listen to the helicopters and sirens around the city echoing off the hills.

The next afternoon I drop something off at a friend's apartment, then decide to cut across town on the freeway and head toward Cedars-Sinai to visit Robert before going to see Steven. When I get on the freeway, there isn't much traffic. Some of the smoke is starting to clear, but people are still being told to avoid traveling across town.

I'm in the second lane from the right. All of a sudden, a black sedan barrels up right behind me. Too fast. Too close. I look in the rearview mirror and see the dark-tinted windows, the extra mirrors, the domed dash lights turned off. Unmarked police car, I think. They show up most weeks at ACT UP meetings. We walk out to the parking lot at the end of the night, and they're circling slowly, taking photos of our cars, and through the tinted front windows we can see them writing down our license plate numbers. We make jokes with one other about why they even bother with the unmarked cars. As though we don't recognize the same officers every week. I look around. There's no one to joke with.

Only a few cars are ahead of me, none in my lane or the next lane on either side. I check my speedometer and make sure I'm not speeding. The sedan is still on my ass. I lock my doors, then I signal right and pull into the slow

lane, hoping it will pass. It changes lanes, following me. I'm now in the far-right lane, and it's still riding me. If I speed up, I'll cross the speed limit, and it will have an excuse to pull me over. None of the other drivers on the road seem to notice. Or at least they aren't looking my way. I think back to the day before, to the cop holding on to my driver's license, studying me, studying the car. The sedan swings to the left and pulls into the lane next to me, pulling alongside of me. I look over, but through the tinted windows I can't see the driver's face. The cop's face. I can only see the outline of a man's face, a flash of light hair, dark glasses.

I tap my brakes, slowing down and hoping he'll pass. He keeps the sedan paced to my car. I'm starting to panic. My heart is racing, and I'm breathing in short, quick bursts. I have almost a mile until the next exit. My fingers are a vise around the steering wheel, and my knuckles are white. I look to my left as the sedan veers toward me, and I turn the steering wheel to the right to dodge the sedan as it crosses into my lane. I feel the bumping change in asphalt as I'm pushed onto the shoulder. I hear Cory's voice in my head: *How long would it be until we knew you were missing? How long would it take us before we started looking?* The sedan moves back into its lane, and I pull off the shoulder back into my lane. Again, he turns hard and fast toward me, and I pull onto the shoulder. I hear my arrogance, arguing with Steven yesterday, *What could possibly happen to me?* This is intentional. No witnesses. Is this really happening? It feels as surreal as a movie scene. I'm afraid to stop. I keep looking back and forth: speedometer–road ahead–shoulder–sedan–speedometer–road ahead–shoulder–sedan. Again the sedan veers, and I'm pushed onto the shoulder. Again.

At the next exit, I turn hard as late as I can and get off the freeway. The sedan doesn't follow. The whole exchange took no more than two minutes. My hands are cramped around the steering wheel. I feel crazy. Was it the cop from yesterday? There is no reason for a cop in an unmarked car to be play-ing chicken with me. Either he doesn't know who I am, or he does. I can't stop shaking.

I turn onto Sunset and park in front of Being Alive. I feel safer as soon as I walk into the building and round the corner to Nancy's office. She's on the phone but looks up at me and furrows her eyebrows in concern. I motion for her to finish her call, and I sit down on the floor in the corner of her little office and close my eyes, push my back up against the steadying wall, happy to be hearing her voice in the small, enclosed room.

After she hangs up the phone, she picks up her pack of cigarettes and lighter, and I follow her to the patio. We sit on a bench, and she lights a cigarette. She

puts her arm around me, and I lean my head against her shoulder. We still haven't said anything.

"Do you want to tell me about it?" she finally asks, blowing smoke away from me.

I don't. I'm not ready to talk about it. But I feel better leaning against her solid form, sitting in the safe, secluded patio pushed back away from the street, the only visible smoke from the cigarette in her hand. I shake my head.

"Tell me something, then."

My voice comes out in a croak. I tell Nancy about Cory and the National Guard, my voice smoothing out and getting stronger as we laugh at the thought of him standing on the roof, tying down the corners of the banner.

"Think he danced?" Nancy laughs.

"Maybe. Think he mooned them?"

It feels good to be sitting with her. Our laughter unwinds the taut muscles of my neck and hands, still aching from gripping the steering wheel. Inside the building the hard work of finding housing and health services for people with AIDS continues. And out on Sunset we can hear the siren of an ambulance race past us. We're quiet again.

Nancy finishes her cigarette. "I should go," I say.

"Where?"

"Steven's."

"Be careful out there," Nancy says.

"Yeah. I promise," I say, and kiss her goodbye.

I pull off of main roads before I get to Steven's neighborhood and drive along small residential streets. I keep looking in my rearview mirror, scanning for cop cars. I don't see any. I'm thinking about the checkpoint, the freeway. About danger and profiling, trying to make sense of it. When I'm with Steven, he's more at risk, targeted, the cultural myth invoked that I must be saved from him. Saving the perceived white woman from the Black man. But when I'm alone, I'm the perfect target. A woman alone. Or could it have been the same cop? Was I being targeted for my alliance with a Black man? I'm safer with him. He's safer without me. Is that how this works?

I park in front of Steven's house and sit in the car for a few minutes, still thinking it through. Then I walk up the front steps and let myself into the house through the cracked-open front door.

When I walk in, he's sitting in the living room scribbling in a notebook. "Hey, Babygirl," he says without looking up, as though nothing has happened.

"If you're working, I can come back later," I say, closing the door behind me but still standing in the doorway. I take a deep breath, steadying my

breathing. The sight of him soothes me. The light falling across his cheek and the notebook in his lap, illuminating his hands.

"Why do you sound formal?" He looks up and pushes his dreadlocks out of his eyes. "Get in here, I want to show you something."

He reaches for my hand and pulls me to him and onto his lap. "I'm sorry," he says.

"Don't," I say. "I'm sorry." I take a breath. "It's just that I don't know how to make sense of it, how to reconcile it."

He shakes his head, sighing. "Can't we both just be sorry? Can't that be it? Do we have to talk about it?"

"Yes. We have to talk about it." I slip off his lap and sit on a chair opposite him, so I can look at his face.

"Here's the thing. Mostly, I'd do anything—we'd do anything. We throw our bodies at the FDA for drug approval, at the State Building against insane policy. We sit-in for hospice funding. I don't care what it is, I'll do any of it."

"Do you think I don't know that?" he asks.

"Let me finish," I say. "It's symbolic. That's the problem." I'm watching the shadows of a tree outside the window dance across the floor between us.

"You don't think it makes a difference?"

"Maybe. Maybe eventually. Maybe a cure someday. Maybe drugs someday. Maybe something. But no." I take a deep, shaky breath. "I'm not going to save Robert. We're not going to save Robert. I can't save..." I can't look at Steven. I can't bring myself to say, *I can't save you.* I close my eyes and keep talking. "If there is any moment where I can use my body as a buffer to save your body, do you really think I won't do it? If I'm there and I'm the reason they come after you, shouldn't I get in the way? That's what you do for me. I can't not try."

He shakes his head, laughing a little at my stubbornness. Then he looks up at my face and sees the tears in my eyes. "Babygirl, did something else happen?"

"No. Nothing else."

"Did you just figure it out? That Robert is...that we can't save him?" Steven has buried lovers and friends. I'm just now watching the first wave of my close friends getting closer to the edge.

"I thought, maybe..." I don't finish. He knows. He wants to save him too.

I don't know why I don't tell him about the freeway, the unmarked car. I think there will be time, or a reason to, later, or maybe there won't ever be a reason to. I understand that his fear about Robert is also his fear about himself. And I can't bear to add to his pain, to make him worry about me. That's also how we tend to each other. How we try.

They're complicated, these intersections. They're not even intersections, not really, not singular moments of crosshatched experience. They're braids. We cross and cross again, from different angles. Different tensions.

We're quiet. I take his hand in mine and lace my fingers through his. The helicopters and sirens are quieter today. There's more space between them.

"What did you want to show me?" I ask, looking across at his notebook. I expect it to be a chapter from his next novel, but it looks like music.

Steven smiles. "Come sing with me, I want to try something."

"What?" I reach for the notebook.

"I'm trying to arrange it for two voices," he says, handing it to me.

I look down at the music. "'Strange Fruit'? I don't sing 'Strange Fruit.'"

"Yes, you do," he says.

"But isn't this what we were talking about yesterday? This experience isn't mine. Adjacent. But not quite ... And there's a big space between the experience and the possibility. When I'm clocked, it's model-minority, exotic bullshit. Not a noose."

"Stop fighting with me. I thought you came over today to stop fighting." He leans forward and kisses my forehead. "Here's my idea. It's a duet. A conversation. And it isn't a song from inside the experience of lynching. It's a song of witness. After yesterday, it's your song as much as mine."

"So, what's your idea?" I'm still looking at the sheet music, his notes scribbled in the margins.

"Let's try trading verses and see what happens," he suggests, and we hum at each other to find the right key.

He sings the first verse, full voice, full force.

Then I jump in with the second verse, more air in my tone, more breath legible in the words.

We stop after the second verse. "That was terrible," I say.

"Yeah," he says. "Why?"

"I think it's the rhythm," I say. "You're pushing it, fast, syncopated right up against the beat. You run at it, starting full and hard, and there's no place left to build. It creates this urgent anxiety."

"Yes. I was thinking full-on and relentless for all the verses. But you're pacing it slow. A dirge, mournful."

"Yeah," I say, "my plan was to build in intensity but not pacing. And the transition between the two doesn't work."

"But they're both right. Both interpretations make sense, so shouldn't they both work?" he asks.

"At the same time?" I'm laughing.

"Why not? What if they're not traded off? What if they're overlaid?"

"The mournful and the fury? At the same time? You're serious?" I try to hear it in my head.

"Let's try."

And so we do. We count out a time signature, and I hold the slow end of the beat. We're singing on top of each other, then he's pulling ahead, pushing the beat to the front end, and I'm struggling not to get pulled along with him. I get lost in his energy halfway through the second verse.

"Let me try something else," he says. "You just hold steady."

"You say that like it's so easy," I say. But we're laughing a little, finally, and he reaches toward me and squeezes my hand.

We try again: I hold the time, and he shifts into a dizzying scat, then into double time, so that by the time I'm into the second verse, he's starting over again, and the layering of words is a complicated, overlapping jumble:

> Blood on the leaves and blood at the root
> Scent of magnolia sweet and fresh
> Then the sudden smell of burning flesh.
> Black bodies swinging in the Southern breeze
> Here is a fruit for the crow to pluck
> For the rain to wither, for the wind
> to suck
> Strange fruit hanging from the poplar trees.[2]

I'm still struggling not to get caught in the urgency of his rhythm. The thumping of his heartbeat against my fingers is pulling me off of my rhythm, and I let go of his hand. He slips out of double time and settles back into the time signature I'm working within. He's still pushing the front end forward. I'm still lengthening the back end of the beat.

Finally, we find it. We both hear it as soon as it happens. The braid of our voices. The intersection of breath and form. We're singing. Again and again. The last verse looping back to the first. Following not each other's utterance as it enters the space as sound but each other's breath. That deep resonance. The unsaid pull. Eyes closed, we hear it. We feel the rise and fall, rise and fall. He's pulling us forward. I'm following behind. Just slightly. Or maybe I'm pushing. Together we hold the tension of the only frame we have. The breathing. The witnessing. The wailing.

ROBERT SLIPPED IN AND OUT of delirium when he was in the hospital. Some days he knew we were there. He'd make jokes. Weep. Wouldn't eat because of the nausea. The faeries took turns sautéing marijuana into scrambled eggs along with parsley and onions, and he'd eat a few bites and mostly keep them down. Then, a few hours later, he'd eat a few more bites. Then he'd sleep.

One day, while Robert slept, Cory and I left him alone and explored the halls of the hospital. In the lobby was a sign for a blood donation drive, so we followed the sign to a room down a carpeted corridor. The volunteer staffing the table looked a little afraid as Cory signed us in. Then we sat down and waited.

"Honey, what are you doing?" I asked, in not quite a stage whisper.

"I just want to see how far we can get. How far I can get. I'm guessing not even in the door."

I looked at Cory and started laughing. His closely shorn head, his white T-shirt adorned with a neon green Queer Nation sticker across the center of his chest declaring FUCK YOUR GENDER, and his ripped jeans with a Day-Glo pink sticker (gamma green and pulsar pink) that said ASSIMILATE MY FIST on the back pocket. The volunteer was still looking at us, wide-eyed.

Separately, we were brought into cubicles for donor intake interviews with a nurse.

Of course, we were both turned away.

"Don't you know you're not allowed to donate blood or tissue?" the nurse had scolded Cory after he answered that yes, he was gay. He was not asked about his HIV status. He was not asked about the status of any of the men he had or hadn't had sex with or whether they had used barriers.

I had recently been tested. But I wasn't asked whether I knew my HIV status. I wasn't asked my sexual orientation. I wasn't asked anything about my sex life. They didn't ask me if I'd had unprotected sex with any women, or if any of those women were HIV positive. They didn't ask me if I'd had unprotected sex with any men. They didn't ask if any of the men I'd had sex with were queer. Or HIV positive. Or if I had through sex or in any other ways been exposed to blood. They saw an Asian American girl wearing a sundress and sandals, her long hair tied into a bun. They did turn me away from donating blood because, they told me apologetically, with my history of anemia and low blood pressure, giving blood would pose a danger to my own health.

Robert began losing his sight. We would meditate together in the hospital. On days he hallucinated, it seemed to calm him, to focus on his breathing. On days he was lucid, focusing on his breathing was too scary because he could feel the diminishing capacity of his lungs to take in air, and he would feel like he was drowning. So we would focus on an image. He loved flowers and found them soothing. We settled on a lotus.

"I used to be able to sit in full lotus position," Robert said, struggling to push his thin body upright in his hospital bed, then giving up. He was reminded of a quote he loved about the lotus as a house in the heart, "something," he would tell me, not remembering exactly, "about enough love in the house in the heart for the whole world. I want enough for the world," he said, crying, frustrated that he couldn't remember. "But I'll take enough for us. Just enough love for all of us."

Robert's sight was dimming, and we were running out of time. I sat in Alex's chair—Alex, the same artist who had tattooed Cory just a few weeks earlier, who tattooed Ron Athey and sometimes performed with him—and as we talked, he sketched out a beautiful lotus, its petals unfurling in shades of lush magentas and pale pinks fading into delicate white sweet spots deep inside the petals and on their undersides. As Alex finished inking the lotus onto the inside of my left forearm, we looked at it together. "It needs something. Maybe leaves?" he said. I agreed that it needed something. "Tell me more of the story," he asked. I told him about Robert, about the house in the heart, about the fading of his vision, the fading of his life.

Alex began mixing inks for yellow and gray. "It isn't a flower," he said, "not really. It's an icon, isn't it? A *milagro*." I smiled at his British accent wrapping itself around the Spanish word, the deeply ritualized symbolic miracles of Los Angelenos. The hybridity of my hometown language, the spiritual practice of my ancestors, and the man-made lake I had grown up with. He fanned golden rays of light around the petals of the lotus, then gray streaks, grounding it in place.

The tattoo was still healing, my skin still wounded and broken, absorbing and integrating the ink, when I went to show it to Robert. In the two days since I had seen him, his sight had continued to fail. My skin still too tender to touch, he held my arm close to his eyes, squinting, smiling, seeing clearly the black outline of the lotus. Then he started crying, unable to make out the shading of specific petals and the subtlety of where colors deepened in intensity. "Describe it to me," he said, as he leaned his head closer to my arm. As I told him about the shades of pink, about the white sweet spots, he

cried. "I can see the halo," he said, describing the yellow and gray. "It's glowing," he said, crying harder, his tears splashing against my raw, still-open skin.

"I like knowing it's there," Robert said. "You'll remember me when you see it."

"Every day, Robert. Even if it wasn't there." I held his hand. Then his head tilted away from me and toward the wall, and he began to chant and chatter at someone only he could see. I sat with him, holding his hand as he chattered at the wall, every so often turning toward me, without really seeing me, but saying clearly, "You'll remember," then turning away again.

⌁

MOMENTS LIKE THIS ARE THE ONES I wish I could forget. The ones I wish I didn't remember. The little everyday gestures. We are sitting in the living room. Steven in a chair, one leg tucked beneath him. Me, on the floor, under the window, books spread around me, studying for exams. Steven is editing a story, a red pen held between his fingers. Billie Holiday on the stereo, softly. So softly I don't realize, for a song or two, that I am no longer singing along with her, my attention half on European history, half on the music, but I am singing along with Steven as he croons the Holiday arrangement of "You Don't Know What Love Is." His eyes are moving across the page of his story, but the delicate vibration of sound is coming from his throat. I watch him take a breath timed to the music. My voice quiets as I listen to him singing into the ache of loss.

"What?" He doesn't look up at me.

"What, what?"

"You stopped singing," he says.

"I was listening to you."

"Join me."

"I'd rather listen to you," I say.

"Join me anyway," he says, and begins again with the first verse. I start singing and then suddenly feel silenced, trying to find my way into the tonal space of his heartbreak, and afraid of joining him in it.

"You choked up," he says, putting down the red pen and loose pages.

"You were watching me."

"And you stopped breathing."

"Well, I can't have completely stopped breathing," I argue.

He ignores my argument. "What is it?"

"I don't know. Maybe a little scared."

"Of me?"

"No, not exactly."

"Of what, then?"

"Something like being too loud."

"We're still working on you taking up space?"

"No," I say. He looks at me and raises his eyebrows. "I mean yes, but no, not with this. It's too loud in my head, the reverberations. I'd rather hear it, feel the vibrations from outside than inside."

"And so you stop breathing?"

"I guess."

"Let's try again."

I take a breath. Then another one, trying to feel myself as I start singing again. My eyes are closed, my head tipped back a little, but the sound thins out and dissipates into the air.

I open my eyes and look at Steven, who is looking at me. "What?" I ask.

"What happened to your breath?" he asks. "What happens to the channel of air with your neck arched?"

I take a couple of breaths, tipping my head back, feeling the tightening of my throat, the closing down of my airways.

"You feel that? Follow the path of air. When you tip back that far, it closes off," he says, and starts singing softly, the lines I had just choked on. He sings the verse a couple of times, and I watch. First, his face, the softness around his eyes, the looseness around his jaws. His head is high and slightly back, but his throat is opened with the ease of breath, a channel running down his chest and into his abdomen. I watch the rise and fall of his belly, the horizontal expansion of his wide rib cage. He opens his eyes and watches me watching him.

"You've got it?" he asks.

I nod.

"Trace the path of air, the whole circular pattern. Trace it with your hands through my body. Find it." And he starts singing again, from the beginning. He loosens the Holiday arrangement, a not-quite scat, but moments veering toward more emphatic call, the response then coming from his own vocalized, melodic grief.

I watch his body as he starts singing. The inhale I don't see him gulp the way my in-breath feels to me is invisible at the level of his face and chest; instead, I see it as his abdomen fills, diaphragm stretching. I place my palms flat and soft against his belly, feeling the rise and fall of breath timed to the phrasing of the lyrics. I close my eyes, feeling the air move through him. I trace my fingers from his diaphragm to his lungs as he continues singing. Sliding my hands up his chest, I feel the deep vibrations starting in his throat, tremoring through his lungs, outward to his ribs, the barely perceptible vibration against my fingertips. I keep tracing the feeling of breath, and my fingertips spread out across the curved bones of his clavicles, that upper edge of the lungs so close to the top of the body. I bring one hand to the base of his head and feel the vibration in the vertebrae and skull. Sound moves across all planes around me. Enfolding me in the circle of his breath. Sound has depth and breadth and width. It moves through the air and within us. As I feel his breath in his body external to mine, I can feel my own breath

mimicking, mirroring. My abdomen loosening to make space for the dia-phragmatic stretch and reverberation, the opening of space in between the bones of my skull. I start to sing with him, mirroring his breath.

"Good, keep going," he whispers in my ear. My eyes are closed.

I hear a deeper resonance this time, but the sound is still thinner than I want it to be.

"Good." He's standing next to me, whispering as I find breath. "Can you feel it here?" He places his hand, flat and wide, against the center of my back, his fingers spreading between the curved scapula and tender expansion of lungs behind. I breathe into his hand on my back body, feeling the press of contact between us, finding the vibration and echo from that place.

He lightens his touch, until he removes his hand. The space between us feels vast. Feels endless. I feel pulled back toward the place his hand had been, the vacuum of presence and a spike of panic. I feel like I'm fall-ing backward. He sees it. Or he feels it. His hand back on me, fingertips measuring the space between the bottom edges of my shoulder blades as I take a ragged breath.

"I'm right here," he whispers. "Keep going. Find the breath again."

What is indistinguishable, inevitable, unavoidable in the organization of a lyric moment made into sound? Is it the word, the vowel toward which tongues curve and outline space? The consonant that shapes the breath? Is it the breath itself?

I settle back in, his hands keeping me upright. He keeps cuing my breath-ing, the resonance between our breath, his timed to mine, holding a beat. His other hand against my belly, my diaphragm stretching toward his fingertips at the inhale. I feel him breathe deeper as I do. At the higher notes, as I feel the soft cartilage of my upper palate shift and open, the air echoing through my skull, I feel like my head opens up. Air and sound pulse and ricochet through the bony sutures in my head. I lose track of the feeling of my feet and feel like I'm going to pitch forward, and I don't know if I'm going to fall or fly. I start to back off from that spaciousness of air and vibration.

"Keep going," he says, or maybe doesn't say with words, just with the shift of his hand on my front body up against my sternum, fingertips spreading wide from clavicle tip to clavicle tip, upper lobes of my lungs reaching toward his fingertips on my skin.

I resteady and breathe, feel his breath pushing the extension of mine. I'm held between his arms. He's standing at my left side, his right arm against my back, his elbow at the junction of my spine and hip, his right hand spread wide across my upper back. His left arm is on my front body, elbow at my

diaphragm, forearm following the centerline of my body, left hand spread wide across my upper chest and lungs and collarbones.

I push and pull myself, my breath, taking cues from the Holiday arrangement, from Steven's breath, metabolizing them into my own inhale and exhale. I feel my lungs expand back against Steven's arms up my spine, his fingers spread against my ribs and my lungs beneath them. His arm in front leaning with enough pressure for me to push against him with each inhale. On the exhale his arms move closer toward each other through my viscera between. I am grounded, pulled groundward by the gravity of his arms. My head opens up for the sound to roil and echo, changing from the shape of breath in my mouth through the vibration in my skull and the vibration back through his hands against my rising and falling bones.

I'm balanced here, not falling backward, not pitching forward into fall or flight. Air and breath vibrate through my bones and soft tissue and then through his hands and bones under his skin and echo back. We're breathing, song and sound, lyrics of loss, an endless loop. We could stay in this place forever.

This is the moment I want to forget. This is the moment I try to get back and cannot say. There are no vowels and consonants to echo that resonance.

Is the body the path to the ineffable experience, or the experience itself?
Is the breath?
Is it the place where our two bodies meet, or the space between them?

▲▸

WE SPEND DAYS BUILDING OUT the LA Theater Center in preparation for the Reality Ball, ACT UP's Women and AIDS benefit. The lotus is still healing. The day of the benefit, I'm wearing a black long-sleeved shirt over a black tank top, black jeans, black steel-toed boots. My hair is tied up in a knot on top of my head. Everyone is on edge. Mark Kostopoulos, one of the original members of ACT UP/LA, is dying. We're waiting for news as we move furniture around the stage, as I learn the hallways and staircases between the backstage dressing rooms, the stage wings, and the greenroom. Right before final curtain call, one of the faeries sprinkles glitter into my hair, lines my eyes with thick black stripes, and swipes deep plum across my lips and eyelids.

My task during the performance is to usher the long list of performers from their dressing rooms to the stage and back to the greenroom. I spend the entire performance running. I'm dimly aware of hearing some of what is happening onstage, but I can't stop to watch any of them: Ann Magnuson, Cassandra Peterson as her alter ego Elvira, Mink Stole, Nathalie Archangel.

Mary is pushed onto the stage to make the announcement that Mark has died.

Once the performance is over, backstage and the greenroom are chaos. Everyone is upset, looking for information about Mark, a political funeral demonstration, a memorial action. Press are wandering around waiting to talk with the ACT UP press liaisons. We're all weepy and wrung out.

Steven's boyfriend is managing the press. He walks over to me where I'm stunned and silent, exhausted, leaning against a wall. He's leading Steven by the hand and places Steven's hand in mine. He kisses each of us and says to me, "Keep him with you for a bit? I have to deal with that mess." He nods over his shoulder back toward the greenroom and the swirling press. I nod.

Steven is looking around, or rather he is swiveling his head, but his eyes aren't focused. His breathing is shallow. I squeeze his fingers tighter in one hand and place my other hand against his chest.

"Baby," I say. His eyes have a wild, panicked look. I recognize the look. I've never seen it on him. "Love," I say.

"Love," I say again, pressing my hand harder against his chest. I start to feel the rising panic in me of my breath shortening, timing to his. We're edging toward hyperventilation. I can feel his fear. We could both drown in it. I recognize the look as he feels his own vitality falter. I force myself to unmatch my breath from his, and I take a shaky breath.

"Love," I say. Again, pressing harder against his chest. Almost slapping him. Rubbing his chest, digging my thumb into the space above his heart. Willing him to come back. He looks at me fully, his eyes focusing.

"Breathe, baby," I say, and together we take a deep, jagged inhale. Tears run down both of our cheeks.

"I . . ." He starts, then stops, his eyes wider, looking at me, then closing.

There are so many ways we lose our breath. We don't even notice the absence.

"Shhh." I move my hand from his chest to his cheek and brush his tears with my thumb. He tips his head down against mine, forehead to forehead. We're both crying. We tip our chins forward and find each other's lips. Soft comfort. Then a little harder. My fingers are still against his cheek, his hand in mine, his other hand finding my cheek. We pause. Forehead to forehead. Breath rushing back into our lungs. We gulp air.

"Shhhh." Barely a whisper. We stand like that, breathing, holding on. Until his boyfriend finishes with the press and comes back to get him.

Later, I'm moving through the chaotic space of the afterparty, which has taken over the LA Theater Center lobby and patio. It's hot. I take off my shirt and tie it around my waist. I pace laps through the space, use the width of my shoulders to pivot and turn and carve a body-shaped space through the crowded room. My tears, Steven's tears, are still drying against my cheeks and lips. I become aware I'm being watched. I make another pass around the room looking for Jeff or Nancy. I'm being followed.

He's tall. Leather jacket, leather pants. Thick arms, heavy-booted feet, shaved head. He's a faerie. Adam is one of the black-leather wings—the BDSM faction of the Radical Faeries. He's been dating a Queer Nation fag friend. And we've been flirting at parties at the Agfay house, the collective Radical Faerie household, off and on for months.

I look over my shoulder as I make another lap through the crowded room. I'm so tired. I can hardly breathe. Once his attention was enlivening. Now I just want to sleep.

Adam doesn't know my cues. He's taken my look over my shoulder as an invitation to follow. A few days ago, he might have been right. I can't turn around to put up a hand, even though some part of me knows he would re-spect the clear message. There's too much inertia to my movement now. I can't break through my own propulsion through the dark, queer-filled space. He's timing his booted steps to mine, his strides getting longer.

I look up and to the side. David is sitting outside on the patio and has seen my last pass through the room. He's watching the whole thing unfold. In a few giant steps, he's walked over to me, intercepted me, and I'm in his arms. In another two steps, we're back outside on the patio, where I'm sitting on his lap, my head against his shoulder. David brushes my hair out of my face. I just shake my head. I can't breathe. I can't speak.

Mark Kostopoulos

1955–1992

ALL DAY AT MY HIGH SCHOOL GRADUATION, I was restless and impatient. It was the week of a big demonstration ACT UP had been planning for months. I had a nagging feeling that something had gone wrong, that someone was hurt. Steven and Pete convinced me that I couldn't miss graduation and kept me away from most of the planning meetings. For a few days they hadn't returned my calls, trying to keep me focused on my family, on graduation.

After graduation and celebrations with my parents and my grandmother, I drove over to Steven's house. As I pulled the car up to the curb in front of the house, I could see Steven sitting on the porch with Wade and David. Steven's arms were out in front of him, his elbows resting on his knees, his palms upturned. I saw that Wade was dabbing at Steven's wrists with white gauze bandages. As Wade pulled the gauze away from Steven's wrists, I could see the bright crimson of fresh blood staining the white.

It happens so fast I'm not even aware I'm in motion, but I must have launched myself out of the car and across the yard because suddenly I'm on my knees at Steven's feet, reaching for his hands, for his wounded wrists. And just as quickly as my instinct to reach for him, Steven turns his upper body, hard and fast, to the left, tucking his hands into his lap, and my reaching hands ricochet off his right shoulder and elbow. "Don't," he says to me, sharp and harsh. His voice is hoarse from yelling at the demonstration all morning. He nods his chin toward the drops of blood darkening to rusty brown on the concrete step below him. We are both tense and quiet but arguing fiercely, silently.

We're in a silent standoff, uneasy, unbroken eye contact as Wade begins to wrap Steven's wrists with clean gauze. I watch Steven flinch, and Wade asks, "Too tight?"

"No. I'm fine," Steven replies.

Wade finishes wrapping Steven's wrists, and Steven gets up and walks into the house. I start to follow, and Wade puts his hand on my arm, keeping me with him. "Let him go," he says.

I take a deep breath, and Wade takes my hand in his. We're quiet, decompressing from the day.

"It was bad?" I ask Wade, though I already know the answer.

He shrugs, closing his eyes, squeezing my hand.

Years later, Jeff will fill in the details:

I think the action was about state health care cuts. It was at the Reagan State Building in Downtown LA. Brian had his wrists damaged, if I remember right. Steven too.

One thing I have not forgotten was Uncle Jimmy stopping all of us as we walked up to enter the building. Instead of opening the doors and walking in (the doors were not locked), he stopped and pounded on the doors, shouting, LET US IN! It was a dramatic strategy to get attention . . . and for creating the illusion that we were locked out.

The circle formed as rehearsed. (A lot of time went into preparation, using the chains, etc.) The plan was that the chains would be foolproof.

I don't remember everyone in the circle.

Their arms were chained together inside the PVC pipe so the police couldn't pull them apart. Maybe seven or eight or ten chained together? We had info flyers about why we were there. Loud chanting that echoed. Workers on different levels above were looking over and down at us. Police were called. Chanting louder and louder. Tension. The cops moving in. Screaming!

AT THAT MOMENT: the doors of the State Building flew open: with MARY leading the charge!!!!! a large group of ACT UP protesters (this group came from protesting at the board of supervisors meeting) . . . came chanting, fist-pumping into the building.

I will never forget the feeling and power of that moment. Loud!! This happened at the moment the police started into action.

Each person was forcibly pulled apart from the others. That wasn't supposed to be possible. Everyone was worked up. It was physical and violent. The demonstrators were taken to an inner part of the building. I followed them all the way inside and barely got back out without being arrested.

That's what I remember.

Steven comes back outside, carrying a cake. He smiles, placing the cake in front of me.

"When did you make a cake?" I ask.

"Yesterday"—he shrugs—"but I frosted it today." I look at the cake. It's chocolate. Frosted with dense swirls of buttercream. I look back at Steven. Wade has wrapped his wrists in white gauze, which covers thicker pads and bandages. The white gauze is glaring against his dark skin, and it makes me squint.

"Today," I echo. "When?"

"When I got home."

"But..." He turns and walks back into the house before I can keep questioning him. He returns with a knife. Plates. Forks.

I piece it together in my head. "You made it last night because you didn't know when you would get home? And then you frosted it today? When you got home from the police station? After they released you?"

"You needed a graduation cake with us. We all needed you to have one. We needed to celebrate this." He starts to cut the cake, then winces at the internal rotation of his wrist, maneuvering the knife. He turns to David and hands him the knife: "Can you do it?"

I start to protest. "Cake first," he says. "I'm fine."

Steven unwraps the gauze around his bruised wrists. When the police tried to pull apart the affinity group, Steven's wrists were the fulcrum, absorbing the force of separating everyone.

"Too tight?"

"A little."

"We can redo it."

"The air on them feels good."

After we eat the chocolate cake, I take the dishes inside and survey the kitchen. The mixing bowls drying in the dish drainer, the cake pan and frosting bowls soaking in the sink along with a heavy whisk I know must have added pressure on his vulnerable wrists. I breathe deeply, biting down on my lip. So much insistence that we keep our world running as though everything were fine, as though we were used to any of this. I stand with my hands under the warm water and take a few minutes to finish the dishes and put them back into the cupboards before wiping my eyes, finding the ice pack, bandages, and gauze.

"Let me see what they did to you." My now-familiar mantra. The cuts aren't very deep, and the bleeding has stopped. But his wrists are swollen and puffy. I look closely at the bruises forming and spreading, those burst vessels spilling blood under the skin. The surfaces of all of us are so fragile. I hold ice to his wrists for a long time, his hands relaxing into my lap.

"Enough," he says quietly, his lips against my hair.

"Cold?" I ask. He nods.

I go inside the house, replace the ice in the freezer, and find sweatshirts for us.

I sit on the step above Steven, my arms wrapped around his shoulders. He leans back into me. The sun fades, and the moon rises. All evening Ella Fitzgerald has been singing *The Johnny Mercer Songbook*, and now she has cycled from "I've Got My Love to Keep Me Warm" to "I Remember You."

We look around and around, memorizing each other, none of us saying it out loud, none of us breaking the spell. But I know this, a flash of panic quelled by the overwhelming flush of tenderness. We hover in this split in time, on the cusp of more and more and more. We hold on to some nights as though they have already happened. Holding steady, remembering as it happens.

⚝

ACT UP WALKS LA'S GAY PRIDE MARCH in silence. We're all wearing our black SILENCE = DEATH T-shirts with their neon pink triangle. We're carrying posters with photos of Mark Kostopoulos. We're usually the noisiest contingent, whistles and bullhorns. This year we're a funeral procession. No one knows what to make of us as we walk up Santa Monica Boulevard, silent in the midst of the celebratory pride crowds. We're a wall of grief and outrage moving through the bright Sunday morning. We stop frequently along the route for die-ins, that gut-punch ACT UP visual of a sea of dead bodies on the ground. And a few people left standing, outlining bodies. When those who have fallen stand up again, names of the dead are written into the outlines of bodies. The rest of the parade following us must walk over the markers of the dead and missing.

At the end of the parade, where ACT UP disperses, Gabe has brought Robert to visit and to see everyone. *To see.* Robert's eyes are shielded by large, dark sunglasses. "Hi, darling," people say to Robert, pausing to kiss him hello, to kiss and hug Gabe. "Hi, dear," Robert says back to almost everyone. Then I understand. In the bright sun, he can't see well enough to tell everyone apart anymore. We're just a wall of lights and shadows and queer sorrow and love surrounding him. As we settle and slow down and pause to actually talk with each other, Gabriel whispers in Robert's ear as people come to talk to him. (*It's Helene, love. It's Seh. David coming over now. Neil on your left. Now Patt, now Judy.*)

A few of us stay close to Robert. He's exhausted, confused, trying to focus. I hold his hand. He feels my left forearm, tattoo almost healed. He brings my arm up to his eyes, squinting through the sun and his dark glasses.

"I can feel it," he says.

"What can you feel, love?" I ask, whispering into his ear.

"The lotus," he says, running his fingers over the tender skin. "Right here. Where it hasn't healed yet."

JULY IS THE LAST FULL MOON I'll be in Los Angeles on the beach with the Faeries. We meet at Mooncalf's house and walk to the beach. Sometimes there is fire. Something to make smoke. There are candles, at least. Flickering light to see each other. An altar in the circle with photos of our dead and our still-living. I look around the circle at the illuminated faces of my loved ones. I feel myself slipping away already. Wayne is standing on one side of me and feels the energetic shift in me. The pull like retreating tide. He reaches for my hand. "Stay here," he says, tugging me gently forward. Robert is too sick to join us. He and Gabe are home. We invoke them, send love and dreams toward them. We don't imagine anymore that we can save each other. But we imagine that we can keep each other close. That everyone will know they are loved. There's singing, but my throat closes up. I mouth words for a while as everyone else sings around me. Then I stop the charade and stand still, taking them in, the song a balm blurring into the sound of the tide. The moon illuminates the water, and the mist is cool against our faces.

It's a grieving summer. Maybe it always is, but I feel it: ACT UP reeling just a few weeks after Mark's death, trying not to hold our breath for Robert. We worry about Wade, but he has recovered a little bit this time and is wrapped in blankets, standing with us on the beach, his hair floating around him in the late-night breeze. There's more singing. Keening, wailing, mourning. We're together in our sorrow, but there's a way I feel our separations. Or maybe I'm just anticipating my own isolation a thousand miles away. Counting down the month before I'll leave for college. Not knowing who will still be here when I return.

After we break the circle, we're still on the beach, talking quietly in small clusters. Against the sound of the water is the occasional laughing shriek of camp, or the mournful tears about Mark, the anticipation of Robert, all of us ricocheting between sickbeds and meetings. Breathing in the cool air.

Adam walks up to me. We haven't seen each other since the night of the Reality Ball. Not since David pulled me into his arms and then Adam stopped pursuing me, watched us, and walked away. As Adam approaches me, David stands up taller, moves closer to me, protective.

"May I talk to you?" Adam asks, stopping more than an arm's length away from my body.

I nod, then put my hand on David's arm. "I'm OK."

"I'll be right here," David says.

I walk a few yards away, and Adam follows me. We turn and face each other. In the moonlight and shadows, his figure is imposing, tall, long-limbed, his shaved head a globe under the moon, standing out against his black shirt, black jeans. His boots are off, and his toes curl into the soft sand.

"I need to apologize," he begins. "I didn't realize until David intervened that you were moving away from me. I thought you were leading me. There was so much play that night, and the way we'd been interacting, I thought you were looking for a place for us to go. I'm sorry if I scared you."

"I know. Thank you." I look up at his face, the way he has contained his energy, keeping in conversation but not encroaching on my space. I feel him making himself smaller, trying not to scare me again. I can't help but smile.

"Can I ask you something?" he asks, seeing my smile and smiling back.

"Sure."

"Did you think that you had communicated a 'no' to me and I hadn't understood?"

I think about his question, replaying the night. "No," I finally answer, "I know I hadn't communicated anything clearly."

He nods. "Did you think that I wouldn't have listened to or respected your boundary?" I look over at David, who is standing with Wade. They keep looking over at us.

"Actually, I hadn't thought about it that clearly. I just . . ." I pause, looking at the water, the wet sand under our feet. "With Mark, and everything else that was happening, I just lost my voice, I think. I was so tired." I look up at him again; he's nodding. "I was just so profoundly tired. I don't know what happened. But it was me. The unclear communication."

"It was both of us," he says, "but that's what I thought happened, when I replayed it later. And . . ." He hesitates.

I look up at him, waiting.

"I'm worried about you. I take responsibility for my part of that night, which was most of it. But I also know protocol, and if I had seen your face, gotten close enough to feel your energy the way I saw it once David intervened, I know I would have understood and stopped everything with no question or need for conversation."

"I know," I said.

"What I'm trying to say, though," he says, "is that not everyone does. I worry about what happens when you leave here. Leave this." He looks back at our friends, who are still clustered with candles and photos, soothing each other. The occasional peal of laughter making its way to us over the crashing waves.

◤

THE SMALL FIRE OF CANDLES and incense. Collective smoke. They make Robert cough, but he wants them. What we burn in the candle's flames: intentions broken or still grasped. Love notes. Broken promises of survival. We pretend we're on the beach. We pretend we're anywhere else. Then we ground ourselves together in the present. In the Hollywood of sirens and cars and life all around us outside the windows.

The lotus on my arm, Robert's fingertips digging into the petals, the new moons of his nails scraping but not quite puncturing the edge of the petal when he coughs. And oh, that cough, larger than him. Rattling through the empty hollow of his chest. We slowly rotate around him so that he is cradled first in one lap and pair of arms, then another, then another.

House like a lotus, Robert whispers in my ear. *Enough love*, I whisper back, when he's resting his back against my chest, my arms holding him up. Enough, love. How we split ourselves, how we help the loved one find ease. Lying to ourselves because we don't think we'll ever have ease again. What hands feel like in mine as we reach for each other again and again: Robert's dry, cool, then hot. Gabe's trembling. Pete's angry and restless. Jeff's warm and steady. Candles making shadows dance the way Robert won't again.

Flowers climbing up the concrete building walls outside. Reaching up from the parched ground for the windows of Robert's apartment, of Pete's, connecting them, one above the other. Green lifeline.

Fire. Candles. Incense. We're all holding hands. We know how to do this. The goodbye. The letting go. *Breathe, love. Enough, love. Like this.*

Robert Nemchik

1964–1992

WHEN I PICK STEVEN UP a few days after Robert died, his writing has been going well. He opens the door humming along with an up-tempo Billie Holiday riff. He dances around the room while I laugh at him, and then he pulls me to my feet, swinging me around the room with him. We dance until the song ends and he pauses the CD. "We should go," he says, quietly, and I nod.

Driving across town to Gabe's apartment, we can feel the unsettledness of the Los Angeles air. Even though it has been a few months since the Rodney King uprising, the ash and debris still feel trapped in the smog. Our eyes burn.

Gabe's eyes are red from tears and sleeplessness. He's wearing baggy beige shorts that flop around his knees, and an old ACT UP T-shirt, white with a faded pink triangle and black lettering saying ACTION = LIFE. He kisses us both hello. He wants to talk about planning a community gathering for Robert, just the queer family, in the apartment, in a few weeks. Gabe wants to distribute some of Robert's things, give us pieces to hold. "Robert would have wanted that, to be carried around with us." We nod. Gabe walks back and forth between the bedroom and living room, showing us photos of Robert, clothes, books, things Robert loved. I curl myself into a corner of the couch as Gabe approaches and retreats, arms filled with ephemera. The bright evening sun is close to setting but still lighting up the room.

I have anticipated this moment, imagined it over and over on the edge of sleep and nightmares, not wanting to see it, but still rehearsing. And I expected it to feel more dramatic; to sob, to feel broken, to be broken, to lay my head on Steven's chest and wail with a new kind of understanding of devastation. Of losing and longing. But it is so much quieter than that. Steven and I are sitting in the living room. Eventually, Gabe comes and sits on the couch next to me and reaches for my left hand, tracing the healed lotus with his fingers. Then his fingers stop, and we just sit. Steven is sitting under the window, across the room from us, and I squint into the summer sun, watching him breathe, the muscles of his neck and shoulders tensing and holding for a few breaths, then a deeper breath and the visible dropping of his shoulders, his eyes closing, another deep breath. I sit silently, holding Gabe's hand in mine, waiting for that devastation to come. Then I understand: this is it. This is the brokenness. It is the feeling that has shadowed us for weeks, anticipatory or furious or crumpled into some quiet part of our bodies. It was always here. It would always be here. Already they were dying, even as we were living. All of us together. And moments like this, all of us so far apart.

◢

STEVEN AND I ARE QUIET as we drive back across town after visiting Gabe. I'm driving, staring straight ahead, not looking at him, but I feel his stillness, and in the glare and reflection on the window, I see his head is turned away from me, looking out the side window. At the intersection of Franklin and Vermont, I stop for a red light. It's the same intersection where we were stopped during the rebellion, on the way home from visiting Robert. On the other side of the intersection are the flashing lights of a police car pulled up behind a beat-up pickup truck. In my gut I know that the driver is probably young. Probably brown-skinned. I imagine there is no good reason he is stopped other than it is late, and he is dark. I scowl, then turn away from the truck and look at Steven, who is now also staring at the police car. The bright, flashing lights cast a strange blue glow against his skin, and I shiver a little.

"Cold?" Steven asks.

"No. Just—" I look away from him. "Nothing."

"Babygirl, what?" He is looking at me, waiting. I can see his face tipped toward me in the reflecting of the flickering lights on the window.

I don't know how to explain it to him. That sometimes I look at Gabe and start to feel the absence of him even as he is with us and we are with him. That I am staving off that feeling about Cory. About Wayne. About Pete. And about him. That tonight I had a flash of remembering Wade's friend who used to drive Wade to meetings. I realized I hadn't thought about that friend in months, that I had in fact forgotten about him. I try to call up an image from my memory. The curly dark hair I picture in my mind is suddenly highlighted red from the strobe of the police car in front of us, and I remember the demonstration at LA County Hospital when we were demanding faster access to doctors and treatment for people with AIDS without health insurance. Wade's friend was arrested that day, and the police drove people around town in circles between the hospital and the booking center downtown so that it was hard for the legal team to keep track of everyone. But we did, I remember that. We kept track. We didn't lose anyone. I try to picture his face and features, but they flicker, disconnected, the turned-up nose, dark brown eyes, tanned skin with a few freckles scattered across his cheeks, but I can't call all of the pieces together at the same time to construct a face, and so he remains a Picasso painting, abstract, all feeling and fragmentation. I shake my head against the press of tears. How could I forget? And if I could forget him, who else would I forget? Would we all forget? I always thought it was just the dead we were in danger of forget-

ting, but what happens if we forget the still-living? How will we hold each other close enough?

The light has turned green, and Steven's fingers brush my hand, clenched tight around the steering wheel. I drive the car forward through the intersection, past the flashing lights and what turns out to be two cars pulled over to the deserted sidewalk. An old Toyota pulled over in front of the pickup, the cop out of his car talking with the two drivers, both of whom appear white, the aftermath of what looks like nothing more than a fender bender. No one is hurt. My gut is wrong. But somehow that doesn't feel any better than being right. My eyes are still on the road, and Steven takes his left hand from my hand on the wheel and touches the side of my face.

"Babygirl?" he asks. I just shake my head, no words coming to me. Sound feels so far away. "Talk to me," he says. "What is it?"

"Nothing," I whisper, and I turn my head away from his hand. Stillness inside the car, Steven's warm fingers brushing against mine, his alive body occupying a shared air. I could reach my hand easily across the space between us. I don't, but I know I could. We are silent for the rest of the drive back to his house.

We're still quiet as we walk into the house and go our separate directions. I kick off my shoes by the door and wander into the kitchen to put on water for tea. We're trying to shake off our fears, which are linked but separate, simultaneous. We don't want to push each other away, but we can't fix it for each other. Any of it.

I don't know what Steven needs. I don't know what I need. I can hear him in the living room flipping on the stereo, and Billie Holiday picks up where she had left off as we walked out the door just a few hours earlier.

Hadn't we been laughing? Hadn't we been singing along with her, dancing around the house in our bare feet, even as we prepared to go see Gabe? Maybe because we were preparing to go see Gabe. Could it have been the same evening? The same lifetime? This is the dilemma: how to stay close as the world falls around us and in us. It would be so easy to retreat. I have a brief flash of leaving: I can picture myself picking up my car keys from where I've dropped them by the front door, walking out that door and down the concrete steps. I feel sick at the vision. I can't possibly know that soon I will leave him, that something will happen that has nothing to do with us from which we won't recover. But I don't know that. Instead, what I know suddenly, so clearly, is that I want the night not to end. What I need is this: the ache and tremble of reaching toward. Even in the rubble.

The teakettle boils, and the steam shocks my face, condensing on my eyelashes, already wet from my tears. I don't hear Steven walk up behind me, but

then there he is. His arms around my waist and hips, his face against my shoulder, and I reach up to his cheek with my fingertips. Wetness against my fingers from his tears. We stand like that, just breathing, finding each other's rhythm. The grief dance of inhale, exhale. The only thing left. Just this. Inhale. Exhale. Fingers against damp cheeks. Arms tighter, holding on. Inhale. Exhale.

What happened next I have tried to write over and over. I've written it as a meditation on grief and attachment, and I've written it as porn. Both are true and untrue. Everything falling away, everything that had been shaping our bodies, pushing them away from each other, tectonic shifts pushing us now toward each other.

This isn't the stylized dance of dungeons, of Saturday night parties after Queer Nation or Sunday nights at Fuck! This isn't a party; there are no witnesses, no audience; there is no extended foreplay of negotiation. Just this surrender into each other's hands, and surrender into each other's breath, and surrender, and surrender.

No lights are on, and the bedroom is just barely lit by the streetlamp. We can see each other faintly, outlines and shadows, the way the light in the Los Angeles night is never fully extinguished. My irises pulse when I blink, gathering in the fading light like a camera shutter capturing. We find each other in the darkness. We are in it. Of it. Of darkness and light reflected back and forth. The shutter captures: the tips of his dreadlocks coiled around my fingertips. And captures: my teeth pressed into the flesh at the joining of his hip and thigh. The shutter captures: my hair draped across his chest, my mouth open, reaching. And captures: the dark top of his hand, the thin healing scars from handcuffs the same shade as my breast. And captures: my legs wrapped around his waist, his hands caught in my hair tipping my head back, his teeth to my throat. And captures again: the insides of our lips blurring into each other. There is no space for light to reflect between us.

What is sex for? To whom and to what do we consent when we are in moments of deep crisis? What is the intimacy we ask for, we demand, we can't turn away from, though we almost can't bear it? And then we can't bear it. And then we can. A moment of saving each other. We are trying to pull each other back from the chasm of absence toward something we want to be connection, want to be life, want to be longevity, a promise even as we know it is momentary, a flash-bang. We want more than anything to save each other. We can't save each other.

No words are left. No stopping to ask questions or doubt or think. Nothing but the moment of reaching. Grabbing great fistfuls of flesh with our whole outstretched greedy hands. Teeth. Tongues. Tears. Our lips will be swollen-

bruised for days. Billie Holiday keening in the background until the album ends and then silence except for our ragged breathing, the cries we feel as vibration more than we hear as sound. Fingertips digging into muscle, deep blue indentations. Nails breaking through skin boundaries. We need more than the ways our bodies enter each other. Möbius of hands, lips, fingers, fist, cock, cunt, tongue. We want to crawl inside the heart of the body itself where there is no time. Only this reaching. The cool metallic bite of adrenaline warming to something sweeter we drink from, unquenched. We can't get close enough.

STEVEN IS TAKING COOKIES OUT of the oven, Miles Davis pouring through the stereo speakers, when I let myself in through the front door.

"Hi, Babygirl," he says, putting the hot tray down on the counter.

"You have to cancel it," I say, taking the spatula out of his hand.

"Cancel what?" He turns to look at me.

"The party," I say, impatient.

"No." He takes the spatula back from me and begins taking the cookies off the sheet to cool.

"It's Robert's memorial," I say, taking the spatula away again. "Look at me."

Steven sighs and turns to face me. "Yes, it's Robert's memorial today."

"So, we can't have a party."

"You're stalling."

"I'm not." My voice getting louder.

"You are. You think that if we don't have your going-away party, then you won't have to go. You can just postpone."

"No." I shake my head.

He looks at me, raising his eyebrows.

"OK, maybe a little bit. But still. We can't go to Robert's memorial and then come right over here for a party."

"Yes, we can. There's time to do both."

"I don't mean time, literally, I don't mean—"

"I know, Babygirl. And I mean it too. We do both. This is queer time. We go to a memorial. Then we have a party. We can celebrate Robert and then come here and celebrate you."

"No." I can feel tears starting to leak down my cheeks.

"Yes. This is what we do, Babygirl. We do both. This is what you take with you. All of this." He brushed the tears away from my face. "Come on, let's go to Gabe's."

The memorial is a blur. We're all weepy, tired, laughing, leaning into each other. Gabe makes a ritual of giving away some of Robert's things. Out of the pile next to him he takes a wide black leather belt, covered with studs, and tells a story about shopping with Robert early in their relationship. "Ohhh," Robert had squealed, holding up the belt, "I want that!" Gabe had laughed at his new boyfriend, the faerie queen, holding up the thick leather. "Please?" Robert had leaned on him. "OK." Gabe had been unable to resist

his boyfriend. Anything he had wanted, Gabe wanted to give him. Already, even at the beginning, there was so little time. He wanted to make him happy in whatever time there would be.

Gabe calls me over to him and wraps the belt around my waist. "A little stealth faerie protection for you," Gabe says. "Feel it as our hands holding you up. Robert holding you."

The party at Steven's lasts late into the August night. Friends from ACT UP and Queer Nation wander in and out all evening. The queer family has bought me a slim set of silver stacking rings. As they slip the rings onto my finger and kiss me, I look around for Steven, but I can't find him.

I walk around the side of the house by myself, listening to the sound of all of my beloveds without me. I'm twirling the rings around my finger. I slip them off and hold them between my fingers, looking at the deep burnish of the silver in the summer moonlight.

Steven comes around the corner and smiles. "There you are."

"Here I am."

"What's wrong?"

"Really, you have to ask?"

"It will be wonderful."

"I can't." We're quiet for a minute, listening to the sound of the party around the corner. We hear Wayne and David laughing.

"Enough already. It's going to be hard, and it's going to be wonderful. You go, tell the stories, date cute girls, come home to us at Christmas. That's how this is supposed to go."

"Nothing goes how it's supposed to go. Isn't that what . . . I mean . . . every-thing the past few months . . . Nothing goes how it's supposed to go." I feel more worn down than weepy.

"Are you worried about me?" Steven asks.

"No," I answer quickly.

"Really?"

I pause and think about the question, picturing him in the house, sitting in the chair with a red pen and a stack of stories in his hand. It makes me smile. "Really, no."

"You're worried about him?" Steven nods his head toward a corner of the yard where Cory is talking with Wade.

"Yeah. Of course, but," I sigh.

"What?"

"I'm worried about me."

"You'll be fine," Steven answers quickly.

"What if I'm not?" I look at him, wanting more of an answer.

"You will be."

"Steven..." I reach for his hand.

"You will be."

"Why are you so sure?"

"Because you have to be." He squeezes my hand, "Really," he says, barely a whisper, "I need to you to be. Someone has to be."

"Don't make me be brave without you."

"But the world is...," he starts, and I interrupt him.

"Don't say it." My voice breaks a little.

"What?" He smiles, laughing again.

"That the world is waiting for me. Don't keep saying that."

"But it is."

"You're my world."

"Don't," he says. "Don't do that."

"But it's true. You. Him." I nod my head over toward Cory, now in animated conversation with Wayne and Christian. "I can't do this."

"If I get sick, I want you to..." The *if* we've never talked about. His voice cracks, and he starts again: "If I get sick..."

"No." I interrupt him, my voice breaking. "Don't." I don't know what I'm saying no to, the conversation, or the possibility of him sick. "Just don't. Not now."

Steven pulls me closer to him. He takes the rings from me and takes my hand in his. He slips the rings back on my finger. "You take it all with you, Babygirl. All of it. Robert. Cory. Me. The whole thing. This is what we do."

I don't know how to tell him what I fear most. That when I attempt to remember the stories, I'll feel crazy—alone with them, alone without him to tell me that it all really happened. Even still standing here together, the hallucinogenic quality of the memories taunts me into feeling my own delusional edges—did that really happen? Did it happen like that? Could it really have? And did we really shuttle back and forth across town all night from one hospital to another to another to the hospice tucked into the park's hillside? With hallucinating queens in late-stage dementia walking the halls pulling their IV poles and singing songs from *Into the Woods*?

To tell it sounds like theater. It sounds like representation, like exaggeration. I have a flash vision of Cory sitting on the floor of his cottage, his finger drawing swirls of drying blood ocher onto a scrap of paper as the helicopter

strobed outside the midnight window. We bleed publicly. We bleed privately. We attempt to shine a light on the bodies of our atrocities, what we've done to each other and how we've tried to atone. How we try to save each other and how we fail.

I start to open my mouth, and Steven presses his fingers against my lips and then replaces his fingers with his lips lightly against mine. "This is what we do," he whispers. "You take all of it."

after leaving

Unsent Fragments (I)

Dear Steven,

I had no idea I loved rain. How would I have known, growing up in the thick LA air? Hot coffee in the early morning rain. Before anyone else is awake. Wet lawn on the way to morning lecture feels like skin. I'm not sleeping much. I don't like dorm living—the hallway lights are never off, and it's always loud. Insomniac walks through the neighborhood surrounding campus. Big houses, tree-lined streets. Mostly dark, deserted in the middle of the night. Houses sleeping. Tricycles and toys scattered on lawns, like the family knows they'll still be there in the morning. Assumes. Sometimes lights are on, and I can see inside. None of the families look like us.

Dear Steven,

I tried to read the Iliad again. I keep trying. All I think during morning lecture: these are not our people. So, the horror and futility of war. Yes. And what is honor, really? And in afternoon conference everyone wants to talk about it symbolically. As though it is only symbolic. As though we aren't at war. Always.

Dear Steven,

The back door of the music building is left open at night. On purpose? It's a converted old house at the edge of campus. No soundproofing. I can hear someone singing arias downstairs while in the upper eaves I'm at a piano plunking out the lead to "You'd Be So Nice to Come Home To" with my index and middle fingers. I miss you.

THIS IS THE PART I don't like to talk about. Because it complicates it. Because it will change how you understand the story. How do I talk about a moment that I didn't control, and control the impact of the telling? As though we could control anything? (And isn't that the lesson here? The illusions of control, not the control itself, are what kept us sane. And when the illusion crumbles, so does our sanity. And the narrative.) But here's the narrative.

The first time, I let him in. We had been hanging out. In my panic about being away, he was someone from home. Or some story of home. He had come to a few Queer Nation meetings years earlier. I didn't remember him. But he remembered me. He said he had a crush on one of my beloved fag friends. I thought that made him familiar by proxy.

But his body wasn't familiar. Wasn't comfortable. Wasn't kindred. He smelled like smoke, tasted like alcohol. Limbs long, angular, and strong and unforgiving.

The second time, other people in the dorm let him in. He had befriended them. My roommate liked to hang out in a room at the other end of the hall. She left our room unlocked so she could slip in and out without disturbing me.

I couldn't sleep away from home. Away from my quiet hill and faeries across the canyon signaling bedtime with their candles in the window. Loud voices in the hall, loud voices outside my ground-floor window always. Muscle relaxants dulled the roar. Dulled everything. Lulled me into sleep that was not sleep.

Fighting back is a problematic concept. Our stories of fighting back assume that will is the same thing as capacity. And that will is constant.

Sometimes we close our eyes so we can imagine that the thing happening is not happening. Sometimes we close our eyes so that the thing happening doesn't become true. Sometimes we close our eyes and wait.

Before I closed my eyes, I tried to pull away. But. Large hands pulled my arms away from my sides and flat to the bed. Then kneecaps slammed into the upturned insides of my upper arms. "You like to fight. I know you do," said the voice. "I remember where we met."

Before I closed my eyes, I turned my head away, toward my desk and the desk chair over which my jeans were draped, with Robert's belt straining the seams of the loops.

I heard the tear before I felt it. Muscle relaxants work that way. My muscles loose and flaccid as I turned and twisted hard from the spine, one direction, then the other, pulling for leverage I couldn't find. Heard it. The tear. Muscle fibers. Ligaments, also. First the right shoulder. Then the left. Hot, then cold, nerve misfirings shooting through my hands. Muscles not able to pull tight to the bone, fragments of bone let loose in the joints and the soft tissue surrounding them.

My breath high and tight against the pain. Then the pain distant. As everything else.

"You like to fight." The voice. "You're doing that to yourself."

Sometimes we close our eyes so we can forget to feel what is happening. Until the thing happening is over.

▲

IT WASN'T EXACTLY THAT I couldn't raise my arms. But it was easier not to lift them. More muscle relaxants, then more again, helped the spasms but didn't quiet the firing nerves. I couldn't rotate either arm, which I discovered when I tried to swim the next morning instead of going to a lecture on the hero's journey. Cold artificial blue water, chlorine clean, sound muffled, carefully choreographed breath. No crawl. No backstroke. I could, if perched carefully, hold a kickboard, my upper body pushed against it. I could still swivel and kick from the hip.

(And even as I write this now, I notice fragmentation of language. *The hip.* Not *my hip*. Not my anything anymore. And not for a long time.)

After swimming, I knelt in the mail room, grinding my teeth against breathless pain as I rotated only my wrists to open the combination lock of my mailbox. Steven's neat and elegant handwriting continuing a conversation now so old and far away I can't feel him: *Love, have you found our people? I'm sorry if I pushed too hard. And I'm also not. You are our memory. You're just going to have to get used to it. Hold on. I love you, S.*

"BABYGIRL! COME HERE!" Steven calls to me from across the courtyard when I walk into the north end of Plummer Park for a Monday night ACT UP meeting during my winter break. "You're home!" I've arrived right as the meeting is about to start and people are heading inside to claim seats and talking about whatever controversy is on the night's agenda.

Steven's face lights up in a huge smile, and he picks me up and swings me around, then wraps his arms around me. I'm shaking, taking a deep breath, trying to slow myself. I want to freeze time. I want to back up in time. I'm flashing back to our first morning together, the clinic defense action almost a year ago where he kept me warm and we kept each other safe away from the police. I want nothing more than to be safe and quiet in his arms. His boyfriend pokes his head out from the Great Hall and calls to Steven, then sees me. "Hey! You're back! We missed you." He comes over and kisses me, then kisses Steven. "We should get started."

Steven and I pull back from each other a little. I have my fingers hooked through the belt loops of his jeans. I can't raise my arms up around his neck or reach my hands to his face. My torn shoulders are on fire. But I want to stand there with him, his body soothing mine. I take a deep breath. He misreads my pain for fatigue and a simpler kind of nostalgia.

He takes my face in his hands and looks me in the eyes. "My Babygirl. We have so much to catch up about. Tell me everything later? After the meeting? I want to hear all your stories. All the cute butches you're dating, all the things you're reading. I'm assuming that's why I haven't heard from you in a while. I knew you'd be out there conquering the world for us."

I start to open my mouth to argue. No sound comes out. He bends and kisses me. Then he's gone. Into the Great Hall for the meeting.

Sister X has seen the whole exchange. She comes up and puts her arm around me. "What's wrong?"

I shake my head. "Nothing," I whisper.

"Dear, I know when I see a missed connection." I look up into his face. "Steven loves you, but he just missed you. I don't think he heard what you said. I think he heard what he wanted you to say."

"I didn't say anything," I manage to whisper, tears starting to leak down my cheeks.

"That says a lot, my dear." Sister brushes the tears from my face with her thin fingers, then takes me into his arms. My shoulders are on fire, but I wrap my arms around his waist. He's so much thinner than I thought was possible.

"You," I start to speak, then stop, looking up at his face. He's not in Sister drag. He's wearing jeans, a T-shirt, a thick sweater, and a vest. And still he looks like he could blow away in the breeze. His always angular face is drawn, deep caverns under his cheekbones. There is no makeup highlighting his eyes or softening the edges of fatigue and pain.

"It's been a hard fall on all of us, hasn't it, dear?" He takes my hand in his. "Shall we go into the meeting and find seats in the back? I don't think either of us wants to be in the center of the fray tonight."

I hold my arm out, and she takes it in hers, leaning on me a bit. And we walk into the meeting like that. The light weight of her is almost too much for my shoulder, and then it is too much. But I won't let her go.

SOME INSOMNIAC NIGHTS I go to the music building. I like the studio in the highest alcove, small, contained. One night I arrive at midnight, and someone is still playing piano downstairs. I finger a melody from a Cole Porter songbook, not singing loud, but practicing trying to find breath in the expanse of feeling between phrases. I lose time in the exercise, looping over and over through the lines of "Every Time We Say Goodbye." When I try to add voice to the exercise, my throat closes, cracking, the stretch of my upper lungs pushing at the strangled nerves in my shoulders. I try again, and in the slow climb up the minor key, my voice falters, becoming more and more shallow. Finally, I back out of sound, continuing the melody with the fingers of my right hand on the keys, my left arm pinned protectively at my side. I imagine where voice could be, lose myself in the reverie of fantasy. At 2 a.m. the person playing piano downstairs stops, and I hear the front door open and close. Twenty minutes later, I hear the front door open again, and someone walking across the creaking downstairs hallway. I hold my breath, take my hand off the cool black-and-white keys. The creaking stops. Then it starts again. I look around the small room, one door, a window with a drop three stories down to the flooded lawn. No exit. The only light is the lamp next to me, and I turn it off, then curl myself into the smallest ball I can against the wall, half under the piano. I have a flash of sitting under the vibes during one of my father's Sunday night band rehearsals. I was probably about four. I was supposed to be asleep. But I crept out of bed and snuck back into the studio. Ricky saw me and winked, angling a little so I could sit under his vibes, where my father couldn't see me over the mixing board and the bass player's amplifier. I don't remember creeping back to my bedroom. I must have fallen asleep there. Someone must have carried me back to bed. Now I am a thousand miles away from anyone safe to carry me home. I hear creaking again, and then it stops. I pull my coat from the piano bench and roll it into a pillow.

Rain through the crack in the window wakes me just before sunrise. It's quiet in the building, and cold. I walk through the canyon and over the rain-slicked bridge back to my dorm. No one knows I've been gone.

Unsent Fragments (II)

Dear Steven,

It's cold tonight. I'm in the music studio. There's a window stuck cracked open. I'm the only one here. Where are you? (I need you.)

Dear Steven,

I don't understand the math part, but the thought exercise is starting to come clear. A little. The cat in the box is either poisoned or it isn't, dead or it isn't. It lives in one reality. We hold the potentiality of both, which is the experience of not knowing. Can our reality hold both truths? Is that the same as knowing and not knowing? The same thing as fantasy? As loving you and being too far away to touch?

Dear Steven,

Schrödinger's Cat—now everyone calls the thought exercise Schrödinger's as though it was his exercise. Really, he was articulating an objection, an absurdity, that the subject shouldn't be the narcissism of the observer but really the cat, who can only be dead or alive. Not both. Now the cat belongs to him, his responsibility, forever.

Dear Steven,

The problem with the cat—as long as it could be dead or alive, I can refuse to find out, to live only within the fantasy where I can keep it alive with me. As with Robert. If I never open the box, can I keep you with me forever?

Dear Steven,

Another problem of Schrödinger's cat—the liminal state of not knowing; the silence before talking—not whether you will still be alive when I return. But whether I will.

Dear Steven,

I'm trying to tell you something, and I can't.

Richard Iosty

1951–1992

GANBATTE: Good luck

SHIKATA GA NAI: It cannot be helped

GAMAN: Perseverance

If the first-year tuition was roughly the same amount as my mother's reparation payment for being born incarcerated and if my parents set aside her reparations to give me something they hadn't had access to and if Queer Nation taught me the importance of infiltration as a long-term strategy for systemic upheaval and change and if because of ACT UP and wartime incarceration stories and asylum testimony I know that survival doesn't always feel like surviving and if we want to be as strong as the people who love us need to believe we are and if we know that the threat isn't only individual but also systemic and so there is no escape and if when we know there is no escape we learn how to keep our heads down and go unseen and if when we go unreflected for so long we are able to lose track of feeling and if the only Japanese vocabulary the white (they almost all were) professor (who was friends with my attacker) who watched me in the coffee shop in the mornings could say to me was *ganbatte* with a kind of sarcasm and if the first Japanese words I ever learned were *gaman* and *shikata ga nai* after reading them in written-for-children stories of wartime incarceration, how much *gaman* will it take to survive (as long as/until...)?

*BONUS QUESTION: What is the distance between perseverance and internalized destruction if survival isn't measurable and isn't always survivable?

MARGINALIA 1993

*Definition of AIDS expanded to include people with
T-cell counts under two hundred, which means more
women will be counted.*

*HIV/AIDS is the fourth leading cause of death in
women ages 25–44 in the United States.*

President Bill Clinton signs "Don't Ask, Don't Tell" into law.

Jerry Mills

1951–1993

STEVEN WROTE TO ME, saying, *Please, come.* His second novel had been published, and now there was a publication date for the third novel. A fourth novel underway. He was feeling good in his work. There was going to be a summer reading from the third novel at A Different Light, and would I please be there? He wrote, *I know we've hurt each other. I'm not sure what happened. I think I'm to blame. Can we fix it? I do miss you. All the time. I love you, always. Please come.*

Steven is luminous at his reading. Standing in front of the crowded bookstore, his resinous voice filling all the corners. He is perfect. Charming and funny. Tender and sad. The novel tells the story of lovers Dexter and Sergio. Sergio has had an experimental procedure, and it will take a hundred days to see if it works and he can be saved. Dexter, the character based on Steven, has to survive the hundred days of uncertainty about his lover's survival, even as we know that there will be no ultimate survival. Steven has told me enough of the story of his partner who died before I met him that I recognize the questions that plague Dexter as the questions that also plagued—still plague—Steven.

Listening to him in the crowded bookstore, I also begin to hear the questions that have plagued us, plagued me. Maybe destroyed us. We need the perfection of each other's survival. And I live in fear of having to live through what he has already lived through. The loss of the beloved. The loss of the possibility of the shared future, which seems like the only future. And that was our rupture. Steven needed me to represent the possibility of survival. Of surviving everything and thriving in the face of annihilation. And I lived in frozen terror of losing Cory and losing him. And through my frozenness and silence, I had already lost him.

There are so many things we need each other to be. And it distills to the question of survival, which is a question of memory, which is the task of queer futurity in the condition of plague time. I needed his body to protect me in the world, to ensure my survival. But we mistake survival for immunity to injury. We've learned so well that queer survival is the act of fighting back. But I still can't separate fighting back, as a bodily move to protect the corporeal self from a moment of possible harm, from the ability to recover from a ruptured self and move back toward, again. And in the absence of his body to protect mine, I had failed at self-protection. And if I can't save myself, how can I save him?

I'm thinking this as I'm listening to his reading, which is the story of asking the same question: How does one live through the uncertainty of the survival of the beloved? The same questions that propel all of our action and paralysis in plague time. How have I become so grounded by the literal inability to reach my body toward him that I'm unable to reach any other way? We want to save our loves. And we want to save who we were when we loved them.

Mostly I keep my eyes shut during the reading, soaking up his voice. Willing myself back to his porch, my eyes closed against the sun, as he read to me. When I open my eyes and look up at him, he catches my eye and winks.

After the reading, I stand in the line of his admirers waiting to have their copies of his books signed. He stands to hug me. I can't raise my arms up to his neck, and so I wrap them around his waist, press my face into his chest, breathing him in. "Babygirl, wait until this is all over. Stay. I want to see you." Tears in his eyes and mine. His hand against my cheek. "I'll see you soon, love. I promise. I'm so proud of you," I whisper in his ear. I kiss him quickly, turning away so he won't see me cry. I want to hold him, for him to hold me. I want to tell him everything that has happened. That I have been so loved and protected, by him, by Pete, by Mary and Nancy, that I never learned how to protect myself, and now I doubt my ability to protect anyone else. I want to tell him not just everything that happened in Portland but everything that happened with Cory. The night with the pills. That in ensuring Cory's survival, at least through that night, I had taken something away from his ability to choose his survival, and now I didn't trust either of us.

I want for us to be back on the porch of the house, none of the past year having happened. Still safe together. And I can't say any of it.

"Wait, Babygirl, please." And as I turn away, he reaches out and grabs my left hand in his, pulling me back toward him. As he tugs at my arm, the fire of nerve pain shoots through me, from my fingertips up through my shoulder and ricocheting through my head, and I fight the wave of nausea that comes with the pain. He sees my flinch, and in response he lets go of my hand, thinking I am flinching away from his touch, away from him. I have no words to explain. His eyes fill with tears and confusion. I try to smile at him through the wave of pain. "Soon. I love you," I whisper and turn away again.

As I'm walking out of the bookstore, I again flash back to our first coffee date, where I sat in the café and watched a white woman turn and run across traffic, afraid of his Black form moving in her direction. Of course, that wasn't what was happening as he reached for me and I pulled away. But I can't get the image out of my mind. His pull toward, my pull away. And then later the

cop pulling us over during the rebellion, his hand on his gun as he stared down Steven in the car next to me. All the ways in which we can't escape the racialization and genderedness of our bodies in relation to each other in the visible, social world.

Was I so angry at his insistence on my survival and strength that I hadn't noticed the ways I put the same pressure on him? That his survival would be the anchor to my own. The way his body had been my anchor and my safety. It wasn't the same as Cory, who had always been sick, as had Wayne and Sister X. Was I denying his woundedness and pain, just as I feared his inability to deal with mine? Is it all a projection? We projected what we needed most onto each other, in the hopes of being pulled through by each other, and pulling each other through. We wanted to bring back our lost beloved. We've come to expect that it means bringing them back from the dead. But what if it means bringing them back from the fantasy of unwoundedness? Pulling me back from my own stubborn denial of all of our survivability, as though it could save us?

After I leave the bookstore, I sit in my car and cry. When I start driving, I don't go to the apartment of the woman I'm dating, a sweet housemate of the Radical Faeries who is kind and gentle and doesn't push me to have sex or talk about why I usually don't want to. Instead, I drive to the nearby apartment of another ACT UP dyke, quiet and brooding with her own hiddenness. We've organized stealth civil disobedience actions together for years, and we know how to maneuver through rage and grief, sitting next to each other without asking for the story. She opens the door to her apartment and nods me into the living room and pours us glasses of wine from the bottle already open on the counter. The lights are off, and Thelonious Monk floods through the stereo. I sit on the floor and take the glass from her hand.

We don't talk. I'm still back at the bookstore. That moment of leaving him, his confusion. We've needed each other to be so strong, to survive. To will our survival because the other has dared it, has needed it in the most profound and vulnerable way. And so we can't say when we crumble, when we need each other. We want only to love and not need each other. But we need each other.

If there's one moment I could go back and change, it would be this. I should have already learned the lesson. We don't always get another chance. We don't always get each other back.

▶

THERE WERE MOMENTS OF SWEETNESS and ease that summer. Roxy, who came into the Women's Caucus having lost her husband and newborn daughter, was cast as a member of AIDS/Us/Women, along with Mary and Connie and several other women living with HIV. Michael Kearns and Jim Pickett, who together founded Artists Confronting AIDS, and both of whom were ACT UP and Highways Performance Space community and regularly called on to perform at benefits, had conceived of a series of testimonial performances under the title of AIDS/Us. AIDS/Us/Women was the next in the series, and the women performed their stories on theater stages and in community spaces throughout the summer. I stood at a table at the back of each performance, handing out ACT UP information, selling ACT UP T-shirts, and listening to the stories.

Mary told the story of how she and Nancy met in drug rehab. Mary was made Nancy's roommate. Mary said, "There's something you should know, I'm HIV positive." Nancy, the story goes, didn't miss a beat and replied, "There's something you should know, I snore." They fell in love instantly. When none of the AIDS organizations they contacted knew what to tell a mixed-serostatus lesbian couple, they came to ACT UP.

Roxy told the story of losing, within days, her husband, Vinny, and infant daughter, Miranda Rose. She ended her story singing "You Are My Sunshine" out into the audience, the way she had sung to her family. As many times as I watched them perform, I cried every time. So did Jim, who was often pacing the back of the theater or community center with me. Throughout the summer, as we hugged hello and goodbye at each performance, Jim felt thinner and thinner. Tension headaches shooting up his neck. I took prescription pain pills to numb my shoulders and then stood in the back of the theater with him and tried to rub the pain from his shoulders. Hot and clammy. *Sorry*, he said to me, one hot afternoon show, leaning on me and sweating through his black turtleneck.

At the end of the summer, Roxy married Matthew McGrath, who she had met in ACT UP. The wedding was held at the Hollywood Hills home of a friend of Roxy's. We all dressed up—there are photos of the day—Mary in a dress, Nancy in black pants, white dress shirt, and flowered tie. I'm wearing a silk kimono, hand-stitched by my grandmother before the war, that somehow made it through the war intact. Looking over the Hollywood Hills, Roxy and Matt, in front of all of us, promised to cherish each other, for the

duration. I looked around the room, Jim, Jansen, Mary and Nancy, my silent plea rising up in me: *Let us all survive. Let us all cherish each other.*

After the wedding, back at Cory's apartment, he says, "I want a husband."

"OK," I say. We are sitting on the floor, drinking tea. I have taken off my black sandals and am wriggling my toes in a patch of late-evening sun.

"I mean it."

"I don't doubt it. You'll find one."

"But...," he starts.

"Don't argue with me. Not today. I'm in queer wedding bliss."

"They're straight."

"Well, kind of. Barely. But seriously, a queer theater wedding in the hills. Nancy was fabulous in a tie. Queer, at least by proxy. Anyway, don't change the subject. A husband for you."

"Yes."

"Yes."

Cory and I erase our pasts when we can, living in the present tense of our bodies together. He's been sick while I've been away. After a few months' absence, I can feel his bones more sharply under the ripple of his skin. Both of us deeply confused by our stories of the year when we try to tell them in overlapping relation to each other. Clay-footed-grounded-in-time, we leave them out, I think, because they demand that we locate ourselves in linearity, that if we mark a past, then we are in a present, and that leaves the problem of a future where, when we do talk about it, he knows he will not be. Sometimes he pushes me to my edge—over the edge—insisting we talk about it. The time when he will not be here. Sometimes he holds it lightly. Sometimes when we're in bed, talking in the sleepless dark, he says, "You'll remember, I know you will. You'll tell everyone." I push back, argue, feeling the deep, tugging echoes of Steven's insistence on my thriving, and Robert's only-partially-demented hospital monologues.

Cory is using blood as a paint medium.

I think back to the night of AB-101 bleeding. And of Ron Athey's bloody performances at Fuck! The way they play with amplification as an externalization of feeling, where my own aesthetic, my familial post–war incarceration training, is to pull back from expansion and move toward the quiet and subtle. To wait. Is that the difference between us? The embodied difference? That I am allowed an assumption of a later. And Cory isn't. And so Cory doesn't leave himself anywhere to go. Full-force full-

speed full-affect. Keening wail. Each is his last note reverberating beyond the last breath.

Jim has given me a copy of the script of *Queen of Angels*, and at night I sit on the balcony overlooking the hills, looking toward the lights in Tura's room in the Agfay house, and read the play out loud to myself. Max survives. At least for a little while. But the playwright does not. Jim leaves us Max as his poet-character-self and writes himself out of the end of his own play.

After many nights of reading the play out loud to myself on the deck through the long summer, I start to admit it to myself, just a little, just sometimes: Jim is dying. And Max is going mad, hallucinating past, present, and future, unable to tell them apart. And how could we be expected to—to tell them apart—and not go mad? It is inevitable, isn't it?

MAX:

My friend Tobias. He died.

We lived and loved together, always at each other's side.

Offering courage when one was afraid.

Laughter when the other was sorrowful.

I was the singer. He was the song.

There has to be some other end to us than death.

Can't you see?

EL COYOTE:

I see you are a big fool, *putjo*.

Better learn to sing solo, *mijo*. Forget him.

MAX:

I will not forget. I will be the rememberer.

For him. For me. For all the rest.

Listen, do you hear?

I don't hear nothin.' An' you won't neither, you know what's good for you.[1]

I will not forget. I will be the rememberer. For him. For me. For all the rest.

It's an inflation of ego, a self-aggrandizement, an anxious attempt to manage our own disintegration, to hold on to our place, our knowing ourselves through our proximities to our vanishing loved ones, and then to leverage ourselves to hold them in place. It's an unconscious and involuntary indictment. *I will be the rememberer.* And also, isn't it a little bit true?

Sister X (John Chidester)

1947–1993

‣

Michael Callen

1955–1993

THERE'S A NEW POET-IN-RESIDENCE on campus, and I take all of her classes. In a craft class we talk about line breaks: the code from the poet about where to pause, how to make meaning, how to find or imagine hidden questions, and how the form is actually an embodiment, a command, a relationship to breath. It requires me to pause, allow my breath to catch and then restart, the attention at the break and then again at the feeling of the gasping start.

The campus library basement houses an audio archive of readings by visiting writers, and between classes I copy them onto cassettes to listen to in the car and in my apartment. I listen to writers I've read and writers I've never heard of, grabbing them from the unsorted library shelves.

One day on the shelf I find a reading by Marie Howe. It's still several years before the publication of *What the Living Do*, her second poetry collection, much of which is about her brother John's death from AIDS. It's the first time I hear poetry that sounds and feels like my nights with Cory and Robert. I listen over and over, trembling within the recognition, the public telling of things I've held secret. For hours in my kitchen late every night while I bake coffeecake for the student-run café. Every day driving back and forth between my apartment and campus. I recite them back to myself every insomniac midnight when I go running in the sleeting dark.

Because it isn't yet published, I can't see it on the page, and so I transcribe the poems and become obsessed with trying to understand how they work. How she might cue the reader when it isn't her physical voice, but words written on a page guiding us. As I sit in physics class, as I sit in the back row during lectures on Shakespeare's tragedies, as I half listen to lectures on Chinese ghost stories, I write out the poems, trying to find the line breaks that would propel me to match my breath to hers. Some poems are the slow ache of intimacy in a captured moment, only fragile in the context of its impending loss. From "Just Now": "He lifts his face so that Joe can kiss him . . . and now Joe is cleaning. What a mess you've left me, he says, and John is smiling, almost asleep again."[2] Over and over I write the story, and over and over I cry. Each time I write out the poem, I write the lines longer and longer, not a prose-poem paragraph but luxuriously long lines that slow and highlight the unrushed sweetness.

When I can't sleep, I work on her poem "A Certain Light." I'm terrified of it, shaking as I write it out, trying to place the lines. When I speak it, even alone in my apartment, I feel exposed, afraid, remembering the night with Cory as he begged for the pills:

He was breathing maybe twice a minute, and we couldn't wake him. . . .
And for seven hours he answered, if only to please us, mumbling
I like the morphine, sinking, rising, sleeping, rousing,
then only in pain again—but wakened.[3]

How does she let us know where to stop, where to breathe, where to pause? The pause draws our attention. A long line would do that. But a short line would clip into the pacing of urgency. I listen to her read the poem again. It feels urgent. But the spacious breath of it isn't in a hurry.

I listen and don't know if I am the sister begging her brother to live, or the brother ready to let go. *Then only in pain again—but wakened . . .*

Then I understand. The hurry is my projection. My desire to be done with it all. What if the slow tenderness of "Just Now" has the same structure as the deep grief and terror in "A Certain Light"? What does it mean if they ask for the same precision of breath and heartbeat and focus? In the absence of answer or cure, just to be with? Is the perfect moment of poetry the one that names what we cannot tolerate feeling and can no longer tolerate not saying?

Unsent Fragments (III)

Dear Steven,

I can't put down Carolyn Forché's book, the intricate weaving of hurried intimacies against the crumbling world. How she insists on space for noticing how precarious the ache of connection. And we're suspended there with her, the break and pause of her lines keep us in the stillness, the hovering, and then the tumble forward. And so, what if there is a code? An answer? What if there is something hidden next to the untangled line that the poet is trying to offer us? What if it doesn't even belong to the poet but to us, or to me? My meaning-making or possibility-holding? What if the breath is here? The attention here? What if this is it? What then?

> *I have kept everything*
> *You whispered to me then.*
> *I can remember it now as I see you*
> *again, how much tenderness we could*
> *wedge between a stairwell*
> *and a police lock, or as it was,*
> *as it still is, in the voice*
> *of a woman singing of a man*
> *who could make her do anything.*[4]

Oh, love, those line breaks. The pause and spatial illumination. Listen. Look again. I'm trying to tell you something.
(again, how much tenderness we could . . .)

Rob Roberts

1958–1994

WHEN I LET MYSELF INTO THE APARTMENT, Cory is standing in front of the wall with a needle and syringe in his hand, a bright light turned toward his arm. He doesn't look up at me. He says, "You're blocking my light."

"Sorry, honey," I say, and move out of the way as he slides the needle into his arm.

I watch as he pulls back on the depressed plunger and the vial fills with deep-crimson blood. He pulls the needle out and unloads the blood into a small jar. His arm is bleeding a little where he's pulled out the needle. I pick up a gauze pad from the table and lean toward him. Without looking at me, he nods toward the box of latex gloves. He takes the gauze from me and holds it to his arm while I struggle into the gloves. They snap loudly against my wrists. I hate these. He holds his arms out to me, and I wrap the gauze, then tape, around his arm.

He hasn't started painting yet, but his supplies are all around him. Paint-brushes. Sponges. Gauze. Tape. Syringes. Whatever he's experimenting with using as blood thinner today. Large white canvases tacked to the blank wall.

Diamanda Galás is wailing through the stereo in the corner.

"Will you check the tea?" he asks. I go to the kitchen, where a large pot has been simmering long and slow with thick slices of ginger. I ladle two mugs for us. The peppery heat burns my throat and eyes. He's tired and suspicious of Western meds. He takes the ones he has to, but more and more the counters are filled with vials of herbs and tinctures, and the fridge is crowded with ginger and pineapple and dark leafy things.

Cory sips his tea, then strips off his clothes. This is the new ritual of our bodies in relation to each other. It's summer. Los Angeles. The night is warm. Blood. Needles. Gloves. He's still working out his technique. I watch how he mixes blood with thinner, checks the tautness of the canvas against the wall. But I'm also assessing his body. I can't help it. It's habit borne from our years together. He's lost a little more weight. His cheekbones and jaw are sharp and chiseled, and the flesh hollowed between them. But his eyes are bright, and his skin is a healthy-for-him shade of brown, his muscles flexing easily, his joints unswollen. I shift my body against a blank wall, taking a deep breath, learning to sit still and watch him work. There is a visceral strangeness seeing his blood, without urgency or intervention. I'm partially watching him and partially reading.

I'm reading *Against Forgetting*, an anthology edited by Carolyn Forché of poets who lived through war zones around the world. Diamanda Galás keeps perfect time with them, until she doesn't, and I turn off the stereo.

"Read to me," Cory says, as he takes out another syringe.

So you are here? Straight from that moment still suspended?
The net's mesh was tight, but you—through the mesh?
I can't stop wondering at it, can't be silent enough.
Listen,
how quickly your heart is beating in me.[5]

"Who is she?" Cory asks about the poet.

"Wisława Szymborska, Polish poet. Writing during World War II."

"That's the question."

"What is?"

"What would you do? If there was a choice. If it isn't random. We think we would do the right thing, but do we?"

"What do you do?" I ask him, as he swirls his brush into the color and begins outlining a body against the wall.

"Tell it relentlessly. Tell it loud. Don't let them turn away."

We keep talking about the problem of how to document. To bear witness. The conversation we return to and return to. We're talking about me but not talking about me. Cory has been talking more and more about legacy. *His.* The duty to remember. *Mine.* But how do we make sense of it as it is happening?

We're quiet for a few minutes. Then he turns Diamanda Galás back on, and she slides into "Gloomy Sunday."

I close my eyes and slide back into music and memory, and Galás turns into Billie Holiday . . .

Steven and I were sitting on his front porch, leaning into each other. Another summer evening years ago. Billie Holiday was wailing at us through the open door at dusk. Steven told me the story of the song. Called "The Hungarian Suicide Song," the original lyrics were about the injustices of humanity, and despair about war. It was in later versions that it was reinterpreted as a love song about suicide after the death of a lover.

"The death of a lover is so much more palatable marketing than the condemnation of humanity." Steven laughed and shook his head, brushing his dreadlocks out of his face. He sighed and sang the heartbroken love song along with Holiday.

Angels have no thought of ever returning you
Would they be angry if I thought of joining you?
Gloomy Sunday.[6]

Steven fades from vision as the song ends. I pull myself back into the room, telling Cory about the meaning and history of the song. How it changed.

He looks up from his canvas and turns to me. "Do you think those are so different? The war and the loss? Aren't they the same thing? Isn't it all the same war?"

We keep coming back to this same conversation about art and edges. He pushes. He isn't afraid to challenge. This is his time-running-out terror. I'm still worried about being likable.

"You could channel Diamanda," he says to me.

Instead, I hover in the compressed, quiet-dirge range of Billie Holiday right before she lets loose into a wail. She was subtle at the low end of her range. Quiet. You have to listen harder.

This is our same fight. Over and over. Taking up space. Not taking up space. Who gets to. Who wants to. Who has no choice. His loud Puerto Rican infected faggot self. My quiet Okinawan dyke self. But I move stealth, move quiet, move unrelenting into. Toward. I memorize him with my movement shadowed to his.

We remember through telling. And we remember through the body of it.

Cory has a smudge of blood streaked across his cheek.

As we argue our slow-motion, familiar bicker, he takes a paintbrush and dips it into a jar of thinned blood. With the brush in his right hand, he paints his left arm—shoulder, biceps, crease of his elbow, forearm, wrist, widened palm of his hand. He leans his arm, the whole weight of his body, against the canvas, the wall under it holding him up. His eyes closed, his right arm held up at an angle, hugging the wall, the paintbrush pressing against the wall, a bit of blood dripping down from the tip.

Is it the difference in bodily experience—in bodily urgency—that allows me to witness Cory's and Steven's lived experience as it happens? My intact veins. I still feel the itchy constraint of the latex gloves around my wrist. I snap them in time with the wailing Galás, then take them off.

I take a damp cloth and wipe a streak of blood from Cory's cheek.

Is there any such thing as ordinary, nonsymbolic touch anymore?

Eventually, we tire of our argument. Cory is lost deep into his shrouds. I read another few poems, and then I go to bed.

At dawn I hear Cory in the shower washing the blood from his body. He crawls into bed next to me and drapes his arm across my chest. He falls immediately into an exhausted sleep. In the almost-light, I can see the dark shadow of blood residue under his fingernails.

I slide quietly out of bed, holding my breath as he stirs a little at my absence, his hand opening and closing against the space in the bed where I had been. I walk out into the living room. The canvases against the walls are partially and unevenly lit by the lamp and the early morning light through the window. The needles and syringes are all in their plastic tubs, the brushes soaking.

The red light of the stereo is still on, and as I turn it off, I can hear the competing versions of "Gloomy Sunday" in my head. Now, without Cory to argue with, I hear what I hadn't heard earlier. The Diamanda Galás variation is closer to the original, but the point of view is different. Like the original "Hungarian Suicide Song," the Galás version holds an ambiguous perspective: the speaker, the singer, is both the rememberer and the lost beloved. The one who is gone. The one who has not survived and speaks as the echo of memory. The Holiday version that I've held so stubbornly to isn't just a love song—it's the song of the survivor. The last one left.

> Dreaming, I was only dreaming;
> I wake and I find you,
> Asleep in the deep of my heart, dear.[7]

Is it possible that the uninfected body—that my body—metabolizes the story, inscribes it as it unfolds, in preparation for remembering it outside of the context of the shared moment? That bodies enact a translation that is less about language than about breath, movement, the endless reaching toward?

As though we could keep each other. As though I could keep him here.

I stand in front of Cory's shrouds. On one wall one canvas is an arm reaching toward me. Another a leg. The side of a face. Disembodied—dis-membered—bodies-that-will-soon-but-have-not-yet-vanished.

Some of them are still damp, the blood brighter and glossy. Some of them have dried, the blood darker and in some places crumbling, disintegrating, just a little.

Bodies push through as if from behind the canvas, led by faces, bellies, cocks, all laid bare—at once the cellular and kinesthetic specificity of an indi-

vidual and simultaneously mirroring the viewer, the witness. Calling forth in them/us/me the awareness of their/our/my own corporeal raw insides turned out, and the possibility of taking their place. At once trapped, displayed, set free. I hold my hand flat to his flattened hand reaching toward me and move quietly through the room, dancing with one body, then another.

James Carroll Pickett

1949–1994

▾

I WANT TO SAY THAT we watched it unfold as it was happening, that we understood. Sometimes we did. Time slowed. We had those awful moments of recognition. While standing in the hospital corridor outside of Pete's room. While lighting a funeral pyre. While standing outside of Wayne's hospital room, Wayne too delirious to know we were there. Sometimes we had no idea. A moment I can now look back at as peaceful, quiet, contemplative, the sun pouring through the living room window as Cory sketched and I read, steaming mugs of ginger tea on the hardwood floor between us. A moment that barely registered, until one of us had a flash of knowing that it would pass, not gently. It was like the moment just before an earthquake, the eerie calm, just before the world changes forever, just before you understand what is about to happen. One of us would look up at the other: I would look up at him and he would have stopped sketching and I would say "Show me," so he would bring me the page and tell me what he saw, or Cory would look over to me when I stopped reading out loud in the middle of a poem, maybe Sonia Sanchez and I would read aloud: "you keep saying you were always there / waiting for me to see you. / you said that once / on the wings of a pale green butterfly you rode across san francisco's hills / and touched my hair as I caressed / a child called militancy / you kept saying you were always there."[8] And then I would have paused, holding my breath, and he would watch me watching him and say, "Not yet," knowing I had just had a vision of sitting in the apartment without him, after, and then he would say, "What else does she say?" and I would return to the page, reading the line "you keep saying you were always there / you keep saying you were always there / will you stay love / now that I am here?" and we wait for the earthquake, not knowing when, but knowing, soon.

Roxy Ventola McGrath

1947–1994

WHEN I WAKE UP, the Portland morning is just finding the first fragment of winter light. I roll away from the window and try to sink back into my dream, where I was negotiating a scene against a dark wall at Fuck! Closing my eyes, I feel my way into the crowded club, the heat of bodies, the throbbing music, low lights. My dreamscape playmate is looking down on me, raising her eyebrows, then her arm. In my half sleep, my body shivers in response, and I'm trying to see what she has in her hand.

This is a winter of knives. In the apartment I've moved into off campus, I keep one under the bed. I reach my fingers down to its hard base in my sleep when wind rattles the door. Sometimes when the pills don't work and nothing else will contain the fire in my shoulders, I carve deep rounds and crosshatches into the skin around the joints.

The release of blood relieves pain.

This is true, and it isn't.

Cutting skin releases endorphins, which blurs physical pain, softens the edges. It also transforms the relationship to pain. Alone, it's a meditation. Or distraction and numbing. When enacted with another, the relief is more complicated. Nuanced. Layered. Satisfying.

This is symbolic, and it is corporeal.

The chemical cocktail of survival is triggered by the crash of bodies into each other, through the barriers of skin-psyche. We know how to ritualize safety. We know how to symbolize survival.

My dream playmate was a waking-life playmate during some of those late-night parties, dark rooms lit by candles that caught the blade of her knife, her needles. Until their tips slid under the top layer of my skin, my breath catching, then the deep release. No fear. Only sensation. Only breath.

Negotiated, empowered pain releases dopamine, serotonin, oxytocin, endorphins, and adrenaline.

What do we allow ourselves to experience because a chosen other has made it visible, made it possible? In the choreographed moment we are required to attune, to mirror.

Somatic resonance is a feeling and a verb.

In the absence of the bodies I trust, I dream them.

Sometimes, in the absence of bodies I trust, I bring home bodies I don't know, don't trust. But there are rules. Never spoken but always clear. My body will not be touched. This is an exercise in the disavowal of vulnerability and longing. The disavowal of feeling. But other bodies keep the dark outside and don't flinch when rain shakes the windows. I don't reach for knives with bodies I don't know. I perform the rituals of invoking sensation, desire, opening bodies. Gloves, condoms, barriers, a kind of safety of distance. I leave dormant the interiority of both of us.

These bodies I bring home are a negation of the bodies I love, long for, miss. I practice how carefully I can attune to bodily response, question, need. Noticing breath, muscle tonicity, heart rate, skin flush. Without attuning to the feeling of desire. I don't want to know them. Before morning I send them away.

Loss is a body-size hole.

About the death of Peter Hujar, David Wojnarowicz has written:

> If I could attach our blood vessels so we could become each other, I would. If I could attach our blood vessels in order to anchor you to the earth to this present time, I would. If I could open up your body and slip inside your skin and look out your eyes and forever have my lips fused with yours, I would.[9]

What is the difference between the performative and the unarticulated body-pull of association and empathic reach? I close my eyes and see Cory's shrouds. Ron's performances. What does it mean that when I watch Ron's troupe perform, I feel an internal pull to move toward, even as I can feel from those standing close to me the teetering brink of revulsion and movement away? My body associates to Steven. And also to Cory, to his blood painting and to his wounding. The recoveries from violence that are only one kind of pain. My automatic reach toward, to stop the bleeding, to press my fingers against the wound. When we practice a movement, when we perform it so many times, how do we know the difference between the performative and the unthought felt?

What is the relationship between repetition compulsion and a queer poet-ics of embodied risk? It happens again and again. And we can't turn away. Is it some form of repetition in search of mastery? Or just the insistence on loving each other until the end. Our bodies ravaged by the stress of that love. That loss.

The risk isn't infection but the repetitive traumatic loss, staying connected until the end, and then the end happening, again and again. Not wanting the end of the loss or pain because it would mean that there is no one left to lose, and so it continues, takes our breath away. This reach and collapse, the collective body of us, reaching and collapsing, reaching and collapsing.

This is love. This is the performance of love.

This is risk. This is the performance of risk.

This is how they roil up against each other, endless tide breaking over itself.

Buried under. Surfacing. Buried.

Wade Richards

1963–1994

I'VE STAYED AT THE JAZZ CLUB until closing, and now I'm driving home alone. It's winter, freezing rain edging toward ice in the wind. My little car blowing around on the bridge. I see him on his bicycle ahead of me. I recognize the angle of his back and his arms. Even in the dark. Even in rain gear. Even when I want to forget, I can't forget. He rounds a curve, and my car is catching up. I feel the edge of my wheels sliding on the almost-ice. My hands are frozen. My shoulders are frozen. I could just let them slide. My hands. The wheels. We stop next to each other at a red light past the bridge. There are so few lights in this part of town. I look at my door locks, check them. Again. I don't know what he sees. I feel my shoulders flame deep in the joints. My hands are locked in place, but I lift and loosen one finger at a time from the wheel. I take a breath, glancing his way, afraid of closing my eyes to blink. But even with them open, I feel the possibility. I hear Sister, remember how she worked with high school students, telling them to turn away from the familiar violence that called to them, the kick-punch of survival instincts awakening. The seduction of revenge. *Turn back toward us*, she said to them. Would have said to me. If she was still here. But she isn't. It's a long red light. One of few on this stretch. By the railroad tracks. He looks into my car window. I think he recognizes me. He laughs. It looks like he's laughing. He jumps the red light and flies through the intersection. My foot is jammed hard against the brakes. I'm holding my breath. My knuckles are frozen white around the wheel. I'm watching him race, slipping along the shadowed street. I'm waiting for a green light that I hope still doesn't come.

MARGINALIA 1994

AIDS *is the leading cause of death for*
all Americans ages 25–44.
Nelson Mandela elected president of South Africa.
Jesse Helms holds up a photo of Ron Athey in
performance as part of a rant on the US Senate floor
against the National Endowment for the Arts.

plague poetics and the construction of countermemory

I KNOW WHEN THE PHONE RINGS it will be Judy. And so I'm not home to hear my phone. I'm in the library, high up in a quiet, rarely used corner of the thesis tower, sitting on the floor with my back against the tall, solid stacks of bound theses, reading Carolyn Forché's *The Angel of History*. I have been obsessed with the book since its release. I don't understand it, not really, not in the narrative, identificatory sense I'm used to reaching for: a clear speaker, a traceable narrative. *The Angel of History* is a polyphonic work filled with layered, swirling images of human-caused catastrophe, the speakers at once multiple, distinct, overlapping, and ethereal.

As I go running in the evenings, as I walk across campus from class to class, as I fall asleep at night, I find myself muttering lines I haven't been aware I've memorized. They wash over me, through me. I think *roses*. Then I think *winter*. Then *the dead*. But not remembering the image from which I am associating. And now I am sitting in the tower, reading them again, running my fingers along the dark ink on the white page and pretending I am not waiting for a phone to ring.

We held roses, then the roses rested on the snow as if someone had
 died there. Winter.
 There were many
 graves. All the same kind.
 So it would be a cemetery of war...

They died and were buried in mud but their hands protruded.
 So their friends used the hands to hang helmets on.

And the fields? Aren't the fields changed by what happened?
 The dead aren't like us.
How can the fields continue as simple fields?[1]

By the time I reach the last two sections of the book, either I am fully im-
mersed in the rhythms and fragmentation of Forché's language, or something
I can begin to project a clearer narrative onto begins to show itself. The poem
"Elegy" is Forché's homage to Terrence Des Pres, whose work on the Nazi
death camps informs and echoes through Forché's work on the poetry of
witness. Des Pres asserts that the will to bear witness is both the impulse of
survival and the evidence of it.

And even less explicit phrases survived:
"To make charcoal.
For laundry irons."
And so we revolt against silence with a bit of speaking.
The page is a charred field where the dead would have written
We went on. And it was like living through something again one
 could not live through again.[2]

I close my eyes, breathing the words in and out. *And it was like living
through something again one could not live through again.* I should get up from
the tower, walk down the stairs to the phone, and call my home voicemail,
where I suspect there will already be a message from Judy. Just like all of the
other messages. I can't get up. Not yet. I keep reading.
 "The Garden Shukkei-en," Forché tells us in the notes section of the book's
end, is an ornamental garden in Hiroshima. The speaker, we imagine, because
Forché has not told us, is a woman who stands in the garden remembering and
narrating what had existed before the war, before the word *Hiroshima* became
the signifier of horror and devastation, no longer just a place, in fact, no longer
a place, but the absence of place, because of the devastation it signifies. Literal
giving way to symbolic by its very experience of the temporal realm. We don't

know if the woman in the poem is speaking to a narrator Forché, or if Forché is a witness in absentia of the collective historical imaginary. Maybe it doesn't matter.

If you want, I'll tell you, but nothing I say will be enough.

We tried to dress our burns with vegetable oil.

Her hair is the white froth of rice rising up kettlesides, her mind also.
In the postwar years she thought deeply about how to live.

The common greeting *dozo-yiroshku* is please take care of me.
All *hibakusha* still alive were children then.

A cemetery seen from the air is a child's city.

I don't like this particular red flower because
it reminds me of a woman's brain crushed under a roof.

Perhaps my language is too precise, and therefore difficult to
understand?[3]

I open my eyes as I finish the poem—but that can't be right, I must have been reading, I must have closed my eyes against the glaring lights of the library tower after finishing the poem on the page, to stay within it. I'm aware of opening my eyes. The book now closed in my hands. And I'm whispering to myself, *If you want, I will tell you, but nothing I say will be enough.* I should get up from the thesis tower. I should walk down the stairs to the phone on the wall of the stairwell alcove of the first floor. I should check my messages. I'm certain it will be Judy who has called about Wayne. *The common greeting* dozo-yiroshku *is please take care of me.* I can't make myself get up. If I postpone knowing explicitly, then maybe it won't have happened. Not quite. Not yet.

And in the moment of reading the poem, my internal reference points are both Wayne and internment. And yet that does not make either of them the same as the other or the same as anything else. Just connected in the associative fragmentations of history. Just as Hiroshima is not the same as internment, the image associations of each are made possible by the other. My mother born in the Manzanar hospital. My uncles running along the rifle-guarded fence. Wayne smashing the State Building door, glass falling like rain all around him. Nothing is the same, but each is made possible in reciprocity—both the carved-out historical space and the frame of reference from which to translate the horrible understanding. That is how the history is made. Made possible by the terrible opening in the world born of imagination of destruction. Makes it so.

The book calls for us, the reader for whom (and of whom?) it is written, to bear witness and catalog the wreckage like the inheritor of Walter Benjamin's angel of history in "Theses on the Philosophy of History," which Forché invokes as an epigraph or prologue to the book:

> This is how one pictures the angel of history. His face is turned toward the past. Where we perceive a chain of events, he sees one single catastrophe which keeps piling wreckage and hurls it in front of his feet. The angel would like to stay, awaken the dead, and make whole what has been smashed. But a storm is blowing in from Paradise; it has got caught in his wings with such a violence that the angel can no longer close them. The storm irresistibly propels him into the future to which his back is turned, while the pile of debris before him grows skyward.[4]

What is the wreckage of our time? How does it build from, or unbuild, the wreckage of every other time? Maybe the point of wreckage is that it is always in associative (if not temporal) relationship to all other wreckage.

During the weeks leading up to the AB-101 rebellion, when Rob went on hunger strike in a tent in the center of West Hollywood to demand that the governor sign the bill, we took turns fielding media, entertaining Rob, and providing security. During one weekend-afternoon trashy drag show, Wayne showed up as a ranting Kimberly Bergalis. He played her role of demented innocent victim whining about chastity and values and who deserved or didn't deserve the plague. Until he snapped, lit a cigarette, and started yelling back at his own character. "Innocence? There is no fucking innocence. We're all innocent. We're all guilty. What are we going to do? What the fuck is left to do? We're all guilty and I love every fucking minute of it." Wayne dragged hard on his cigarette until it was gone, then lit another. And another. We cheered him on, taunting his embodied Bergalis, and laughing until we all cried.

In a few years I will sit in the auditorium of the building across the small walkway from this library and listen to Forché read poems from *The Angel of History*. She will say of poetry of witness:

> I was particularly interested in the poets who had endured conditions of extremity in the twentieth century, had been through wars, had lived under military occupation, were imprisoned, went through the Holocaust, went through Stalin's camps, lived under house arrest, were forced into exile. These kinds of public, historical, collective experiences. And I believed it was possible that these experiences of extremity had marked the poetic imagination in some way.... And after a long period of time

it occurred to me that the trace of the experience remained legible in the language regardless of the subject matter. If a poet wrote about the snow falling, you could hear the poet's imprisonment in the snow falling. Even in the emptiness of the snow falling, I can hear the despair. And so I decided that poetry of witness was really a mode of reading rather than a mode of writing, that it was a mode of deeply considering works in light of their passage through extremity.[5]

And yet how does it work when we all call forth associations from our own, specific/overlapping, unconscious narratives? The plague is a (mostly unacknowledged) condition of extremity. What happens when the images are rearranged in our fragmenting memories? Do they still mean the same thing once they are connected? Maybe meaning is a flexible nonnarrative of association and feeling.

But what, then, do we make of the specificity of language and story and image? Does it point to a more universal experience of suffering? At once specific and mirrored (and altered) in different contexts all through the world? (*Perhaps my language is too precise, and therefore difficult to understand?*)

I close my eyes and feel what I remember when I hear *The Angel of History* and what gets called forth is:

Suffocation of ammonia and latex powder at Cedars-Sinai, our booted feet echoing against the tiled linoleum.
Smoke burning our eyes as Steven and I drove home during the rebellion.
Robert's chapped lips, both rough and gentle, brushing against mine.
Sticky paste of Cory's blood drying on my chest.

What does it mean that I sit reading Forché's invocation of Walter Benjamin and Terrence Des Pres and associate not to the death camps of Shoah but the hospices of Los Angeles whose halls we walk through now? The specificity of history and the conditions of history (and counterhistory) that we live in are simultaneously expansive, distinct, and inextricably linked.

I read Forché and hear the actual images, what I know of the worlds represented. And I understand the feeling, the body experience of them, through my own echoing context. Hospice. Cory. Wayne. Images of Pete and Robert flood the visual field of my closed eyes, overlaid against the snow falling, the now-vanished black pine in the garden Shukkei-en. We live in the aftermath. And in the aftermath piles up the wreckage toward which Walter Benjamin's angel of history turns their face.

Against Forgetting, released just before *The Angel of History*, opens with an epigraph from Bertolt Brecht:

> In the dark times, will there also be singing?
> Yes, there will be singing.
> About the dark times.[6]

I sent it to Steven on a postcard with a photo of Billie Holiday, that photo of her that everyone knows, the one with her eyes closed, her head thrown back, singing, her throat vulnerable and exposed.

I stayed up nights reading *Against Forgetting*, the images and narratives of war and torture and repression and hiding and survival and subversive rebellion, which felt like a familiar, terrible balm. The images and the language were sometimes strange and alien on my tongue as I read them out loud in my studio apartment late at night, by myself. I read them out loud until the strangeness itself was the familiar.

Anna Akhmatova writes in her poem "Requiem":

INSTEAD OF A PREFACE

In the terrible years of the Yezhov terror I spent seventeen months waiting in line outside the prison in Leningrad. One day somebody in the crowd identified me. Standing behind me was a woman, with lips blue from the cold, who had, of course, never heard me called by name before. Now she started out of the torpor common to us all and asked me in a whisper (everyone whispered there):

> "Can you describe this?"
> And I said, "I can."
> Then something like a smile passed fleetingly over what had
> once been her face.[7]

I sent Akhmatova's words to Cory on a postcard of Mark Rothko's *Four Darks in Red*. Cory sent a postcard back, a photo of Adrienne Rich, writing, *I could paint it. You find language.*

"Can you describe this?" How do we give language to the things for which there is no language, no history by which to claim a name and place in similarity, contrast, or horrible homage? Or is that also Forché's point in the collecting of works from around the world and across a century for *Against Forgetting*, that history repeats, sometimes in specificity, always in affect and echo. There is nothing that does not, even within, or because of its specificity, mirror something else.

Is this how we make a counterhistory? It is not just the unmaking of the narrative assigned to us by the dominant forces but our asserting ourselves into an existing lineage of resistance? The plague enters the poetics of witness.

The last time Wayne and I talked was not the last time I saw him. The last time I saw him, he was in the hospital. Richard and I stopped by to visit. Wayne never woke up while we were there. I brushed his long hair out of his face and kissed his forehead, which smelled, as always, of cigarettes. The last time Wayne and I had a few minutes alone together was in the summer. There was a party at his house, and our queer family was hanging out, making food, lounging in the Silver Lake sunshine. Wayne was lying on his bed, listening to music, holding court as we wandered in and out of his room, singing along with Bernadette Peters and Marianne Faithfull. I stood in the doorway, and he patted the bed next to him. I stretched across the foot of the bed, my head resting on his calf. I watched his reverie at the music, lost in his own world. He looked at me and smiled. "Did I ever tell you about the time—oh, listen to this," he interrupted himself as Marianne Faithfull began to sing "Sister Morphine."

He drifted into the music, his eyes closed. At the end of the song he opened his eyes and saw me watching him. I was quiet, waiting. He furrowed his eyebrows. "Was I saying something?"

"You were going to tell me something."

"I don't remember . . . ," he said, frowning. Then his boyfriend and a few friends walked back into the bedroom and piled onto the bed, and we turned up the stereo as Marianne Faithfull began her gravelly chain-smoking-hard-drinking-hard-living interpretation of "As Tears Go By."

I never knew what story he wanted to tell me. Maybe it was nothing important, a fragmented memory, a story of a concert, another story of his outrageous queer youth. Maybe it was a story that, once told, I would have forgotten other than the way it enters the unconscious fabric. But he didn't tell it. And it is the absence and disruption of the telling that remains in my memory.

Somewhere in a distant part of the library I hear a phone ring. My heart stutters. I'm flooded with Forché's lines again: *Then someone calling. It might be from the past. It has that quality.*[8] Of course it isn't Judy. It's the reserve desk, where some frantic student has probably called looking for the philosophy text they need for tomorrow morning's seminar. But still. It is a phone, and its ring admonishes me that I can't postpone any longer. I walk downstairs out of the tower, past the reserve desk, where the student worker is on the phone, to the alcove off the first floor. I pick up the phone and call into my home voicemail. One new message.

"Hi, darling, it's Judy . . ."

W. Wayne Karr
1954–1995

WE MEET AT JEFF AND PETE'S apartment, gathering supplies, gathering together, gathering our strength, gathering our courage into motion. We coil our muscles tight to the bone.

We march down the middle of Santa Monica Boulevard through West Hollywood, sweeping people into our collective as we pass.

We pass the median triangle where Rob camped out on hunger strike. We can see the ghost of Wayne's demented Kimberly Bergalis chain-smoking and pacing. The echo of ranting: *Innocence? What is innocence?* The grass tamped down where she/he paced. Paces still.

Smoke in the air. Cigarettes. Candles. Bonfires kept small in preparation.

We carry the coffin high in the air, balanced between our hands. Cory sways his hips in leather jacket and pale tulle trailing from around his neck. He and Pete keen loud into the dark night, their sound swallowed by the cold surrounding us. (*And so we revolt against silence with a bit of speaking*, writes Forché.)

We who do not carry the coffin stay close by, protective, scanning for police and bashers. Cameras and candles in our hands.

We walk in silence, or maybe only I am silent. Mute. Voice vanished into the air. Cory and I keep eye contact. I keep track of Jeff. And then I don't. I just move through the crowd, our crowd, my camera in front of me.

Marching past Mickey's. We march past Rage. We pause at A Different Light. Some step outside to watch. They might laugh or think it's a parade. Then they see the posters. Wayne's beautiful face. They stop. They're silent. A few join us.

Someone lights the funeral pyre. We're in a circle in the intersection. We protect the flames. Cops are behind us. West Hollywood police are used to us doing this. Even more than we are used to doing it. They hover on the precipice between protecting us and arresting us.

Smoke. Fire. Flames.

Fire visions blurred into fragments by the rising heat. This moment a poem to which we return and return. And Forché is right. Even without the whole poem, whole context, whole story, exact replication, which is itself a fragment, we recognize what we are doing. We know the ritual. Forché says of recognizing poetry of witness, "Even in the emptiness of the snow falling, I can hear the despair."

We have done this so many times before.

We can always hear the despair.

Across the circle is a friend I dated last summer, but it feels like years ago, it feels like yesterday. Her face lit up orange from the pyre. Red from the glow of the neon store sign above us: "Don't Panic." I make my way to her, and we kiss, sweet connection, then not sweet, no sweetness left, anger, frustration, biting down on her lip, on my lip. Bitter blood tang pulling me back to the fire. Red in my mouth, red glow around us.

After we burn the coffin, after the police extinguish the bonfire in the middle of the intersection crowded with queers, we stand together, all of us coated in a fine gray ash. And then without speaking—but someone has a drum—it is (not) only the amplified beating of our raging hearts—Patt moves to the center of the ash first, carving Wayne's name in the debris. We follow, writing Wayne's name, all of our names, in the ash that settles thickly on the Hollywood street.

> *The page is a charred field where the dead would have written*
> We went on. *And it was like living through something again one*
> *could not live through again*[9] (Forché continues).

The ash settles against the lens of my camera, a thin film casting shadows like the shadow of Wayne hovering over the scene. Except it isn't. It is only the ash from the extinguished pyre.

We stand back in our circle around names written in ash and yell. Cory next to me reaching for my hand, yelling. I can't find breath or sound. I let go of Cory's hand and back up, lens to my face. We call out the names of the dead. Wayne's name a sharp punctuation. Over and over. The first time added to the litany. Forever now.

> *And so we revolt against silence with a bit of speaking.*
> *The page is a charred field where the dead would have written*
> We went on. *And it was like living through something again*
> *One could not live through again.*
> *And so we revolt against silence with a bit of speaking.*
> *The page is a charred field where the dead would have written*
> We went on. *And it was like living through something again*
> *One could not live through again.*
> *And so we revolt against silence with a bit of speaking.*
> *The page is a charred field where the dead would have written*
> We went on

SUSAN AND I ARE DRIVING across LA on Sunset, heading east toward Echo Park. Summer. We're both home for a few months before our senior year of college. We're talking about what will happen after. Mostly, she's talking and asking questions, and I'm driving. The car windows are down, and her blonde curls are blowing toward my face. We look out the window at all of our landmarks, nodding our heads toward the Vista Theater, A Different Light Books (which will close in a few years; we don't know that yet, though we can imagine it from the way the neighborhood is changing and being built up, the new money pouring east across LA), the ACT UP office, Being Alive, the now-closed clinic where we gathered on Saturday mornings to assemble against Operation Rescue, and Basgo's. She is quiet. I can hear her hesitating even though I am looking out the window, navigating traffic.

"What?" I ask.

She looks out the window as we drive past Café Tropical, where I used to stop sometimes with Wayne for Cuban coffee and *pasteles*.

"What?" I am short with her. We are never short with each other. "Just say it, whatever it is."

"Someday"—she takes a breath, looking at me, though I keep looking out the window—"you're going to have to learn to live without them."

I refuse to look at her. I shake my head *no*. "No," I say out loud, "I won't." We're quiet for a few minutes, tense, our words hanging in the car between us.

We're a few months past Wayne's death. Cory isn't well, and he's preparing to move to Germany to be with his beloved. I'm heading back to Portland. I can't envision farther than that.

We could have so many lives is what she's said. It's a question. Vast. She's doesn't know if she'll stay on the East Coast, or if she'll move back to California to dance and choreograph, or if there's grad school in the near future. I'm sort of thinking about grad school, but it's a story I can't feel. It excites her as much as I feel numb to the question.

She could have had so many lives . . . is how I'm already holding the question, as Susan poses it. Past tense. Third person. Not the me now but some other now-impossible me. Had my loves survived. Not just Wayne, Wade, Sister X, Roxy. But the ways in which we all made families together, even in the absence of future. I haven't spoken to Steven since he moved to New York, and Cory will leave LA soon.

What does it mean to have one's primary relationships with the dead? Susan and I talk on the phone when we can, the line crackling across miles

and time zones. But daily, hourly, constantly, I talk to the dead. In that way I can move them into any possible future with me, but I also can't imagine a future where they haven't yet been.

Soon poet Mark Doty will publish his memoir, *Heaven's Coast*, about his lover's death. Doty will write of the last few months they had together, of taking care of Wally as his illness progressed and he began to disappear from their shared world: "All my life I've lived with a future which constantly diminishes, but never vanishes."[10] Is this the experience of queerness—of deviation from the normative narrative as magnified by plague time? Is this a global experience of traumatic rupture to the self that leaves in question the ability to embody a sense of futurity? Is plague time only specific in that it is what we live in now, in our queer collective?

And Susan knows me so well. She can see what I'm turning over in my head and not able to say. "What would you want, if you let yourself?" she asks.

We turn up Echo Park Avenue and drive past the cottage that for so long was Cory's, where we worked on the earliest issues of *Infected Faggot Perspectives* and where the National Guard was posted across the street with rifles aimed. I change the subject and ask Susan about her experience of her body in her new project choreographing Adrienne Rich's "Diving into the Wreck." She knows what I'm doing, and she lets me. We're driving past her father's law office on the way to her mother's house. Past my elementary school and the hill where the Agfay house was and the cottage Kate lived in for a little while.

What does it mean to want something that one can't have in the present tense? Or in the future tense? Does the impossibility of a future make the present already vanish from reach?

MARGINALIA 1995

First protease inhibitor is approved by the Food and Drug Administration (FDA), beginning HAART (highly active antiretroviral treatment).

First White House Conference on HIV is hosted.

Three US servicemen based in Okinawa are convicted of the kidnapping and rape of a twelve-year-old Okinawan girl.

I'M STANDING FACING the mirror in a grungy fag gym in Silver Lake where I'm the only woman in sight. As I lift weights out and away from my body, I can hear the grind and crunch of scar tissue deep in the joint of my shoulder. The sound isn't audible as much as it is a deep vibratory echo up my neck and into my jaw. I try not to clench my teeth. I'm still taking pain pills, which dulls the feeling. Distances it. The scars on my shoulders are bright pale skin against my summer tan.

I step away from the mirror and begin stacking weights on the bar of an empty bench press. As I'm about to lie down on the bench, I hear a voice ask, "Do you want a spotter?"

I look up. The face is familiar. It takes me a minute to place him, so out of context. John. He was a friend of Steven's in ACT UP. African American, dark skin, hair cropped close. Muscular, compact body. Sharply contoured shoulders, like Steven's.

"Hi," I say. We kiss hello. "Sure."

He eyes the weight stack. "Damn, girl."

I laugh. "Well, we'll see how long I last," I say as I position myself on the bench and he positions himself at my head. "How are you?"

He fills me in a little on his life in the few years since we've seen each other. I push through one set, then pause, then another. My arms start to tremble, and he holds his hands just under the bar. I sit up for a break.

He starts adding weights to the bar for his set.

"Do you want a spotter?" I ask. He raises his eyebrows, motioning to the weight stack. I shrug. "Sure." He laughs.

As he stacks more weights on, I finally ask, "How is Steven?"

He hesitates. Lies down on the bench, pushes up and out on the bar.

"He's"—John hesitates—"not good."

One, two, three. I'm counting his reps. Four. Five. Six. (My deep breath. Then his.) Ten. Eleven. Twelve. He finishes his set.

"How not good?" I ask.

John stands up from the bench and begins pulling weights off and reracking them for me. "How long has it been since you've talked to him?"

"A while," I mutter, thinking about his reading, before his move, how long ago it seems.

How long ago it actually was. How he was waiting for me to come back. How I promised I would.

"Well, if you want to see him, maybe now is the time. But . . . ," he trails off.

"What? Should I go?" I ask, a little too quickly, even though I know he can't answer for me.

"He always loved you, you know." He looks away from me. It isn't really an answer.

I'm getting more and more uneasy. I try again. "Should I be getting on a plane?"

His hesitation tells me everything. Finally, he says, "I don't know."

"Whether I should go?"

"He might not know you."

It hasn't been that long. I've heard him wrong. I think he's said I won't recognize him. I reset the weight stack for my next set.

"He might not know you."

"What?" I lie back down on the bars and push up and out. My shoulders are fatigued and starting to burn. I tighten my lower back and try to widen my pecs. I allow his words to sink in. I try to push them away. I push away on the racked bar.

My breath is tight, making it hard to allow the slow descent of the bar. John keeps his hands right under the bar, waiting to catch me.

I breathe deep into my belly, finish my set, and sit up.

"I'm sorry. I shouldn't have told you."

"No. I'm glad you did. When you talk to him, will you tell him that I . . . if he'll . . ." I don't know what to say.

He knows what I'm asking and what I'm trying to say. He doesn't make me say it. "He always loved you. I'm sure he knows you love him."

I look at John. I don't know what he knows of how we loved each other. Of how I left Steven. And all of a sudden I don't know if it matters anymore.

We keep chatting, shaking off the dread, forcing ourselves to shift gears into catty small talk and reminiscence about some of ACT UP's other People of Color Caucus members. Then we say our goodbyes, and he moves on to another part of the gym. I stand in front of the mirror with dumbbells in my hands. Trying to rebuild my ruined deltoids, I raise and lower my arms until I can't raise them anymore through their trembling and pain.

I go right from the gym to Cory's house. I'm pacing and shaking. He looks at me out of the corner of his eyes, but he lets me be. He's in his own tremble and excitatory state: he's getting ready to move to Germany to be with his boyfriend. I pace around the house, dodging boxes and packing tape.

By the time I get out of the shower and am buttoning my jeans, my hair dripping down my back, he's made lunch for us and is sitting on the floor waiting for me. "What happened?"

I sit down next to him and shake my head.

"Silence won't do it this time." He flips my wet hair away from my face. We both eat a little lunch, then I push my plate away.

I'm rocking, I'm holding my arms and can feel my nails biting into my skin where my deltoids ache from my workout.

"Enough," he says. "Look at me."

I look him in the eye, and tears start. We stare at each other and take a breath.

"Steven," I say. "I ran into John at the gym. Steven is . . ." I can't finish.

Cory looks at me, a brief flash of a question, then knowing. He takes a breath, and then he says it. "Dying."

I nod. I look away. I could make this go away. I close my eyes.

"Say it."

I shake my head. He takes my hands in his, and I lean my head against his thin shoulder.

"Say it," he whispers.

I make my mouth form the words, though there isn't enough breath to propel sound. "Steven is dying."

"Are you going to him?"

"I don't know."

"Why wouldn't you?"

"He won't . . . I'm not . . ." I don't know how to finish. "I haven't . . . He won't . . ." I raise my head from Cory's shoulder and look him in the eye. "It's too late. Sometimes it's just too late."

"It isn't too late. How long has it been?"

"I don't know. A year? Two? I don't know what he's been doing. I don't know who he's with. Who loves him. Who's taking care of him." I can feel my breath shortening, tears close to the surface. I get up and start pacing around the small room. Cory sits still, watching me. "He has a life. Without me. I can't intrude now. And why? So that I won't feel . . . what? So I won't feel like I left him even though I know I did? It's just too late."

"What if it isn't?"

"It is."

"It can't be." Now Cory is edgy, angry. Because now we aren't just talking about me and Steven. We're talking about him. About his move to Germany

to be with his beloved. About not knowing how much time there is left. But I can't let it go.

"But what if it is?" As I say it, I feel it again. That rising panic in me. Trapped. But also tension in the cord between us. Cory gets up and starts moving rolled shrouds and paintings. He's trying to decide what to ship to Germany, what stays here and with whom. He doesn't know if he'll come back.

He pauses in his sorting and stacking. "Help me," he says. We move a couple of paintings away from a large installation leaning up against the wall. It isn't even an installation, really. It's a wall. It probably weighs several hundred pounds. When he pulls the sheet away from it, my heart stutters and skips.

"This one stays here. With you."

The bodies are imprinted with blood, profiled against the wall. It looks like a man and a woman. The man is tipped forward, his arms outstretched toward the woman. She's leaning back, or falling back, her arms out behind her. The way her arm stretches out, her palm is facing us, almost reaching through the canvas.

Their mouths are slightly open. Are they talking to each other? Are they calling out? Yelling? They're falling. There's something deeply distressed about the stiffness of the fall. It won't end well. And we're watching them, helpless.

Cory stands with me as I stare. "I'm calling this one *Heteros*," he says.

"Seriously?" I can't tell if he's joking.

"Well, seriously as a title. But it's more complicated than that, isn't it?"

I reach my hand toward the wall, then pull my hand back quickly. I feel like I've been seen, captured, indicted. I feel myself as the woman, falling. I feel myself as the man, reaching toward the falling one. I open my mouth and close it again.

"Who are they?" I ask.

Cory turns to face me and reaches his arms out, tilting his body forward, toward me. His shadow is the man in the painting. Exactly.

"He's you," I say.

He nods. "The woman's body is mine too, the breasts fake. I used balloons. If I'm going to have breasts, I want them to be perky." He laughs. Then he holds his palm flat to the woman's hand reaching through the canvas. They match perfectly. His alive hand covering the blood paint.

"They're both you."

"And they're us." He turns to face me.

"What do you mean, us?"

"She's you." He watches me closely as I stare at the outline of the woman who is and is not me. She's Cory's projection of me. Her mouth is open, in horror or mid-yell. So is his. The man's. Cory's. I see in this Cory's fears about harming me.

"I thought we were past this?" I say, my fingers tracing first her mouth, then his.

"Past what?" But Cory isn't watching me. He's gotten distracted by the piles of his packing, and he's looking at a love letter from his beloved in Germany. Next to it is a printout of recent blood labs. The damage we're talking around, we're afraid of now, has nothing to do with sex and everything to do with death. About how he will die. When.

"You want me to go to Steven, don't you?"

"Yes." He looks up. "No."

"Which is it?"

"Both."

"You want me to go to him. And you want me to let him . . . what?"

"You left him."

"I know. And now you want me to fix it. I can't fix it. It's too late."

"It's never too late."

"He might not know me. This isn't about whether I go to him now. This is about me not going to him earlier. When it mattered." I stop. Cory gets it, then.

It is too late.

What are we really fighting about? Cory wants to know if I'll be there for him. This is what we can hardly talk about. We're talking in code. All of it. The unspoken or unarticulated-in-language code of our racing hearts. Ragged breath. In this conversation Steven is Steven, and he is Cory. And Cory doesn't want to be Steven, and he is afraid that if—that when—he is, I won't be there. He wonders who will. He's looking down at the love letter again. He needs to believe he'll be OK. That he and his love will have a future together. He needs to know that if the unthinkable happens, I'll be here. That I won't leave him the way I left Steven.

"I won't leave you," I say, quietly.

He isn't sure he's heard me. "What?"

"You heard me." I'm crying again, looking at him. "I said, I won't leave you."

"Why will it be different?"

"It just will."

"Why?" He's crying now too.

"Just trust me. I'll be here. Always. I'll be here."

"But...," he starts.

"But what?" I interrupt, impatient. I can see that he's mad; he looks away from me, closes his eyes in a gesture of memory. Then I get it. "Are you really still angry that I wouldn't give you the pills? All those years ago?"

He looks at me and raises his eyebrows, daring this conversation.

"You are." I shake my head. "Even now? Still? Would you really have wanted me to?"

"It wasn't your decision."

"But wasn't it? Isn't that why you told me? Why you asked? Why you didn't get up and get them yourself? Didn't you want me to make the decision?" My voice is rising, lifting toward shrillness in my frustration.

He shakes his head. He is still mad. Even though I know some part of him, even most of him, now, wouldn't want me to give him the pills, is glad I didn't. But still, it was a test. And I failed.

"What else were the safeguards other than my terror? What else was there?"

"Your terror?" He turns to me. "What about mine?"

"I never wanted to be the one to decide."

"But you agreed."

"Your beloved, he decides now, with you. If it ever comes to that."

"Yes. You're off the hook now."

"That's not what I meant."

"Will you be there?" He looks at me, tears in his eyes. "No matter what? Will you be there?"

"Yes. I promise."

"How do I know?"

"Let me promise," I interrupt him. "I need you to believe me. Just believe me." I slam my fist into the floor, and in a corner of the room, a rolled shroud slides to the ground.

We both get up and walk around the room, pacing a bit. We're still in a standoff, looking at *Heteros* from different angles. Our bodies edgy and circling each other, the way Steven and I circled each other after being stopped by the LAPD at the checkpoint. When we fought. When we almost broke apart. But before we actually did. The laughing edge of disagreement and anxious frustration, delirium, him feeling the running out of the clock, his internal clock, needing to be right, needing me to remember his narrative

as he understands it. My anxieties, not wanting to imagine a time when I will be left without him, knowing in the visceral turning of my stomach that I will need to consolidate a narrative of us—and of me without him—that I can bridge forward into a life without him, and use to return, if only in my dream life, to the space we occupy together.

(*I will not forget*, wrote Jim Pickett, now one year dead. *I will not forget. I will be the rememberer.* . . .)

Cory and I are tired of arguing, still edgy, our blood coursing with the metallic bite of adrenaline, with unfocused urgency. But one of us needs to stop it before it becomes a fight we won't be able to back off from. I sit back down on the floor in front of the wall and hold my hand out to him. He takes my hand and sits down. We've run out of words.

Cory uses his body as leverage, tackles me, pins me to the floor, his thighs against my thighs, his arms pressing mine against the wooden floor. Where our bodies meet, I push back. We're ferocious until we're not. A moment of meeting each other's force equally, we're balanced, cautious, love-frustration-muscles-rigid with things unsaid. And then finally we're laughing, meaning it fully, the adrenaline decompressing, deep exhale. He kisses me. His art supplies—boxes of syringes, needles, sharps containers, boxes of gloves—are all stacked against the walls that surround us. Evidence everywhere. Ephemera. I could throw him off of me. Once, that had been the embodiment of all of our struggles, the way we gave physicality and muscle to our frustrations with each other and with the world, or our need to push, to push back, who could top whom. Once, he was stronger than me. But he has been sick. And I have discovered the feral enjoyment of weightlifting in a queer bodybuilding gym. Even with my broken shoulders I'm stronger now. But I can't bring myself to throw him off of me.

Feeling my surrender, he pushes his upper body up off of me, using his hands against the floor to levitate above me, narrowing his eyes, angry that I haven't pushed back, angry that he's not as resilient as he once was, angry that I can feel it, angry that I changed the ritual of our engagement.

Wait, I want to say, as he rolls off of me and stands up. But I don't say anything. Neither does he, both of us silenced by our separate shames.

As he walks into the other room, I look at the wall, and I understand something of the dynamics of us. Something of how he sees us. How he fears us.

I see all of the ways we've witnessed each other, been with each other over the years. It's the story of us codified into one moment of our

resistances to a monolithic *us*, our resistance to a narrative of us as a kind of lovers or friends whose intimacy might move us away from the other people we've loved and lost, even as we kept some of the edges of our intimacies hidden.

In the image of *Heteros*, the man is burdening the woman. Is that how he sees an inevitable gendered power dynamic that he did not want to reproduce with me? Or a serodifferent dynamic? My argument in response has always been that we remake our worlds and relationships when we make them conscious, when we choose them. But he reminds me that we wouldn't choose this. And he couldn't live with my choosing to care for him, to be with him, or to set aside any part of my aliveness. I think back to the night he was beaten by the LAPD during the AB-101 rebellion, how he never knew what happened in the middle of the night. The bleeding. How I never told him. What he doesn't know about how much we've always risked, not making conscious, thought-out choices in each moment but by having made a metachoice to put each other, our community, our family, first. We want to choose each other. We want desperately to know that we will be chosen. And we are so ashamed to ask to be chosen. To be remembered.

Heteros isn't exactly a photograph. It is an image frozen in time. A descriptor. A literal and metaphorical fall. But unlike photography, the medium isn't representation of the body but Cory's actual body. His body making up his image. And mine. Or maybe it isn't me, even as he meant it to be, but the ways he has internalized me through the years of our relationship. And maybe also the ways I have internalized him.

What is symbol? What is real? What is representation? What is meaning-making in a plague that has challenged us to make meaning without a context from which to cull pattern or template? We're all falling.

I hear Cory in the next room, packing. I should go apologize and help him. But I can't stop staring at *Heteros*.

It looks like this: His hands, stretched toward her, are dripping blood, repelling her.

Or it could be this: His hands, stretched toward her, are dripping blood, an offering.

And: She is backing away.

And: Their feet are touching, bracing against each other for balance.

And: They could be calling to each other, trying to save each other.

Or: Her arms are stretched out, breaking the fall for both of them.

And: She's going to fall anyway.

I stand in front of the shroud and mimic her body with mine. My shoulders can't rotate into that position anymore. She's going to fall. I am.

Nothing can stop it. Nothing will break our fall.

Steven Corbin

1953–1995

BACK IN PORTLAND, I drove to the campus music building. I let myself in the back door and walked up the stairs to the little studio alcove. All night, warm summer wind pushing against the windows and a brief flash rain. With my index and middle fingers, I played through the end of our Billie Holiday songbook, no sound from my throat. Just fragments and vibration of the keys through my fingers. Then silence.

At home, at dawn, I took a couple of muscle relaxants and waited for sleep that never came.

Two days later, still without sleep, Michael and I got into my car to drive to Seattle to meet friends. Michael and I had met the year before when he arrived on campus as staff. Black, queer, dreadlocked, he stood out, and we found each other immediately. We escaped campus in the evenings for poetry readings and jazz clubs. When stuck on campus, we organized visits from bell hooks and study groups reading Cornel West. It's an oversimplification to say that he was a stand-in for Steven, but the ways in which we moved through the whiteness of our campus, and the whiteness of the Pacific Northwest, reminded me of moving through the world with Steven.

Did I tell Michael that Steven had died? I don't remember. I remember we were quiet on the early morning drive, listening to a bootleg recording of jazz poet Sekou Sundiata performing a narrative poem called "Blink Your Eyes" about a Black man pulled over by the police. In Sundiata's routine traffic stop, routine cop/hand/gun, I am flooded with memories of the cop's hand on his gun when Steven and I were pulled over during the Rodney King rebellion.

What happened is hazy. Two days' worth of muscle relaxants, painkillers, and insomnia kicked in suddenly, aggressively. Michael had been napping while I drove. Until I blacked out. I don't know how many lanes of traffic we crossed. Away from the center divide and over the side of the highway. I opened my eyes as we were bouncing along the upward slope, then let them shut again. Thinking I was dreaming. Some part of me knowing I wasn't but also not caring. Until I heard Michael startling, waking up in the passenger side next to me. We rolled to a rough stop against a tree. Neither of us hurt. Getting out of the car. A police car arriving. Shaking my head, trying to clear my vision, my thoughts, gather a story. The young white officer moving toward Michael, hand on his gun, asking which one of us had been driving. Me stepping in between them. Hand. Gun. Hand. The officer not believing me, then believing me. No ticket. No arrest. No handcuffs. No questions.

> Up to the window comes the Law
> with his hand on his gun
> what's up? What's happening?
> I said I guess
> that's when I really broke the law.
> He said a routine, step out the car
> a routine, assume the position.
> put your hands up in the air
> You know the routine, like you just don't care.[11]

The cop pushing me into the back seat of his cruiser on the side of the highway, my vision blurry, him telling me that he wasn't arresting me, no charges, I was just in the car for my safety along the side of the highway. Where was Michael? I lost track, off and on, sometimes seeing his pacing form nearby. Shaking my head to clear my vision, trying to track him, his safety. His dreadlocks bouncing in the wind out of the corner of my eye. He won't get in the back of the car with me. He shouldn't. I'm not sure whether it's better for us that I do. Deep breaths, gray morning. Was it still morning? Was I back in Silver Lake with Steven, stopped during the rebellion? The cop leaning toward me, hand on his gun, leaning toward Steven. Needing to distract him, pull his attention away from Steven's Black body next to me. The cop is too close. What year is it? Where am I? Where is Steven? My vision is clearing. I'm angling my body away from him, keeping my eye on Michael on the side of the highway. The cop's hands on the back of my head, saying he's checking for injury, then pulling my head toward his lap. I pull away, he grabs my arm, I pull back hard, shoulder on fire as I pull my arm away, stumbling out of the car. His hands leaving my body and reaching toward his gun. Hand. Gun. Hand. Michael turning toward us. Tow truck arriving. Right then.

> I could wake up in the morning
> without a warning
> and my world could change:
> Blink your eyes.
> All depends, all depends on the skin,
> all depends on the skin you're living in.[12]

The next few hours are foggy. Kaleidoscopic light. Tow truck back to Portland. Michael and I don't talk much. We never talk about what happened. He gets back to his apartment. I get back to mine. Pain. Shoulders icy electric shocks. A muscle relaxant. Long, hot bath. Another muscle relaxant. A pain

pill. Another one. Fire in the fireplace even though it's the beginning of September. I flip through music. I start with Billie but can't stand words. No voice. I pull out John Coltrane and let his wailing fill the room.

I take the box of Steven's letters out from under my bed, where they live next to the knife.

A bottle of wine. The knife.

I sit in front of the fireplace. And one by one, dissolve us to ash.

SOMETIMES DEATH COMES QUICKLY, and we're surprised. Sometimes it takes a long time, and we're surprised by that. I don't know how death came for Steven. I don't know if he was surprised in the last months. I don't know who was there with him. He was good about allowing people to be with him, most of the time, allowing people to love him. And people did love him. But I'm assuming that he stayed true to his core self. Stayed recognizable to how I understood him. I think about lying on that gym bench in Silver Lake as John told me that Steven might not know me. Might not recognize me. Is it possible for there to be a core self that doesn't change, even as the processing of others changes? Even as the recognition of others gets hazy, like a gauze scarf thrown over the lights, billowing in the breeze, casting shadows at once familiar and ungraspable. Is there some part of the self that isn't relational and yet engages with the world?

When we think about relationships, we think about attachment. Contemporary psychological theory says that we attach in service of both bodily and emotional survival. But if attachment is in service of survival, what does it mean when we attach to the dying? And more complicated, not just dying of viral trauma to the immune system but dying from systematic erasure and exclusion by the dominant paradigms of power, privilege, and entitled access? If we weren't already erased—and most of us were—now most certainly we are, by virtue of our attachment. Is there a fundamental masochism to our love? When we speak of survival, we mean something more than longevity. We mean ferocity. We mean tenderness and risk-taking. We mean something durational and not abstract.

And what about the agency and ferocious love and attachment of the dying? Wayne despaired, ranting on so many Gender Queeries afternoons, "You're not hearing what my rage is about! It isn't just the loss of my life, it's the loss of my relationships, that I won't get to witness them. I miss them already. Today I don't give a fuck about who will miss me. What about what I'm missing? I'm pissed off about that!"

Who will the dead miss? And what will the dead miss? What if they had been the ones who survived? I think about the Wisława Szymborska poem about the randomness and luck of survival:

> You survived because you were the first.
> You survived because you were the last.
> Because alone. Because the others.
> Because on the left. Because on the right.

Because it was raining. Because it was sunny. Because a shadow fell.[13]

What comfort is it to the dead when we claim it could have been any of us? In a 1993 interview, two years before the cocktail, when survival meant seronegativity, and seropositivity almost certainly meant death, Tony Kushner said:

> You keep it very clear that you've been spared by accident. I'm thirty-seven years old and this is a very hard world to survive in. But people do survive. I mean, it's really like Holocaust survivors have to think of it. There is a fantasy that a lot of survivors have that they outwitted death. But in point of fact, they were just lucky. And luck is this blind thing that flies around and hits some people and doesn't hit others.[14]

Yes, luck. But also, who was meant to survive? And who expects to? That first coffee date with Steven, after the white woman ran from him, reading Audre Lorde's "A Litany for Survival," that was the question between us: Who was meant to survive, and who was, through generations of embodied structural trauma, not going to survive? We want to live in service of each other's voices, and still sometimes we fail each other.

Just a few months before Steven's death, the FDA approved the first HAART treatment. Highly active antiretroviral therapy—the cocktail—was the beginning of survival for some people living with HIV. Those who might have access to care and medication. And luck enough to still be well enough for the drugs to take hold and steer their immune systems back to functionality. To recovery. ("Cocktail? It isn't a fucking cocktail. That makes it sound like fun, makes it sound like a party," Pete would say years later. "This shit is toxic. This shit is hard. It isn't a party.")

What do we mean by *survival*? What is recovery? The poetics of survival are different from the corporeal experience of survival. The relentless traumatic loss of our queer families destroyed our belief in the possibility of survival of our whole selves, if our whole selves were not just our bodies but our bodies in relation to each other's bodies. When we find ourselves still alive, we are surprised, feeling ourselves outside of the systems set up not to save us, but to destroy us.

We translate through time and context. What happens once the unimaginable is enacted? Is it still unimaginable through the loss of survival testimony? Sometimes even in the survival, context renders speech untranslatable. How do I translate Steven and carry him with me now? When he died, his third

novel had been published, and he was working on his fourth novel. What happened to it?

This is how we live dailiness in the context of constant and overlapping historical trauma. It shapes our expectations of each other and the world. How do we embody—on energetic, relational, and cellular levels—the belief that we don't expect to survive? Maybe this is what we mean by dying of heartbreak. Were we all dying of heartbreak? Are we still? No time to recover. The waves crashing again and again.

In writing about survivors of the Holocaust in his book *The Survivor: An Anatomy of Life in the Death Camps*, Terrence Des Pres writes, "Vast numbers of men and women died because they did not have time, the blessing of sheer time, to recover."[15]

To recover. To recover one's voice in the world through the translation of another. Or translation by another into a time that keeps moving. The way we carry our dead with us still.

There are so many ways the heart can be broken. And there are so many ways the body can be broken.

The story has been told—was told for years—that Walter Benjamin intentionally overdosed on morphine in Spain during flight from the Nazis. That he and his traveling companions were going to be put back on a train returning to France, where they would be sent to the death camps. That night, instead of waiting to be sent back in the morning, Benjamin took a lethal dose of morphine. He had with him on his journey a suitcase with his last remaining manuscript. The manuscript vanished. The next morning, whether confused by their orders or by the death of Benjamin, the Spanish police allowed the train to continue its passage into Spain.

Now historians are revisiting that story, questioning whether Benjamin was actually murdered by Soviet agents. How does that change the myth of Benjamin? The story of the angel of history?

(*I like the morphine, sinking, rising, sleeping, rousing, / then only in pain again—but wakened*, writes Marie Howe.)[16]

Terrence Des Pres died by suicide a decade after the publication of his book on the Holocaust. None of us knows what the conditions of survival are for anyone else. How long survival can last and what happens when survival runs out. We don't know if, or when, we will no longer be able to withstand what we have witnessed. What we now know.

(*Vast numbers of men and women died because they did not have time, the blessing of sheer time, to recover*, writes Terrence Des Pres.)

Maybe what we mean by *recovery* is really the integration of unimaginable knowledge. Maybe some knowledge cannot be integrated. Cannot be survived.

Steven died within months of the approval of the cocktail. How does it matter? How does it change the story? Does the possibility of survival change what it means to not survive? Does it make even clearer the divisions between who does and who does not have access to the conditions of recovery?

Is it the Schrödinger's box question of plague time? Put all of us in a box with a small vial of the cocktail. Who will survive? Who will be left to open the box?

Tura (Greg Carlisle)

1962–1996

➤

SIX MONTHS AFTER STEVEN DIES, it's winter. Raining. All afternoon and into the night, wind and torrential rain have kept me inside. Too wet to go for a walk, and I couldn't bring myself to drive back across town to the music studio on campus. Now cold and dark push at the windows. I have a fire lit in the fireplace, and books shedding scraps of paper and bookmarks are stacked everywhere for my thesis about theater as collective plague memory. Ella Fitzgerald is singing "I've Got You Under My Skin" from the Cole Porter songbook.

I pour a glass of wine. The fire, the music, the words, the rain at the window. I roll my neck and stretch my shoulders. They burn and pop as the ligaments torque, but my muscles loosen in spite.

Again and again, I'm reading Tony Kushner's *Angels in America*. There's something nagging at me that I can't quite articulate, about the gallows humor of Prior and Belize colliding into the anxiety and loneliness of Harper. I think about camp, the way the affect of outrageous, overblown queer laughter (which is adjacent to queer rage) functions as a kind of invocation of a plague witness poetics.

I open the pages of *Millennium Approaches*, the first book of the play, to the first contact between Prior and Harper, where they meet in what is a pill-induced hallucination of Harper's and a fever dream of Prior's. They are trying to understand how they are appearing to each other.

HARPER: I don't understand this. If I didn't ever see you before and I don't think I did then I don't think you should be here, in this hallucination, because in my experiences the mind, which is where hallucinations come from, shouldn't be able to make up anything that wasn't there to start with, that didn't enter it from experience, from the real world. Imagination can't create anything new, can it? It only recycles bits and pieces from the world and reassembles them into visions.... Am I making sense right now?

PRIOR: Given the circumstances, yes.

HARPER: So when we think we've escaped the unbearable ordinariness and, well, untruthfulness of our lives, it's really only the same old ordinariness and falseness rearranged into the appearance of novelty and truth. Nothing unknown is knowable. Don't you think it's depressing?

PRIOR: The limits of the imagination?

HARPER: Yes.[17]

I'm deeply unsettled by the scene, the way Harper's fear reminds me of my own spinning thoughts, my desires to make sense of the unfolding wreckage of the world, and the way Prior's acceptance, at once campy, defiant, and blasé, reminds me of Steven's endless patience with my panic.

HARPER: The world. Finite. Terribly, terribly... Well... This is the most depressing hallucination I've ever had.

PRIOR: Apologies. I do try to be amusing.

HARPER: Oh, well, don't apologize, you... I can't expect someone who's really sick to entertain me.

PRIOR: How on earth did you know...

HARPER: Oh that happens. This is the very threshold of revelations sometimes. You can see things... how sick you are. Do you see anything about me?

PRIOR: Yes.

I put the book down and stir the fire. On one side of me is the empty glass of wine, on the other side a half-empty mug of now-cold coffee. A photo of Steven glows in the light of the fire. The threshold of revelation isn't magic. It's the way we become so used to scanning, a kind of vigilance about the body and spirit of those we love, that we know in our body, even before we find words, that something is wrong. The threshold of revelation is the anticipatory pain that comes from connection. From love.

PRIOR: ... I just looked at you, and there was...

HARPER: A sort of blue streak of recognition.

PRIOR: Yes.

HARPER: Like you knew me incredibly well.

PRIOR: Yes.

HARPER: Yes. I have to go now, get back. Something just... fell apart. ...

PRIOR: I ... I'm sorry. I usually say, "Fuck the truth," but mostly, the truth fucks you.

HARPER: I see something else about you ...

PRIOR: Oh?

HARPER: Deep inside you, there's a part of you, the most inner part, entirely free of disease. I can see that.

PRIOR: Is that ... That isn't true.

HARPER: Threshold of revelation.

I hold my hands toward the fire to warm them, and the light glints off of the stack of slim silver rings still on my finger where Steven placed them years ago. I pick up *Perestroika*, the second part of *Angels in America*. Harper says, "I don't understand why I'm not dead. When your heart breaks, you should die."[18]

The phone rings, and I'm pulled out of Harper's despair and back into my rainy Oregon night. I stare at the phone, counting the rings, as panic starts to flutter in my chest. One ... Who is in the hospital? I can't remember. Two ... Pete? Three ... Mary? Four ... (Harper: *Imagination can't create anything new, can it? It only recycles bits and pieces from the world.*) It's after midnight. I pick up the phone.

"Hello?" My heart thumping loud over the rain. The line is crackly, and I'm straining to listen for the voice at the other end.

"Hi, love." It's Cory.

"Hi, love. It's you." I'm smiling at the sound of his voice.

"Is it late there?" he asks. I can't tell if his voice is wavering or if it's just the connection.

"I'm up. Reading. What's up, love?"

I hear him take a deep breath. "I'm not so good. I ..." I don't know if it's static, or if he's stopped.

"Baby, what is it?" My eyes start tearing. *Threshold of revelation.* I already know.

"The brain tumor. They can't do anything else. The surgery helped, but not enough. I was seeing four of everything. Now I'm only seeing double."

"Oh, love."

"The headaches are better. That's good."

"Yes. That's good." I turn down Ella.

"It's over," he says, quietly. But I can hear him clearly.

"But, can they . . . ," I start to interrupt, then force myself to stop. To take a breath and listen.

"It's over. I'm coming home."

"What about . . ."

He interrupts me. "He's coming with me. I want to die at home."

I'm silent.

"Are you still there?"

"I'm here, love."

"I want you to meet me there. Meet me in LA."

"OK."

"I want to say goodbye in person. I want you to sing to me again. I want you to be there."

I know what he's asking. We've rehearsed this. But the rehearsal didn't feel anything like this. I take the deepest breath I can, holding as still as I can so he won't hear me shake. "I'll meet you there."

"Promise? I love you." His voice is getting fainter.

"I promise. I love you too."

We hang up the phone. Nothing has changed. The rain is still pouring. The fire is still crackling. I pick up *Perestroika* and stare at the page. Harper is still longing for her love. As many times as I've read the play, I always think she should be talking to Prior in this scene. That there should be more dizzying dreamscape scenes—those surreal illuminations about the imaginary and the amplification of the mundane—between the anxious, lost, grief-stricken woman and the beautiful, fever-dream-associating faggot. That they need so much more time together. But she isn't talking to Prior. She's hallucinating and talking to Mr. Lies, her imaginary guide, a travel agent who has come to help her home.

◂▸

NOT LONG AFTER CORY'S CALL, I've left the Oregon rain and am sitting in the coastal winter sunshine in Mary and Nancy's yard. I squint toward the sun, then surrender to it and close my eyes. Warmth. I'm sitting next to Nancy, and we're holding hands. Mary is inside cooking something we may or may not eat.

Settling into hospice, Cory and his German husband are using Mary and Nancy's house as a home base. They come back from an appointment, and Cory's husband helps him to the guest-room bed. I follow into the house, and Cory reaches his hand out toward me. His husband smiles at me, at Cory, then leaves us alone.

In its virus-induced failings, ease leaves Cory's body first, leaving stiffness, aching, disorganized limbs, a fever that hasn't broken in two days. "I'm so tired that I can't rest," he whispers as I sit down on the edge of the bed. "Help me. Like before."

I help him pull his shirt off and roll onto his stomach. I straddle his bony hips, balancing on my knees, careful not to put any weight on his sacrum or the knobs of his lumbar spine, and rub the deep spasms in his shoulders and midback. I slide one hand under him to cradle his sternum, my other hand on his back, holding his thin chest between my hands, taking the pressure off of his wasting muscles, which were exhausted from the effort of holding up his bones, the boundaries of his flesh and mine as familiar to me as my own skin. His muscles tremble a little as they start to relax, start to let go of their effort.

He's so close to the final letting go that he slips toward panic as he feels the edge of deep relaxation. His ragged breath gathers itself, and he uses the muscles of his back and the intercostal muscles between his ribs to roll his spine like a wave, gathering his waning strength, the muscles tremoring like the ground under us during all of the California earthquakes we'd lived through together. "I've got you, love," I say, as his spine flattens again, having used up his effort, his chest relaxing into my hands again. "Hold me," he whispers so softly that I almost don't hear him. Or maybe I only imagine what I want him to have said. He shivers and curls onto his side, and I lie behind him, spooning him and holding him in my arms. I hear the lullaby of voices outside the bedroom door. Mary. Nancy. Cory's husband. I want to hold everyone close, this quiet, safe bubble of our family. I slow my breathing and time it to Cory's. A few minutes later, he is sleeping, and his fever breaks. I hold him closer as he sweats through my shirt.

Chris Brownlee Hospice was nestled into a corner of Elysian Park. I drove past the field where we ran and laughed as Sonia took photos of us. The hospice, the former site of Barlow Hospital at the edge of Dodger Stadium, which opened as an AIDS hospice in 1988, was a revolving door of community. You'd go to visit a friend and run into three others serving meals or hanging out with lovers and friends. Friends who hadn't been very sick the last time you'd seen them would be there, and for a minute you wouldn't know if they were visiting or if they were newly residents. If you were there a lot, you'd see people come and vanish quickly. You'd also see people stay.

There were people clustered around Cory's room. His biological family were being corralled and managed by his husband. So was the line of queer family who all wanted a little more time. Cory had always played at loving the spotlight, and most of him had, but it had always taken its toll. He had always needed to retreat after big demonstrations and performances, regroup quietly with art and silence. Now, there was no more time to settle and find space. Or settling and finding space was all that was left.

Everyone was allowed a few minutes alone with Cory. His husband was at the door keeping time so that none of us would keep him to ourselves, edging out the others, as we had always competed for his time.

Finally, I was allowed my time.

Light. Dark. Shadows.

Cory has headaches from the brain tumors. His vision is still swimming, doubled. The low light makes it easier to focus. The perfect sweet spot, low enough not to glare, but enough brightness to almost focus.

I sit next to the bed. "Hi, love," I say.

"Hi, love," he says, and reaches his hand toward my face. Hesitation right before contact. He can't tell, in his doubled vision, which is me and which is his illusion of me. I take his hand in mine and bring it to my lips, then my cheek. We smile at each other.

"Here we are," he says.

"Yes. Here we are."

"It's harder than I thought. Leaving."

I take his hand again.

"I don't want to leave him. Anyone. I wasn't done. I'm not done. But it's also, I don't, don't know, a relief, maybe a little."

"What part? Not fighting anymore?"

He laughs. "You really think I stopped fighting?"

I laugh too.

"No. Not making decisions. That's a relief. No more decisions. So I can just... I don't know. Be here. A few more minutes."

"You? Letting go of control and not making all the decisions?"

"I know, right? It takes dying for this queen to let go a little."

We're caught in the strange moment. We're quiet. Holding hands. I feel his skin warm in my hands, his fingers longer and thinner, less flesh on them; the slight puff of skin from fluid is different from the solidity of muscle and bone.

"I love you," I say.

"And I love you."

"So it's all decided?" I ask.

He closes his eyes and nods.

"What happens now?" I look away from him, toward the door, the foot of the bed. I can't look at him. I exhale, ragged, then look at him again.

He opens his eyes again.

"What do you want me to do?" I ask.

"You go," he says quietly.

"What?" I'm confused.

"You go."

My heart starts racing, and my breath tightens. "I thought you wanted me here."

"I did."

"And?" It's a question. I pause a beat. "Oh. You changed your mind. What did I do?"

"Nothing. This isn't about you."

"What will happen?" I shake my head. "How..."

"Just go." He looks away.

"Is this what you want or what you think I want? Because what you want... That's why I'm here. I promised. I still mean it."

"I know. And this is it." He looks at me again.

"Don't do this." I don't want to cry, don't want to make this about me. But I am crying. About all of it, about leaving, his and mine, about this moment that I never thought would really come.

He watches me for a minute, brings my fingers to his face, mirroring where tears are leaving tracks down my cheeks. "You'll tell it. Us. Don't forget any of it."

"How could I forget?"

"Well"—he laughs—"there are a few things you could forget. A few things you could omit."

I laugh a little too, trying to breathe, trying to take him in, the place the strength of his laugh meets the quaver in his breath.

I look away from him, trying not to cry again. "Just a little longer?"

We're quiet again. It's sunny. It's late winter, which, in Los Angeles, is the temperature of spring, but just before the blooming starts. Inside the room it is impossible to tell what time of year it is outside. And these rituals of leaving are timeless. We've done this so many times. And it doesn't matter. It's different. Always. And this is it. This matters.

"Sing something."

"I haven't really been singing," I hedge.

"Deathbed request." He looks at me. Impish smile.

"Really, we are doing that? You're pulling that card?"

"Isn't now the time?" He laughs. Then I'm laughing with him. We're laughing the outrageous campy laughter of despair. Tears streaming down both of our faces again. Then he takes my hand and tips his face toward mine. "Please? It's just us." But I can hear his husband outside the door. Other friends wanting their turn. It's never been just us. I nod. Close my eyes. I start singing "I've Got You Under My Skin," remembering the moment right before the phone rang, right before the world began to fall.

I make it through the first verse, deep, shaky breaths into my belly, voice quavering a bit. Cory closes his eyes, smiling, listening. I take a breath and start the second verse, but my throat closes, the words scraping through, then my mouth forming them around only a rough whisper, those heartbroken lines about being willing to sacrifice anything in order to keep the loved one near. Anything, in order to keep them.

I pause, breathe for a minute. Cory's eyes are closed. I think he's sleeping. I force the lines through my mouth again in a whisper.

I feel his hand in mine. Warm. Dry. The long bones. I worry them gently between my fingertips. I feel the vitality of sinew and blood under the skin. He moans slightly at the massage of my fingers against his. He isn't sleeping. Just resting. Being with.

"You'll tell?" he asks, smiling again, brief return of his troublemaking self. "Promise you will?"

"I promise," I finally say, forcing sound from my throat. He's looking into my eyes. Or he's looking in the direction of my eyes. I don't know if he's seeing me, or the outline of where he trusts that I am.

Cory Roberts Auli

1963–1996

Gabriel Arreola

1964–1996

Connie Norman

1949–1996

AIDS *is no longer leading cause of death of all Americans ages 25–44 but is still leading cause of death of African Americans ages 25–44.*

President Bill Clinton signs the Defense of Marriage Act.

SUSAN SENDS ME LUCILLE CLIFTON'S *The Book of Light*. A starred page, and a note saying, *Come home*:

> she walked away
> from the hole in the ground
> deciding to live. and she lived.[19]

But I wasn't able to hear her. Not really. Not yet. Not for a long time.

then, after

THERE ARE ALWAYS WAYS TO LEAVE. For years there was free jazz at the museum on Friday nights. There was wine. There were hikes through sun-parched dusty hills and black-iced forests. There was successful surgery to remove the bone fragments from my shoulder. There were the pain pills that worked. There was failed surgery to repair the shredded tendons of my shoulder that would not reattach. There was daily physical therapy. There were the pain pills that did not work. There were knives. There were jazz clubs on quiet weeknights. There were two nights a week when each set of friends thought I was with the other. There was the bass player whose name I don't remember or never knew but I can tell you about the calluses on his right hand, thumb and middle finger, the way they scraped the strings. That resonance. There was a birthday cake with strawberries, but we had run out of candles. There were women to fuck and other women to date. There were queer writers reading into filled bookstores and the closest bar after for shots. And more shots. And no words. There were late-night margaritas and enchiladas in the rainbow-muraled restaurant that has since lost its lease to gentrification. There were bottles of wine and foggy mornings after. There were art galleries and performances at Highways and tequila and Kahlúa-laced coffee at midnight. There were writing groups and poetry readings and the week Olga Broumas read, "The friends of the dead lie on my table. I do what I can with their breath and my hands," and Cyrus Cassells read, "Lord, let me live long enough to dare a love poem."[1] All of them

crowded in my head and the wine and knives it took to push them away, even as I held their books in my shaking hands. And the notes from Susan saying, *Come home.*

Then Judy called.

the rememberers

WHEN I WALK into Highways Performance Space in the summer of 2000 for *Loud, Proud, and Pissed*, the show Judy Ornelas Sisneros has curated of LA-based queer photos, graphics, and memorabilia from 1989 to 1994, the first thing I notice is that the floor has faded. It has been almost a decade since Susan and I sat on the concrete floor on our first World AIDS Day with ACT UP, tracing the names of the dead, who have now become our dead. Every time we've walked into the gallery and performance space, we've arrived early for the show, picked out black and red markers from the tin can by the door, and traced over the names. Names have faded as people walked over them, pacing the length of the gallery to witness representations of our lives. I look for the names I know, the names I have drawn onto the floor over the years. There are new names on the floor. Some of them I recognize. I want to touch my lips to the worn, cool floor, but I don't.

There is nothing happening on the main stage of the theater, so I walk out onto the stage and remember the last time I stood under the spotlights. In *AIDS! The Musical*, a play written by a trio of ACT UP/LA members (Wendell Jones, David Stanley, and Robert Berg), ACT UP/LA itself was re-created in exaggerated stances that distilled archetypal community members to their recognizable best and worst. Two of the most complicated representations come back to me as I stand center stage—Bob Summerbell, the Radical Faerie who dies in the opening scene and comes back to haunt and guide the central character, and Carlos, a gay man dying of AIDS who embodies the raging

despair familiar to us all by singing a song called "Momma, I Need a Gun for My Birthday." What made the characters of Carlos and Bob especially complex for the ACT UP/LA community in the audience was that the lines between the characters as fictions and the characters as only slightly intensified camp alter egos of the actors who played them—dear friends who were both ACT UP/LA members and frequent Highways performers—were so thin as to make us forget we were watching a fiction and not the monologues of our beloveds' dream states.

In the finale of AIDS! The Musical, the actors, after taking their bows, sang Silence equals death, action equals life while pulling audience members, one by one, down onto the stage to dance with the cast, until no one was left in the theater's seats. The audience had, at that point, joined in with and become a part of the action onstage. Cory, Wayne, and I had seen AIDS! The Musical together several times, laughing together as we held hands with the cast and twirled around the stage, simultaneously witness and embodied, dancing participant.

I turn right, around the corner from the box-office window, and walk up the narrow stairs to the newly converted second-floor gallery. Ascending, I am confronted with images of our lives. Judy has gathered photos of demonstrations. Of parties and ritual gatherings. Posters wheat-pasted around the city in the middle of the night. Posters made for demonstrations and press conferences. Fragments of burned flags from the weeks of protests when Governor Pete Wilson vetoed AB-101. I am standing in a room filled with evidence of our lives, evidence of our dead.

I feel fragile from the years between. My shoulders are frozen, my elbows glued to my sides. I try to deepen my breath, looking around. I had forgotten how strong we were together, and how much we accomplished. Not fearless, never fearless. At least I wasn't. But we did it anyway. I walk around the room, reaching my fingers out to the photos, smiling at faces that are no longer here to smile back.

In the middle of the room, Robin is being interviewed. She points to a photo framed high on the far wall of a group of people blocking the entrance to the Wilshire Federal Building. In the front left of the photo, Robin is surrounded by men who have since died. "Why civil disobedience? Why not other forms of activism?" Robin is asked. And without a pause, she answers with the sound bite I have not heard in years: "One of our slogans was 'No more business as usual.' People were dying. It was the ritualization of our rage. And our grief."

I turn away from Robin, my eyes filling with tears, my breath shallow. Another wall has a small alcove holding the memorial that Judy created for the ghosts of our community, our family. By the light of flickering candles, I slowly read the names of people I knew, the names of those who died before I entered the community, and finally tears spill when I see the names of people who have died in the years I've been away, who I hadn't known had died. All around me, lit in the late-afternoon coastal light and the flickering candle flame, are the faces of our ghosts. On the wall to the right, a photo of Steven. I stand so I can see it more clearly. Then I close my eyes and remember:

Maybe it was after the first early morning clinic defense. Maybe after the first coffee date at the Onyx. I no longer remember where we were, but I remember the feeling of the moment, telling myself, *Remember this*. Memorizing the feeling of his arms around me as we say goodbye. I don't know why I know to do this, why I think to remember. No, not just remember, which is passive, unconscious, but memorize: This is his arm around my waist; this is my cheek against his chest; this is connection, then disconnection at the belly when we inhale, then exhale, diaphragms expand and relax. It was late winter, slightly cool, a little breeze, a few cars driving by. Somehow, I know to do this. Some part of me knows, even as I refuse the fully conscious thought, that there will be a time when I need to conjure this. Not yet, but soon. Too soon. Because this will happen: the beginning of unmemorization. Memorizing and unmemorizing. It isn't the same thing as forgetting, which is passive. Unmemorizing is action, is the reorganizing of a body to accommodate the absence of another body.

For months I curled my body into the safety of Steven's body, and then for years I curled my body into the possibility and memory of his still-somewhere body: steady shoulders, open arms that closed tight around me. I curled my body into the space his body might have been because it still could be again.

And then it couldn't. It wasn't. And now I begin the action of unmemorizing. Unpeeling my arms from their pose of holding, one arm around the space his waist might be, the other reaching my hand up toward the side of his neck, my face against the echo of his chest. I pull my arms back against my own body and then farther away, stretched back the few inches my shoulders will allow. I uncurl my spine from its forward tilt, relaxed into the ghost of him and stand upright, alone, then arch back, my chest vulnerable, exposed, the muscles of my throat pulling tight against my vocal cords. There is no relaxed breath in this position, no deep exhale. Only holding myself up. Only my throat and heart exposed. I feel the air around my whole body. My

singular body alone. Arched back, nothing to catch me and nothing to reach for. I hate this feeling. I drop my arms to my sides.

I stand quietly, my shoulders burning, tears sliding down my cheeks. The names on the wall in front of me blur, and I close my eyes. I'm holding my breath. I feel someone near me but don't open my eyes.

"Sweetie," I hear. I open my eyes, and Robin is standing with me. She places her hand lightly on my sternum, and my breath catches in a deep gulp. We look at the names together.

I point to a name. "I didn't realize he had died."

"Last year."

I point at another name. "And I don't remember them."

"They were before your time in ACT UP. You didn't know them."

I turn away from the wall and look at Robin. "Are you sure?"

Robin looks at me steadily. She knows what I'm asking. "I'm sure. You didn't forget."

Then the rest of our outlaw family starts to arrive for the show's opening. For hours we all gather, chatting excitedly, then standing quietly, awed by the images of ourselves, and of our dead. During a decade of celebratory rage and grief, the streets and galleries of Los Angeles became the veins between hospitals and homes. On one wall Judy has created a collage of buttons that ACT UP and Queer Nation had designed for different actions, everything from the visually familiar SILENCE = DEATH to the less familiar intracommunity reference tag I WAS ARRESTED FIGHTING AIDS and next to it, . . . AND AGAIN. Photos of me and Cory from our photo shoot with Sonia are on the wall near a photo of Pete. At the top of the collage, a shard of glass, broken in the AB-101 demonstrations by Wayne, is attached to strips of burned flags. We tell the stories to each other, remembering, as we walk around the gallery looking at photos. We had walked around in a daze, bailing people out of jail and tending to wounds inflicted by state and city police during the AB-101 rebellion, our fingers grazing the edges of glass we kept in our pockets or pinned to our jackets as a reminder. We had joked that the clicking glass fragments were our outlaw prayer beads.

There is a strange stillness in the room as we look at our photos, a film loop of Wayne's political funeral playing on the monitor at one end of the room. Outside the gallery, the world is still dying, and there is an even greater economic divide in treatment access, but for a few minutes, no one in the room is walking with the familiar death rattle.

At the end of the night, when we finally walk out of the gallery together, those of us who are left, I turn back to look at the faces one more time. Wayne

smashing the State Building door. Mary speaking at a demonstration for health care access for women with HIV. Two men I don't remember, kissing. We have blown out the candle on the altar, so the room is lit only by the faint glow on the stairs behind us, casting all of our shadows against the floor, outlining our bodies over names.

MARGINALIA 2000

World Health Organization (WHO) announces that HIV/AIDS has become the fourth-largest cause of death worldwide and the number-one killer in Africa.

WHO estimates that 33 million people are living with HIV worldwide and that 14 million have died of AIDS.

LISA AND I MET AT A WRITING workshop along a river in Oregon. We caught each other's attention immediately but waited, cautious, a few days before we started talking. Almost an accident, early morning, river sunrise, throwing endless sticks for the resident border collie. I was taking a workshop on political poetry. Lisa had flown out from New York to study storytelling with Grace Paley. A full-moon solstice. We all howled together overlooking the river. We were delighted by each other but cautious until the evening readings, where we listened to each other tell stories that felt deeply familiar and different enough to keep each other surprised. She lived in New York. I lived in California.

Maybe our commitment, or mine, began on September 11, when I woke on the West Coast to the news of the attacks on the Twin Towers and the devastation in Manhattan. My first response was panic and wonder about Lisa's safety. Her survival. We were living on opposite coasts, saw each other only when work travel brought us to the same place, and were both dating other people. But doesn't it matter who you reach for first when the world is blowing up? It was the first time in recent catastrophe I had woken reaching for the living and not the dead.

Three years later she moved to California so we could live together.

There have been so many moments of catastrophe. So many losses. And so many ways we try to love each other through them.

When Lisa ties me down to our bed, restraining all the movement from my arms, the nerves in my shoulders quiet, protected, unshattered. She controls every movement, and I close my eyes into the flood of sensation. I close my eyes, and the echo of surrender to other now-gone bodies flickers at the edges. Past and present tangle, and the collision takes my breath away.

JOËL TELLS ME the story over and over. Cory needed the money, so he took a job working the door at the Exile, a Silver Lake sex club. But Cory was sick then, thin, IV attached to his arm. He clicked people in and out while holding on to his IV pole for stability. Joël writes a poem about Cory and the sex club. *Tell me again*, I say. And he reads from the poem:

> warm, summer santa anas, wind
> troubling his toxo drip, i drove out to the exile
> broke & lonely, to keep him company. keep him steady
> through the long night. he *has* to work. sinks
> every penny he earns on meds & bills. the door swings
> open, an old queen walks out, eyes to the ground. click
>
> another one vanishes into the night, clicks
> endless scour for flesh. techno floats out, mingles with the wind
> he jumps off his stool. swings
> & jitterbugs with his i.v. pole to **thumpthumpthump**. pariah, this
> exile
> invites me to join him, orders me to wipe that hopeless sinking
> look off my face & DANCE! he stumbles i rush to steady
> him. he pushes me off & sits back down, steadies
> his breathing, a queue is forming & he resumes click clicks.[1]

I close my eyes as Joël tells the story. I remember the Exile, the gritty ground, the exact spot Cory would have stood holding on to his IV instead of sitting on the door watcher's stool. I know the direction he would have looked over his shoulder, keeping watch on the unguarded street for harassers and bashers, campy nods and winks at the men going in and out of the club. Did they see his body as warning? As gallows humor? As coded defiance and reclamation? I can't see them when I close my eyes. But I see Cory clearly, his strong, thin hands white-knuckling around the silver metal IV pole.

And I can convince myself that I was there, propel myself back in time to stand with him as Joël did. I can see Cory turn his head and laugh with Joël, how he must then have held the IV pole in his hand, letting his body sway in the breeze, unsteady and delighted by his own joke.

But I wasn't there. I know that. Instead, Joël indulges me, telling the story over and over, and I'm soothed by another narrative of Cory, my story of him expanding decades after he's gone.

Jeff tells a story about Pete and the Highways floor. "Do you remember? Were you there with us?" he asks me. Over and over he tells me. So that he doesn't have to remember it alone.

There was an ACT UP/LA event at Highways. The memorial floor was deteriorating. Pete and I and probably everyone else were very much into honoring our dead activist friends. Never forgetting them. Old names were fixed up with new outlines of their names. New names were added. It was emotional. Pete worked away with a real sense of purpose. Finished, he showed me a name he added. It was his own. It said, "Save a place for me" with his signature. I looked at it, and it made me sad. The day would come. He knew that. So did I. I have said this before. Pete wanted to be remembered. He wanted all of us to be remembered.

Sometimes I'm convinced I wasn't there. Sometimes we block out what we can't metabolize because it has no frame of reference for integration. "Don't you remember?" asks Susan, telling the story of a demonstration. But I don't. How do we know how to give language and meaning to that which is without prior narrative from which to frame a story? Years later we talk about it again. But now it's after another demonstration where the police box us into deserted downtown streets, closing in on us in full riot gear, the airspace above us closed, no helicopters, no witnesses, fear rippling through all of us until someone defuses the standoff enough for us to get the most vulnerable out of immediate danger and then steer the rest of us away from confrontation. And then all of it comes back: that earlier afternoon on the other side of town. The police, the echo of their booted feet and ours through the underground parking lot as we scattered in all directions, trying to find safety. Trying to hide. Trying to keep track of all the demonstrators wearing red JUSTICE FOR JANITORS T-shirts, a moment of dread and panic (Are they the same thing? Is dread a conscious processing of what had been unarticulated as panic?) when we start to count heads, lose track, and don't know how many people might be deported if they're caught in the police kettling. The association. I remember. I see it. Susan is right. I was there.

Our tender, relational memories are a construction of empathic attunement. We can feel the stories of our loved ones, imagine ourselves into the moment with them. I can feel it. The memory of the fear is encoded in my bones. Their fear. My fear. My sense memory. In relationship to those I love. The missing and the still here.

There is evidence that children of Holocaust survivors carry in their genes verification of that historical trauma—that epigenetic inheritance means that the nervous systems of children of survivors carry the trace of the experience in the ways they process stress hormones.

I believe this. I think about my own loved, protected, safe childhood, yet still the way my teeth rattle and grind with flashes of the barbed wire at Manzanar during Mehmet Sander's herding of us at Highways years ago. And I think it's more complicated. What do we mean by lineage and inheritance? How do we understand the nuances of the biological and the sociocultural chosen kin?

What is genetic inheritance—transmitted through blood and DNA—and what is learned, embodied, symbolic? Memorized. Queers especially know about chosen lineage as distinct from (and sometimes coexisting with) genetic markers of families of biological origin. Bodies are shaped by genetic possibilities. Bodies are also shaped through use and time. Mirroring and repetition.

Our bodies develop throughout our lives, through the ways in which we use them as well as the ways we move through the external forces we negotiate with. This is what explains my grandmother's folded spine from a lifetime of picking strawberries. The way when I bend to pick them, I am surprised by how far I have to reach. The way Cory develops the tic of a quick look over his shoulder to assess safety, disguised as a turn of seduction. The ambivalent way I turn to watch Adam approach me at the Women and AIDS benefit. The way I know to square my shoulders and make myself bigger, shielding Wade from the onslaught of Operation Rescue rushing at us, or the way I know to flip my hair back and smile at the cop while tracking his right hand on his gun, distracting his attention from Steven sitting captive in the car next to me.

The moments when we automatically move our bodies through historically and culturally scripted enactments change us over time. The unthought felt of mirroring and reflecting and the unconscious choreography of cocreated moments of embodied intimacy. Children learn how to move their bodies in the world by mimicking the movements of their caregivers. As our worlds expand, we continue to develop our bodies, and we have more and more people after whom to model our posturing. Kids practice moving the way their superheroes move through the world, rescuing themselves and those they love.

As queer kids grow up, if we're lucky, we find other queers who become our heroes and who we model our movements after.

And what happens to us when those we model ourselves after are caught in the webs of traumas—both big and political, and small and intimate? How do their bodies change? And how do we emulate those moments of attempted protection, or failure to survive? How do our nervous systems imprint and adapt to the traumas of our beloved community members, mentors, and comrades?

Our bodies are evidence of our direct experiences in the world, and of our intimate embodiments with our loved ones, helping them to metabolize their experiences.

Time moves forward and backward. We feel into the experience had by our loved ones because the intimacies of our bodies together over time—that somatic resonance allows—no, demands—that we feel into—embody—the experiences they have had. They become inextricable in our feeling. Our bodies lean into the possibilities of mirroring their experience. We are so deeply affected that we metabolize it. We remember things not as they happened (not only as they happened) but as we felt them.

Cellular memory is a genetic possibility and a collective somatic unconscious.

Our bodies are evidentiary of our love, our attachment, our empathic witness of each other's body stories. And even as I write this, the image flashes, vanishes, flashes back again. Pete, the gallery floor at Highways. "Tell me again," I write to Jeff, "the story of Pete and the floor and remembering him."

We are evidentiary in our nostalgia, our longings for our dead. The way our bodies curl into the shape of their missing bodies next to our bodies.

Our bodies, sometimes, are predictive. Over and over I ask, and over and over Jeff tells me the story. *Save a place for me*, Pete wrote, the thick Sharpie held in his wide hands, sitting on the floor, tracing the names of our already dead.

▴

ONE SUMMER LISA AND I WENT on a road trip through California. Gold country. Coastal pine. Giant sequoias. We stopped for a day at Manzanar.

The visitor center is open during tourist season. *Tourist season* seems a strange designation at a site of suffering, which is also a site of *gaman*, which makes suffering hidden, subtle. You have to know where to look. How to look.

I had been here before. On family vacations, on our way to mountains with green space and running water. Snowmelt rivers we jumped into at dawn and dusk.

There is no obvious water in the Owens Valley summer.

The closest town is called Independence.

The visitor center is comfortable, air-conditioned, the walls hung with art, some made by detainees during incarceration, some re-created after, from photos and stories and memory. Dorothea Lange and Ansel Adams documented the camps. Their photos loom near us. Outside the windows and glass doors, the landscape is barren. Almost what it would have looked like before the camps were constructed.

The tallest visible structure is the memorial to the dead. The obelisk is white, stark against the blue sky. Mount Whitney in the far distance. Engraved black kanji says, "Monument to Console the Souls of the Dead."

The monument and the barriers around it are draped with origami cranes mostly faded to gray under the sun, blending into the soil that coats everything. Some, still bright, must have been recently placed. We walk through the small patches of grave markers, many unnamed. Some names echo my family, and I have to remind myself that the names of my family were common here. Some names are written in kanji. Some kanji looks like it was added later, after Roman-alphabet markers. That graves were reclaimed after the war (is the war ever over?).

We meet with a volunteer and look through camp records. We find the block where my family was housed and drive as close as possible. There are no barracks left. Just occasional slabs of concrete that propped up the wooden housing. And signs marking block numbers.

(*Housing* is a euphemism. Barracks held up to eight people in one or two small rooms. Communal bathrooms were a long walk away. Detainees

had to grow their own produce, inventing makeshift irrigation, navigating constant wind.)

I expect to find something at the block where my family was incarcerated. We stand where they would have stood, where they would have slept. I take small steps to walk what I imagine the dimensions were. Imagining our family of five, then six.

We squint into the sun to see the fence line where my uncles ran and played with other children. The guard towers are mostly dismantled or disintegrated, though we feel the echo of them. I can see my uncles Kei and Eddie—small children, running, running, running. The distance to the towers where guards were armed, aiming, always aiming, spotlights at night.

We keep wiping dust from our faces, rubbing it out of our gritty eyes. I bend to the dirt and sift it through my fingers. Rocks, pieces of parched wood almost petrified in the dry. A rusty, bent nail. A blackened screw missing its head. I can picture Uncle Kei, how he still can take anything and make it into anything else, carefully sorting his tools. Everything useful.

I rock back and forth, standing in the wind, letting it push me. Tip forward from the chest, pulled back from the midspine. Echo back to the Highways World AIDS Day quarantine experience.

What did they have to not feel to brace against the wind, the dirt, the crowd, and choking grit?

What consoled the souls of the still-living?

We brace against it now. Dirt blowing hard against our faces. Ashes feel like this.

Ferd Eggan

1957–2007

I HADN'T THOUGHT I'd get married. But now here we were, in an upper balcony of San Francisco City Hall, about to say vows. The last time we had been in this balcony was for the public political funeral of Del Martin. Phyllis Lyon and Del Martin had been together for more than fifty years—radical political lesbians gathering community to them and making visible space in the world. They were the first couple married in 2004 when then-mayor Gavin Newsom ordered the city clerk to provide marriage licenses to same-sex couples. Those marriages had been voided. Then, after the California Supreme Court legalized same-sex marriage in 2008, they were, again, the first couple married. A few months later, Del Martin died. Lisa and I perched in the balcony listening to people rhapsodize about spaces that Phyllis and Del had created in the world, and the worlds she and Phyllis had made possible together. We wondered how to have a commitment that wasn't a pull toward the fictive seduction of protective normativity but continued to make larger space for our communities in the world.

Now we were standing in the balcony at City Hall, about to be married. Just a few months past the fortieth anniversary of my parents' City Hall wedding in Los Angeles (which had been just a year after *Loving v. Virginia*), they were standing in the balcony with us.

It's Halloween, and all around us are people in costume. Classrooms of children roam the hallways with their teachers, escaping San Francisco's cold autumn rain. A teacher dressed as Cruella de Vil walks past us with her pack of children dressed as 101 Dalmatians. People stare at us as they walk by. In each of the alcoves and balconies, couples, mostly queer, are marrying, racing the election-day clock.

San Francisco's city hall has a long history in the visibility of queer historical self-determination. It was the site of the assassinations of Harvey Milk and George Moscone, and then the site of the eruption of the White Night Riots in 1979, after Dan White was given the lightest-possible sentence for those murders. In 1979 queers refused to back down to the police and city, and it remained the largest queer rebellion until we took the streets in the aftermath of the veto of AB-101.

Eight years after the White Night Riots, the mayor's balcony at San Francisco City Hall was the site of the first public display of the AIDS Quilt.

(Years later Jeff will remind me that he and Pete, without any contradiction to their queer politic and community commitments, were married at the March on Washington for Lesbian, Gay and Bi Equal Rights and Liberation:

I think the march was 1993. Yes. Sister X arranged for the wedding ceremony. It was preplanned, and they wanted to do it right. A group of Sisters were involved. X and the others put a large rainbow net over us, covering us. It was very serious and dramatic. I was caught off guard with unexpected deep emotions. Pete was wearing his pink pointed faerie hat and a white net skirt over his jeans with boots. He was so so beautiful. Sister said that ours was the first marriage officiated by the Sisters. The first certificate. X signed with an X. Without a doubt, no question, it was the happiest day of Pete's life. Sister was nearing the end of life but was also so beautiful. Saved in a little box, I have the gold eyelashes she wore that day. The sun flashed off of the lashes.

After the wedding we went on to more full days of activism.)

What is marriage for? The dominant narrative sets it up as a project of exclusion—taking a singular partner to the rejection of all others. And a promise of a long life shared until death at a shared old age. So, if we queer marriage, what is it for? How do we maintain a loyalty to our own narratives? I think about Jeff and Pete, married by the Sisters at the queer March on Washington. Maybe queer marriage is a fidelity to our queer lives, a commitment to standing with each other in the context of our communities and chosen families—and when we are lucky, as Lisa and I are, our families of origin. We hold with us our whole lives.

What if, when we say *marriage*, we do not mean the exclusion of all others but the insistence on holding each other close no matter what? What if, when we say, *'Til death do us part*, we know exactly what that means? This is the push-pull. The living and the dead. Maybe it isn't that I never thought I would get married. It's that I never thought I would live long enough to struggle with the question. And still, most nights I wake up in the dark, listening for Lisa's breathing next to me, holding my breath until I hear her, feel her warmth, *nothing can happen to you*, the endless mantra, still.

The flowers I'm holding are Japanese lantern flowers, those paper-thin, veined, bulb-shaped puffs of deep orange. They're the flowers of the Japanese Obon festival—the festival of the dead. And just a shade darker than the marigolds of Día de los Muertos, which we will wake up to the morning after our wedding.

I think of all the vows I've made, the stories I tell myself about having broken those vows, that I left Cory and Steven, failed them. I close my eyes and can see Cory shaking his head. It's an oversimplified story to say that I left him, I hear him scolding me. He also left. He found a husband and left

with him. And when they came back and he called for me, I was there. So maybe the story I tell myself is the wrong story. It isn't the fear that I'll leave, it's the fear of intolerable loss. Again and again. I close my eyes and see Cory, the ways we turned away from each other. But what if we weren't turning away from each other as much as turning toward? The story of leaving is also the story of staying, of expanding the circle of our families. That's the story of marriage in plague time.

The question of staying is the question of living through again. Of risking again the loss of the beloved. This is what we know from the ferocity of queer commitments. 'Til death do us part is a promise that we might make over and over. That risk. The pull between staying and leaving. It isn't frenetic and fast but a slow-moving deep pull like a tide. Like breath. We're standing in front of my parents, a few friends. We're in the balcony of San Francisco City Hall. The friend who is officiating, a former San Francisco Health Commissioner, is standing in front of us, in front of our family, talking about commitment. I don't know if I can bear it. And then I can't bear it. And then I can. That's the pull. The ambivalence isn't uncertainty or lack of feeling as much as it is an overwhelm and terror of loss. I want to stay in this moment forever. Like all the other moments I've wanted to stay in, holding on. I close my eyes and take a deep breath, and overlaid against the scrim of our lives, of the moment, is Steven, full of vitality, throwing his head back in his delighted laughter I haven't heard in fifteen years, saying, *Go date hot butches and come home and tell me all about it. Promise you'll tell me. Find one to marry and tell me everything. I'll be there with you, I promise.* And our officiant friend asking if we have rings to mark the moment of commitment. Lisa and I smile at each other, trying not to cry, and I take apart the set of slim silver stacking rings and slip one over her ring finger.

MARGINALIA 2008

September 18, 2008: first National HIV/AIDS Aging Aware-ness Day.

Proposition 8 passes in California, declaring marriage to be between one man and one woman.

WE DIDN'T KNOW if Pete would be well enough to come to the reunion dinner Judy planned. When Pete walks in, leaning on a cane, he is so lovely he takes my breath away. We light up when we see each other. I hug him lightly, too carefully to match the joy at our reunion. "I'm not that fragile, girl," he whispers, and then we hold each other as tightly as we can, his weight on me more than on his cane. We can't stop smiling, and I trace his face with my fingertips, his hands gripping my shoulders.

During dinner I sit across from Jeff, and he tells me he hadn't thought Pete would be well enough to come, but Pete refused to miss the night. I look at Pete, who is sitting next to Jeff and is deep in conversation with Lisa. I've lost track of what they're talking about, but they're laughing, and it feels like family. Robin is sitting on the other side of Lisa, joining in their conversation and chatting with Judy. Judy's cell phone rings, and it's Jansen, who is running late from work, stuck on the bus. He tells Judy to order dinner for him. "But what do you want?" she asks, and through the crackling phone I hear him say, "Whatever you're having, girl, just order me that."

It's been twenty years since the AB-101 rebellion. I have positioned myself at the table so I can watch our whole group as well as the crowd filling up the restaurant. The neighborhood has changed. It's whiter, less queer, and in the dimly lit space it's hard to tell if some of the pierced and tattooed folks lining the bar are queers from the old days or twenty-something hipsters who have migrated the few miles east from Hollywood and Beverly Hills. We're just a mile up Sunset Boulevard from the old ACT UP office, and a little farther up from Fuck! We're only a few blocks from Steven's house. We're only a few blocks from where Steven and I were pulled over by the LAPD.

During dinner Pete tells me what he's been up to. His body doesn't always allow him to be out in the world, and so digital activism has been good for him. He is obsessed with Twitter, talking with people all over the world. "It's so cool, girl! Talking with queers everywhere, and talking with young queers who don't know what's possible, who think they're alone, educating them, and learning from them about their lives, and if they can get messages to me then I can blast their messages to allies all over the world. We're not so alone anymore. Even when I'm in my apartment alone. I love it." He is beaming, telling me and Lisa all about it.

My attention is mostly on the sweetness of watching Lisa connect with Jeff and Pete, Robin and Judy at the table with us, and Jansen, having finally arrived, is hungry and digging into his dinner. But at some point I spot him.

Across the room, half in shadow, his back mostly turned toward me, so I can't see his face. Tattoos across his fingers, hands, wrists, continuing, I imagine, up his arms, which are covered by his black jacket. His tattoos stretch up his neck above the collar of his shirt and disappear into the dark hair of his closely clipped head. Thick gauges puncture both ears. All evening I am aware of him. His attention is mostly on his table of similarly tattooed and pierced men. At some point I notice him looking at our table. Occasionally I look over, his face still in shadow, and I let myself imagine that he is one of our friends from twenty years ago.

I miss men's bodies. Not sex, not exactly, but the intimacy of visceral knowledge. I cruise queer men when Lisa and I are out in the world. She's used to it. And I know I'm not the only one. I catch other dyke friends, even the ones who never fucked fags, who don't realize they're cruising, scanning rooms of men when we go out together. Or maybe we aren't cruising. Not exactly. Maybe we're searching the crowd for ghosts. We're not looking at the young, pretty men. Not the ones who are the age our friends were when they died, frozen in time. We're looking for the ones who are still alive, the beautiful aging bodies of men our dead friends might have grown up to become.

"Who are you watching?" Judy asks, noticing my gaze. "Just a ghost," I say, drinking more of my margarita.

Our dinner plates have been cleared from the table, but we're having another round of drinks, and no one wants to leave. We're migrating around the table, scooting in between each other so that everyone can talk quietly with everyone else. I sit next to Jeff. We hold hands and lean into each other, forehead to forehead. "How are you, really?" I ask.

He shrugs, looking over at Pete. "It's day by day, but today is better than sometimes."

"I miss you so much," I whisper. "I knew that, but I didn't feel how much."

"Me too," he says, and turns my left hand palm up in his hand and traces the lotus with his fingers. "I remember this."

I lean my head against his shoulder, and we watch our partners laughing with each other. "I don't want to lose you two again," I whisper.

"No. Let's not, then, lose each other again," he says back to me.

Pete and Lisa are teasing Judy, who is taking their photo. Pete looks over at us. "I love you," I say toward him, softly, and Pete, never subtle, laughs, full-bodied, delighted. "I love you too," full voice into the room.

A few minutes later, the ghost approaches our table. As he walks through a circle of light, and I see his face clearly, I start laughing. He is someone we knew twenty years earlier, and he is coming over to visit Pete, Jeff, and Judy.

As they chat, his face comes into focus, and I remember him from ACT UP meetings, though we never worked on projects together. I am still laughing a little after he leaves, and Jeff turns to me, eyebrows furrowed in question. I can't quite explain to him what happened. All I can say is, "There are still a few of us left, aren't there?" But we are so many decades into the plague now, and our hope is worn thin and precarious. He looks around the room, looking for other living ghosts who he cannot find before he settles his gaze back on our table, on Pete, on me. "A few of us," he concedes, "just a few."

When we say goodbye that night, we stand on the sidewalk in front of the restaurant for a long time. No one wants to leave. Pete looks tired, and he's swaying slightly, leaning on his cane. I stand next to him and put my arm around his waist, and he drapes his arm heavily across my shoulders. We promise we will see each other again soon.

But for the rest of the night, I toss and turn, not sleeping, even as Lisa sleeps deeply next to me, wondering what it means that I didn't recognize that beautiful punk fag from twenty years ago. That the specificity of his face blurred into the wide swath of narrative loss that permeates our days and nights. What else don't I recognize? Who else has become a signifier of loss instead of someone who is actually still here? Who else don't I remember even as I am haunted by such specific memories that I don't recognize the present?

◂▸

AFTER DINNER, PETE SENT ME a text telling me how much he loved Lisa, and how glad he was that we were back in touch, that we were still family as though no time had gone by. Then I signed back into the Twitter account that I hadn't looked at in over a year, just so I could follow him and see what he was up to. We tweeted global news at each other, and privately texted I love yous. It was almost the twenty-fifth anniversary of ACT UP, and we briefly wondered what kind of marker there should be. Judy and I wondered if we should have some sort of reunion, gather everyone together again. Pete wanted a big demonstration. As always, he wanted to get arrested.

Then I got busy.

Then Trayvon Martin, a Black teenager, unarmed and walking home in Florida from a convenience store where he had purchased iced tea and candy, was killed by a neighborhood-watch vigilante. Social media erupted with demonstrations and the renewed, outraged energy of tracking and protesting the deaths and beatings of young Black men. As the silhouette of his sweatshirt-hooded face became iconic to the moment in the justice movement, I couldn't not see Steven's hooded head walking toward me for our first afternoon date of coffee and Adrienne Rich's poetry.

Then Adrienne Rich died.

And I couldn't get Steven out of my vision. Every night in my sleep I saw his hooded head moving toward me, and I woke before he reached me. I started writing about how the connections between those things were living in me, about witnessing Steven navigating the intersection of racism and homophobia as we moved through the world. My rage and helplessness standing next to him. The way we all longed to save each other. Twenty-five years of ACT UP. So many things had changed. And so many things hadn't.

I texted and tweeted Pete. He didn't respond. He gets busy, I told myself. He vanishes when he doesn't feel well, I reminded myself. He'll come back, I reminded myself. He always does.

And still he didn't respond.

Lisa and I were home on Friday night. Tired from the week and scrolling through Netflix for a movie to watch after dinner. I picked up my phone and opened Facebook. A gorgeous photo of a smiling Pete on a carousel popped into the top of my feed. I smiled at the photo. *Hi, friend*, I whispered, brushing my index finger over the photo, which then blew it up on the screen, along

with the caption from Jeff. I stared and stared, trying to make the words make sense. "What's wrong?" Lisa looked up at me. I showed her my phone screen, and we both crumpled a little. I closed Facebook and put my phone down and paced the length of our living room. Then I picked my phone back up and opened up my speed dial and looked for the number. Then I took a deep, shaky breath and tapped Judy's name.

Pedro "Pete" Jimenez

1964–2012

PETE'S MEMORIAL WAS OUR ACT UP/LA twenty-fifth-anniversary gathering. We met in Plummer Park's Great Hall, where ACT UP meetings had been held. The ripple effect of Pete's memorial is that we are all connected again. No, less passive than that. We are all more aware of time passing. We fight for time with each other. We fight to reimagine dailiness even from different cities. Our phones ring more often. As many of our conversations begin with "Do you remember?" as begin with "How are you?"

Fifteen months after Pete's death, Mary and Nancy come to the Bay Area, where Lisa and I are living, to ride with the Dykes on Bikes contingent at the San Francisco Pride Parade. They have come over for dinner, and all evening we've laughed, grilling burgers, fresh corn, peppers, and piles of zucchini from the farmers' market. They're telling Lisa stories she hasn't ever heard from me, stories I've forgotten.

"Remember the balloon launcher?" Mary asks. Balloons filled with red paint were a way of disrupting AIDS-phobic and heterosexist billboards. If the balloons exploded just right—or even more advanced was the project of aiming a filled and tied-off latex glove so the fingers would also explode—a delicate balance of filling the latex to the perfect tension and aiming just right—the splatter pattern of the paint echoed the bloody red handprint graphics of ACT UP, updated too frequently, overlaid with THE GOVERNMENT HAS BLOOD ON ITS HANDS. ONE AIDS DEATH EVERY HALF HOUR. And then later iterations, THE GOVERNMENT HAS BLOOD ON ITS HANDS. ONE AIDS DEATH EVERY 10 MINUTES. And then ONE AIDS DEATH EVERY 5 MINUTES.

"Remember Halloween?" Mary asks.

"What year was that?" Nancy says.

I remember. It was 1991. Right after the AB-101 veto. The Agfay house hosted a Halloween party that brought together an intersection of Radical Faeries, ACT UPers, Queer Nationals, and Fuck! folks. Someone came into the house wearing a full leather hood that he wouldn't take off. Only small slits for vision and oxygen. I couldn't identify him. Neither could the faeries I was fluttering around the kitchen with. We couldn't figure out who he'd come in with. I'd felt my muscles tense, all of us on alert, thinking about how hard we tried to monitor the edges of meetings, demonstrations, and parties, keeping each other safe from undercover police and vice. As long as someone trustworthy could vouch for someone, we felt safe, whether we were or not. We watched, waiting for someone to vouch for the man in the hood. The Agfay house had an occasional dungeon in the basement. Including the

night of the party. One of the ACT UP fags who we did know walked past me and reached for my hand, leading me toward the dungeon. One of the faeries then grabbed my other hand and pulled me back, having just watched the hooded man walk down those stairs. The hooded man must have known people, must have slid easily into the dungeon fold. I never knew who he was. And I never made it down into the basement that night. Instead, we headed outside to the backyard, where the firepit was lit, illuminating the PLEASE FUCK SAFELY mural. Pete and Mel had come to the party dressed only in Queer Nation stickers and boots.

Mary laughs, lighting a cigarette. "Remember how long it took them to get those stickers off? All that glue!" Connie came in drag as a man, and no one recognized her. "How old would Connie be now?" I ask, and we're all quiet, doing the math and imagining the image.

"Let me see that tattoo," Mary says, pulling my arm to her.

"Which?" I ask.

"I remember that," she says, running her fingers across the lotus.

"Remember Ferd's arm?" I ask. "It was always excruciating to see that tattoo change."

Lisa furrows her eyebrows. Have I told her about Ferd and his arm? So we tell her about him. Ferd was the LA city AIDS coordinator and had been the director of Being Alive and helped Nancy start Women Alive. He'd worked to get a city state of emergency declared that led the way for the Clean Needles Now campaign to continue the needle-exchange program safely both for health and outreach workers and for clients. He'd also been a writer and performer at Highways and a collaborator of Robin's. He'd been close to Mary and Nancy, and I'd gotten to know him through Cory when he'd written for *Infected Faggot Perspectives*. His arm was tattooed with the names of his comrades. Every time someone died, their name was crossed out with a thick line through it. They were engraved into him, in living solidarity and again in death, the burn of the tattooist's ink sealing them into his skin.

"Ferd's tattoos," I say.

"Yeah. Ferd's tattoos," Mary says, still rubbing my lotus. Then she looks at my other arm. "What's that one?"

I hold out my right forearm, tattooed with two cranes flying together, the tattoo I got after Lisa and I got married.

We start talking about marriage. How ambivalent we all are, how they are thinking they should do it anyway, and how Lisa and I have done it anyway and been relieved to have the safety of the legal-bond shorthand when we

have had emergency trips to hospitals and doctors we don't know. "We could have a big party on the beach. What if all the couples who want to get married, or need to get married, can, and we can all renew our commitment to each other as family?"

"Just like the old days, those parties at our house," Nancy says. Then we're off again, telling stories of parties at their house in Venice, which was one of the gathering spaces for ACT UP. "Last party I remember at the house was the ACT UP reunion in 2000."

The summer of 2000 had been a summer of presidential conventions. At the Democratic Convention, Susan had been a part of the organizing core of the Convergence Center, a headquarters of organizing in downtown Los Angeles that had housed workshop spaces for giant puppets and banners, rooms for civil disobedience training, legal-observer training, union and labor organizing, and childcare for people organizing. The center had been raided by the police multiple times in the days leading into and during the convention. On the East Coast, Kate had been arrested at the Republican Convention in Philadelphia and held on $1 million bail. She was charged with inciting a riot and imprisoned for ten days before finally being released. The legal battles and organizing around the activists arrested in Philadelphia would go on for a year.

In the midst of the organizing frenzy, Mary and Nancy hosted an ACT UP reunion party. We'd hung out in the hot sun of the front yard, the first time I'd been in that yard since Cory had come home to die.

"Right." I smile to myself, remembering. "That party."

Mary shakes her head at me. "No."

"What?" I feign innocence, and Nancy laughs, then tells Lisa the story about their butch friend who used to roar into town on her motorcycle, staying with Mary and Nancy, flirting with everyone at parties and demonstrations, where she yelled the loudest, irritating some of our friends but always making me laugh. She earned my respect, and my attention, with her fearless rodeo-clown approach to the police that kept Pete and Cory, much to their annoyance, from getting beaten and arrested more than once. Finally, one summer she and I made plans to spend an afternoon alone together. We were shirtless, flirting, sunbathing in the yard when Mary came home from work early and yelled at her (eventually I would learn that this was a frequent lecture) that I was off-limits.

"Why exactly was I off-limits?" Now I am just teasing Mary, remembering the feel of her mama-bear protectiveness.

"Just no. You just were off-limits. You were so young."

"But Mare, come on, you know I was in my twenties by then. You forget that I wasn't sixteen the whole time."

"It doesn't matter. We didn't have control over much. But there were a few things I still had control over. And you were . . . I don't know . . . but protecting you mattered."

"I was the canary, you mean," I say. "As long as I was OK, then there was hope."

Mary and Nancy both shrug, Mary's fingers still tracing my tattoos, Lisa and Nancy smiling at each other across the patio table and lovingly rolling their eyes at the endlessly rehashed conversation.

"Well"—I pick up where we have veered off course—"I still think you should get married. And I want to be your witness," I say.

We go into the house and turn on the TV while we clean up dinner. The news is filled with a global vigil: Nelson Mandela has been hospitalized, and the world is preparing for his death. We watch a few minutes, then turn it off to tell our own stories of where we were when he was released, when he came to the United States for the first time, when he was elected. Susan and I and our Student Coalition crew had been part of a collective of organizations in Los Angeles putting together a march, led by young people from across multiple communities in Los Angeles, to the Coliseum, where Mandela would speak. It was some of the most difficult cross-community organizing we had ever done, and throughout it we kept thinking about Mandela in Robben Island Prison, talking about forgiveness and curiosity, about the systems of power and oppression that keep everyone imprisoned. There are so many things I don't know if I could forgive. In others. In myself. Lisa makes a pot a tea and brings it to the table. We toast to Mandela. We toast to revolution and persistence and the possibilities of forgiveness.

Mary walks back through the dining room toward the kitchen. She pauses at the dining room wall to look at the photo of me and Cory that Sonia took all those summers ago in Elysian Park. We hadn't, in that moment, known she was shooting. I had just agreed to give him the pills. Cory stands behind me with his arms around me and his chin resting on the top of my head. My head is tipped down, and I'm looking down. He looks forward into an uncertain distance. "Beautiful, you two. So long ago." Mary stands and stares. "You will tell the story, right? Write that story."

"Yeah, someday," I say. "I sort of am. I'm trying. In bits and pieces."

"No, tell the whole story. In one place. It's a love story, tell the whole thing."

Nancy goes outside into the backyard to smoke. I walk out and sit on the stone bench next to her. It's dark. We can see into the lit kitchen, where Lisa and Mary are cutting up strawberries and peaches for dessert. We can't hear what they're saying, but they're leaning into each other, smiling. Nancy takes my hand in hers. My shoulder clicks and crunches as I rotate my neck and lean my head on her shoulder. It's almost like being back on the patio at Being Alive.

I think about all of the things we've tried to protect each other from, the things they've protected me from, the ways we tried to throw our bodies between each other and danger. The ways we couldn't protect each other but continue to bear witness to each other. The ways Nancy has borne witness to me, even when she hasn't known it. The way she sat with me after the cop tried to run me off the road. The way we sat together when Cory came home to die. The way we still sit together. I squeeze Nancy's hand, and she squeezes my hand harder.

Mary calls us from the doorway: "It's cold out here. Come inside." And as we walk in, Mary puts her arm around me. "It is a love story," she says. "Tell the whole thing."

"What, me and Cory? Or all of us?"

Mary smiles and shrugs. "Just tell the story. The whole story," she says, again.

▴

THERE IS A STATE-DEPENDENT embodied memory of intimacy. With queer family my body changes shape. I feel the S curve of my spine exaggerate, pelvis tip, my shoulders loosen in their sockets. Body opening and closing like a slow blink.

We need to make meaning with each other. Of each other. We make symbols of each other's bodies in order to know our bodies in relationship. Love in the context of annihilation becomes weighted with something more than love. We expected to save each other by surviving. *We do not always survive intact* (the bastardization of the Judith Butler quote that haunts me in the original: "One does not always stay intact").[2] We do not always survive.

I reread Terrence Des Pres and wonder if we have abandoned them by surviving, by moving into a future without them. Is this the grief that keeps us frozen, remembering, uncertain of building futures in which they do not exist? And then Tony Kushner again in my head, Harper at the end of *Perestroika*: "Nothing's lost forever. In this world, there's a kind of painful progress. Longing for what we've left behind, and dreaming ahead."[3]

The movement from violence to repair isn't erasure. My skin carries the map engraved on it. We tell the story through breath and movement.

Ron has developed a bodywork practice in addition to his performance practices. I lie on his table, and his forearm leans heavily into the frozen muscles around my scapula. When he turns me over, his fingers press hard and precise, untangling the scar tissue strangling the nerves of my shoulders. His breath reminds me to breathe as he separates the tissue and adhesions, bringing feeling back to the numb places. I surrender to his hands and his breath as the room tilts and spins. I'll have his fingerprint bruises for a week, and the sound of his voice pushing me toward the deeper breath.

Lisa ruptures her Achilles tendon and needs surgery to repair and reattach it. In the mellow little outpatient surgery center, she lies on a table partially separated from the rest of the room and the rest of the surgical patients by hanging curtains. The nurse comes to check her vital signs and hook her up to a blood oxygen monitor. We're chatting together, laughing a little with the nurse, who Lisa has charmed. The anesthesiologist comes in. He's rough

with her arm as he inserts the IV into her hand. Blood spurts out of her hand and drips onto the floor. The nurse cleans it up, puts on a new set of gloves, and hands gauze to the anesthesiologist. I'm watching Lisa's face for signs that he's crossed a line and is too rough and I need to intervene. Finally, the line is in, and she begins to drift into twilight sleep. The nurse walks away, pulling off the gloves, to check on another patient. Lisa takes a deep breath, and her hand starts bleeding again around the IV. I take gauze from the package the nurse has left and wipe the blood from her hand. She's half asleep. The nurse comes back over to us, putting on new gloves and looking over my shoulder. She catches my eye and nods toward the gloves. My hands already have blood on them. I shake my head no. Lisa's hand stops bleeding. She wakes a little. "What?" "Nothing, honey. You feeling OK?"

"Sleepy."

"OK, sleep then." And she drifts off. Her breathing slows and shallows, and I watch the blood oxygen machine as her stats lower and the numbers turn red. A low alarm sounds. I feel my breathing speed up, and I put my hand on her chest. "Take a deep breath, honey."

In her sleep state she takes a deeper breath, and the numbers rise. I keep one hand on her chest, and my eyes move back and forth between her face and the monitor. Every time it dips, the alarm sounds, and I say it again, *Breathe.*

The nurse comes back over, having watched from the other side of the room. "She's OK. It's OK if it drops, she's not in any danger, just feeling the anesthesia."

And still. I watch the rise and fall of her deep breathing, counting the space between breaths.

After they roll her into surgery, I wait in the little quiet waiting room, shaking, trying not to panic, hearing the alarms echoing in my head. I text back and forth with Jeff and Nancy.

I'm worried.

She'll be fine.

I know. But I'm scared.

I promise it will be OK.

I know. But that alarm. So familiar. And I had forgotten.

I know. I love you both.

Nothing can happen.

It will be OK.

Let me know when she's out.

I love you.

I love you.

When Lisa wakes up from surgery, she wants lunch from the bagel shop across the street.

MARGINALIA 2012

FDA approves PrEP, pre-exposure prophylaxis, a cocktail of AIDS medications taken by an HIV-negative person that keeps them from contracting HIV if exposed through sexual contact.

A study shows that one-quarter of Americans do not know they cannot contract HIV from a drinking glass. This is the same percentage as in 1987.

on archives

I WALK INTO A ROOM in the Guggenheim during the retrospective exhibit of Catherine Opie's photography and am faced with larger-than-life photos of Ron Athey. The prints are nine feet tall. Opie took the large-format Polaroid series of Ron in 2000 in a room-sized photographic chamber. Poses were held perfectly still for several minutes as the film developed.

The photos are majestic. Most of the images are moments distilled from Ron's performances. Images that in performance would have been part of a fluid movement. Motion. Response. Dialectical interaction. In photographed form, they are now stillness. And the stillness is an amplification, calling attention to the frozen, fractured, perfect moment. Movement implied but not enacted.

I'm moving between the images, remembering him at Fuck!, at Highways, performing some of those images. What does it mean to see them static? As with being in the presence of Ron in action, I become aware of my body, my breath shallow, and I slow to deepen each breath. Moving through the space to watch him.

In one of the photos, Athey's longtime collaborator Divinity Fudge (Darryl Carlton) sits naked, straddling a chair, leaning his body forward over the back of the chair so that his exposed back faces the camera. Athey stands in front of him, his left hand resting on Divinity's shoulder. In his right hand, a scalpel that etches into Divinity's back. Athey's head is tipped down, all his focus on his action, so we can't see his eyes, just the top of his brow furrowed

in concentration. There are a few drops of blood dripping down Divinity's back and onto the floor under him.

This photo is a reenactment of a scene called "Human Printing Press," which was part of the performance *4 Scenes in a Harsh Life*. In 1994 Athey and a few of his collaborators performed the "Human Printing Press" at the Walker Art Center in Minneapolis. In the scene Athey cuts patterns in Divinity's back with a scalpel, then blots the blood with absorbent towels. The towels are strung on a laundry line through the theater.

A theater critic who was not at the show wrote a story that the audience was in danger, that AIDS-tainted blood was dripping through the theater, and that audience members had left in a panic. In fact, none of the critics who were invited to the show attended. And no audience members left, panicked or otherwise. Many stayed for a nuanced postshow conversation with the artists. But the article was used by Senator Jesse Helms and other Republicans to fuel their fight to demonize art in general, queer embodied art in particular, and defund the National Endowment for the Arts—though Athey had never been the direct recipient of a grant from them. Athey's name and reputation were vilified by Helms on the Senate floor, and it would be a decade before he performed a full-length finished work in the United States again.

By slowing the "Human Printing Press" into a distilled moment, Athey, Divinity Fudge, and Opie re-create the precision of Athey's handling of the scalpel. In performance he wore gloves. Athey's hands are bare in the photo. Divinity's and Athey's bodies are balanced and supported by each other in the deeply intimate, ritual scene. The photograph is an enactment, and a subversion—hanging the scene that had fed into the culture wars of the 1990s on the walls of the Guggenheim.

I'm smiling a little, laughing at my fantasy of the Guggenheim's and Opie's *Fuck you* to Helms, the larger-than-life Ron Athey and his delicate and deliberate bleeding on the walls of a major museum fifteen years after he was blacklisted. (And six months after Helms's death.)

In another photo distilled from the performance, Divinity Fudge cradles a limp and mortally wounded Athey in his arms. The intimacy of the photos takes my breath away. Different from the adrenaline roiling of feelings at a performance of constantly increasing affective amplification and transitional time and space, the stillness of the images allows me—forces me—to stay with the feeling and intimacy of one piece at a time. One moment at a time.

Absorbed by the photos, my breath catches, and for a moment I feel Steven's hands against my diaphragm, the way he knew how to transform breath to feeling through the vibration of sound and echo, and I am aware of the

viscera of absence. (In one giant Polaroid the deep velvet of Leigh Bowery's gown drapes over a chair, empty of body.)

In *Ron Athey/Suicide Bed*, Athey lies on gold fabric on a platform, the camera's focus on his raised left arm with hypodermic needles attached to syringes puncturing his arm from shoulder to wrist. The lower half of his body is slightly out of focus. I stand quietly in front of the photograph. Other people in the gallery are pausing at this photo. I become aware of two of them glancing at me. I realize that my sense of relationship to these pieces is apparent—not specific—but some ease implied in a gallery of photos where it is difficult to find ease. People are glancing at each other looking for recognizable responses. I feel visible. My queerness visible in my stance toward this difficult work.

Being watched. What does it mean to tolerate or not tolerate the intimacy of exposure? The exposure of a photo. The exposure of relationship to form and subject. The relationship to light. Being watched because people in the gallery are looking for anywhere to look other than Athey. And looking for cues about how to feel.

For whom do we perform? There is a man standing in front of the photo, alone. Perfectly still. I look at his face and see tears slipping down his cheeks. I look again. Thick piercings in his ears, a bit of black ink visible on his wrist below the ribbed cuff of his charcoal sweater. He looks over at me, and for a moment our eyes make contact. Watching each other watch. Then we turn away again. Startled in our seenness.

In *On Photography*, Susan Sontag writes: "Photography is an elegiac art, a twilight art. Most subjects photographed are, just by virtue of being photographed, touched with pathos. An ugly or grotesque subject may be moving because it has been dignified by the attention of the photographer. A beautiful subject can be the object of rueful feelings, because it has aged or decayed or no longer exists. All photographs are memento mori. To take a photograph is to participate in another person's (or thing's) mortality, vulnerability, mutability."[1]

Opie's photos are a queer wartime photography, capturing within it the acuity and breathtaking ache of intimacy. What does it mean to still the action? To freeze us into moments of realizing what we made, what we loved. What we might still lose.

In 1996 filmmaker Catherine Gund made a documentary about Ron, *Hallelujah! Ron Athey: A Story of Deliverance*. The film follows Athey and his performance troupe, which included Opie, on tour in Mexico and Croatia, where they performed Athey's *Deliverance*, which ends with Athey and two

others buried under dirt onstage, other performers/gravediggers bleeding onstage around them. Athey reflects on the time and performance, and conversations with Croatian artists: "They realized atrocity is atrocity. They've been through something very real and immediate. It's predictable how they pictured a group burial. That's their reality. Their friends are buried in group graves and communal graves. It's very immediately heavy for them. They have this heavy black cloud over them. They were a pretty young audience and they're just grabbing for something."[2]

And then toward the end of the documentary, the tone of the interviews with Athey's troupe changes slightly, and it sounds as though they are reflecting (asked to reflect?) on Athey's legacy. Athey has been seropositive since 1984, and when the documentary was made, no one was assumed to survive. The reflection is a preparation for a loss that has not (yet) come.

▶

JEFF, JANSEN, AND I GO to the opening reception for *Fuck! Loss, Desire, Pleasure*, a 2016 retrospective exhibit of photos and ephemera from Fuck! Cocurated by Toro Castaño, who had been a card-carrying member of Fuck! (yes, that was a literal thing), the exhibit also brings into dialog with Fuck! contemporary queer HIV-positive artists working with blood, bodies, and performance.

A sign on the gallery door says, "Tonight's performance includes piercing and blood which may not be suitable for all audiences." Part of me rolls my eyes at the sign. Part of me is thinking that it might have been a good deterrent to cultural tourists years ago.

Now here we are, walking through the packed upper balcony looking at photos on the wall, hugging and kissing old friends, and looking around at faces familiar and unknown. Jeff stops us and stands still, staring at a photo, unspeaking. He points. On a wall in a sequence of photos, Cory's face in profile, along with musician Robert Woods and Fuck! founders James Stone and Miguel Beristain. All of them now dead. I remember the last time I saw James Stone.

One Sunday night at Fuck!, Cory and I were wandering through the crowd, and a face stood out. White. Mid-twenties. Male. Short-cropped hair. Jeans and white T-shirt covering a compact, muscled body. He could have just blended in. He could have just been one of the straight people who were starting to come to the club to gawk. He could have been harmless. But something about his stance made us stop and watch. Uneasiness. Tension in the turn of his head watching bodies move around him. He looked familiar. Or maybe only his stance of edgy observation looked familiar—that way we didn't know if he would settle into ease or revulsion. Cory and I looked at each other. *Cop?* I can't remember which one of us asked it. Whispered it to the other. We nodded, alert to the possibility. Cory maneuvered and caught James's eye, tilting his head toward the unknown man. James followed with his eyes, a slight nod back. So used to surveillance and defense and guarding against the need to hide in this space, which was exactly the relief from that impulse. It was also my cue to leave. I was still under legal age to be in the club. I was careful. I never drank at the club, and I stayed in the company of people I already knew, going out of my way not to capture attention. I wasn't worrying about my safety but worried about the implications for everyone else if I was rounded up in a raid. Cory and I maneuvered our way to the door, Cory always blocking the direct line of sight between me and the presumptive

cop. The presumptive other. Then out the door and back to my car, where we kissed good night. He waited for me to start my car. Then I waited, watching him reenter the club, before I drove home.

I had already left LA in the spring of 1993, when LAPD's vice unit raided Fuck! and shut it down on grounds of obscenity and lewd conduct, ending the life of the club.

I wonder when I had put people at risk by my presence. Where had I been a liability? Where had they made space for me anyway? Cory was always willing to take risks to insist on my presence. To pass on the responsibility of community to me. He depended on the idea of me as memory, and I depended on him to allow me to witness, to become a part of. To belong.

Before leaving the exhibit, Jeff, Jansen, and I circle back to see Cory on the gallery wall one more time. When I look at the photo label on the wall, it says, "Unknown individual, Robert Woods, James Stone, and Miguel Beristain inside the DJ booth at Fuck! c. early 1990s."

Unknown individual.

I feel my breath catch. The three of us stare. We're surrounded by people, and we're the only ones noticing, as people read the labels, taking in the information as though it is all the information that exists, marking a past, marking who was there, who is left, and who is gone. As the whole story. What do we do when the past pulled toward the present is an erasure?

A few days later Jeff texts me a photo of the label. He has gone back, spent time with Toro, filling in the spaces. *Unknown individual* is now crossed out, replaced with Cory's name in Toro's handwriting. Now the label marks both the difficulty of documentation and the importance of correction. This is why we need to remember together. This is what happens when we don't.

SOMEONE WHO HADN'T KNOWN Cory stands next to me looking at one of Cory's shrouds and asks, "He had AIDS, right?" And suddenly I don't know how to answer the question, stumbling over tense. Cory is dead. His blood is on the canvas laid out in front of us. Is it still infected? Does his blood still have AIDS? Epidemiologically, I know it isn't infectious, but symbolically? Is it just symbolic of his body, or is it still a part of his actual body? Does the outline of his body made from his blood on the canvas in front of us still carry the virus in its cellular structure? If it does, does that mean that Cory is still here?

▲▼

WE'RE HAVING ANOTHER WINTER reunion in LA. Just past the new year, we're gathered. Fifteen of us at a long table. We take up the whole wall of one side of the restaurant.

I look down one end of the table to Judy, where she's talking with Tae and fiddling with her camera. Next to me, Lisa is deep in conversation with Robin, now a rabbi at a local synagogue. Mary and Nancy are across from us, Jeff and Jansen at the other end. My chest vacillates between the tightness of panic and the open sweetness of love. *Nothing can happen.* My old, familiar mantra, my universal plea, repeating in my head over and over long before I realize it. *Memorize this night. Keep them safe. Nothing can happen to them. Nothing else.*

Nancy looks at me across the table. She recognizes the look on my face. We'd seen it on Jeff, watching Pete, and I've seen it on her face, sometimes, watching Mary. Nancy holds my gaze, smiling, then intentionally looking down one end of the table—Judy, Robin, Lisa, Wendell—then the other end, Jeff, Jansen, Mary, Tae, Christian. Then back at me. She nods. I nod back. She takes a deep breath. I take a deep breath, mirroring her. Still here. We're all still here. Tonight, we take none of it for granted.

We all keep our phones in easy reach, snapping photos as the night wears on. And Judy with her new camera, moving around the table to get the best light, making sure we have documentation. She thinks her documentation will be just for us, but it's been almost fifteen years since *Loud, Proud, and Pissed*, and quietly Jeff and I start talking about the idea of another retrospective of our queer kinships. *See, we were here. See, we're still here.*

The restaurant isn't one that was here years ago, when we all used to gather. We're in downtown LA, miles from the old ACT UP office, and even farther from West Hollywood's Plummer Park. This place has never been occupied by our ghosts. Jeff is the one who found it for us, and the walls are hung with local art. Later, when I look at the photos from the night, I'll notice the paintings hanging over Nancy's and Wendell's heads as they talked. Two separate, discrete paintings, but a pair, next to each other. In one, a man sits and holds a skull in his hands. In the other, a woman with long hair and a long, white dress sits with a skull held gently in her lap. I stare and stare at the photo, the woman and the skull hovering over Nancy.

Halfway through dinner, we're giddy. We're up and down out of our seats in musical chairs so we can each visit with everyone, nibbling from each other's plates and nudging each other aside with our hips to make room on

the bench along the table. I scoot in between Jansen and Jeff. Jansen hands me his drink. I eye it suspiciously, a bright slice of jalapeño floating on an ice cube. The drink is sweet, pineapple bursting on my tongue, and then a moment later the burn of the pepper lighting my mouth on fire. I laugh and hand it back. "Damn, girl. Your signature drink? All nice and sweet at first, then it bites you in the lip?" I reach for Jansen's water glass to wash away the heat. We can't stop laughing.

After dinner, we pose on the patio for a group photo. And then we stay on the patio, even in the January chill, talking in clusters, our arms entwined, fingers reaching for each other. The restaurant closes, and we migrate from the patio to the parking lot. Still not leaving. No one wants to leave first.

Finally, people start to peel off, saying good night. Jeff starts to leave, and I grab for him again and hug him closer. I can feel my shoulders click a little as I wrap my arms around his neck. I hold him, not letting go. He holds me closer. Then he loosens his grip, laughs at me. "I'll see you tomorrow for lunch. I promise." "I know." *Nothing can happen. . . .* But I hug him one more time, another minute longer, still not letting go.

(Wisława Szymborska in my head: *Listen, how quickly your heart is beating in me. . . .*[3])

I get a little lost driving home from the restaurant. Lisa and I hold hands in the car as we loop through downtown and I point out our queer landmarks. Parker Center, the home base of the LAPD, where I went to pick up Wayne after he was released from police custody after disrupting the red carpet of the Academy Awards. He paced and smoked a cigarette on the sidewalk before getting into my car. I could see uniformed police still watching him, his long hair and beard and bright neon Queer Nation stickers glowing against his chest in the dark evening. I held open the car door: "Get in. Now." Wayne: "Is the demonstration still happening? Can we go back?" And the downtown Federal Building, where I had been arrested on the anniversary of the assassination of the nuns and their housekeeper and her daughter in El Salvador, and then later Susan and I had been arrested during the first Gulf War, police batons coming at us from behind, and Radical Faeries in tulle visible in the crowd in front of us, giving me strength months before I came to know them. So many years ago. Now more wars brew, and the front of the Federal Building is dark, though I know there are guards right inside the door. Just out of our sight.

The next afternoon, I hug Jeff hello as though we have not just left each other twelve hours earlier. The ghosts have vanished. The bright California winter sun casts a halo around his head. Jeff and I imagine what might have happened if they had lived. If Cory and Steven had lived just a little bit longer, they would have made it to the cocktail. Maybe it wouldn't have been magic. It didn't save Pete, even though it gave him another decade. Maybe it wouldn't have saved them either, two radical queer men of color, and of course we don't know whether they would have had access to the drugs, but for a moment, in our fantasy, they would have. And they would have been saved. Would we have stayed with each other, all of us? Would Cory still be living somewhere in Europe with his husband? Making art from blood and piss and fury? Would we have stayed in each other's lives, writing love notes of bodies and art projects from across oceans, or maybe switching to email and then text so that we didn't lose weeks in the translation of pages over air and water, delivered by mail carrier so that we came home and eagerly checked our mailboxes for each other's barely legible scrawl? Would I have found my way back to Steven? Would I finally have written back, saying, "I'm here, love, and I need you"? I like to think that we would have found our way back, all of us. Because those of us who are still here have found our way back.

We make talismans of each other's bodies. Still. My fingers brush against the stubble on Jeff's cheeks. He plays with my wedding rings as we talk and hold hands across the table, then turns my arm so my palm faces up and he traces the petals of the lotus with his fingers.

We talk about all the things we weren't able to do, haven't done yet. What it means that we now strive toward them in the absence of our beloveds. That queer time and place without them is not the queerness we had dreamed of. And might it ever be? Or has the fantasy of our particular queerness vanished as they have vanished? Queerness has not yet come. Can it be both foreclosed by their absence and still possible in our own embodiments, even with (or because of) those spaces once occupied by the bodies of those we loved? Jose Esteban Muñoz writes: "Queerness is not yet here. Queerness is an ideality. Put another way, we may never touch queerness, but we can feel it as the warm illumination of a horizon imbued with potentiality."[4]

In Queer Nation we insisted that queerness is a constant state of becoming. And it still feels true. And also untrue. Because what if it has arrived, in fragmented moments of possibility? What if queerness is a volatile, ever-shifting state defined by, or recognized by, our attachments to each other, the love and furious devotion that keeps us coming back, fighting and longing and remembering and building context after context in which we can hold each

other close, in spite of the instability of bodies, time, and memory? What if this is it, these flash-bangs, the illuminated moments where we find each other? Maybe this is the future. Our queer future. Maybe this is what we get if we pay the right kind of attention. Maybe we're here. Maybe it only lasts for a second. And if we look just right, sometimes the second echoes back. And again.

After lunch Jeff walks me back to my car. We say our ritual *I love you* to each other, not letting it go unsaid, but we hold the goodbye lightly. His work will bring him to Berkeley soon, and we promise a brunch date when it does.

I start driving back across town but veer left at the corner of Sunset and Fountain, wind my way through the neighborhood. I drive through the intersection where Steven and I were stopped during the rebellion. I park my car in front of Steven's old house and stare at the quiet lawn, the shaded porch. I know that when I get home to my parents' house, Lisa will be hanging out with my mother in the kitchen, making dinner from the last of the winter tomatoes and arugula from my uncle's garden. My mother's Manzanar paintings are visible from the dining room table. My father and his composing partner will be in the studio sketching out new tunes for the next gig, maybe the next album. We'll open a bottle of champagne with dinner and toast to their anniversary—fifty years of making music together. Who gets fifty years? If Lisa and I are very lucky, we will get to fifty years as a couple. If Jeff and Mary and Nancy and I are lucky, we will get to fifty years as chosen family. But most of our friends haven't and won't.

I postpone that homecoming just a few more minutes, sitting in front of the house that is no longer Steven's, twisting my wedding rings around my finger. The wide porch is empty, shaded, and I know the concrete is cold, the winter sun already sunk behind the next hill. It will be dark soon. I dig around in the bag of CDs until I find what I'm looking for, and Ella Fitzgerald fills the car singing about the cold night and the man who got away. Reluctantly, I start the car.

DOWN IN MY PARENTS' BASEMENT, stacked alongside my mother's paintings, Cory's *Heteros* is tightly covered and leaning against the back wall. Even covered, I know where the bodies are. Standing in front of it, I feel them through the sheets and tarp. And I think now that there may be another way to see it.

Cory saw it as the man inevitably pushing her. She's falling because of him, even as he reaches for her. He could never tell if the reach was benign or malicious, conscious or unconscious. But what if she was falling anyway? What if he is only reaching toward, to pull up, or what if he is falling next to, simultaneous, not causal, and has nothing to do with her descent?

I look at the wall, and for a moment I can see it. I was going to fall anyway. He reached out a hand. I couldn't take it. I know it isn't the only truth. But just for a moment I hold the possibility of that story.

The woman is falling back. The man is falling toward her. The image, the movement, approximates something like our relationship to each other's bodies. For him, my uninfected body was not just symbolic but an actual experience of stability, of longevity, of a permanence that would both outlast him and memorialize him. For me, his body was the symbol and the experience of decay, of bloodletting and resistance, of weakening and then waking up again, of the perpetual cusp—losing, always the risk, the threat of loss we lived with and he lived within, until the actual, nonsymbolic, embodied loss.

In *Mourning Sex: Performing Public Memories*, Peggy Phelan writes: "I am investigating, in *Mourning Sex*, the possibility that something substantial can be made from the outline left after the body has disappeared. My hunch is that the affective outline of what we've lost might bring us closer to the bodies we want still to touch than the restored illustration can. Or at least the hollow of the outline might allow us to understand more deeply why we long to hold bodies that are gone."[5]

I worry, sometimes, about my tendency toward nostalgia and sentimentality. That's the voice of futurity anxiety, isn't it? We're supposed to move forward. And yet can't we reclaim queer sentimentality and nostalgia in our narratives as a linguistic signifier of tenderness and embodied resistance to annihilation?

I ask Jorge this, and he writes back, "Allergies to longing for the past, or allergies to 'excessive emotion,' are just ways that white supremacy polices us, telling us that it's wrong to be us."

And maybe, then, homonormativity is a (misguided—as though we could ever be protected, insulated) defense against the relentless experience of queer loss and powerlessness.

Cory and Steven lived their art and their bodies moving through the world as an act of resistance against the forces of assimilation and normativity—homo, hetero, white, gendered—which would demand a narrowing and erasure of the complexity of experience. How do we tell the stories now? I long for them to help me. See, there it is again. That longing.

AND, OF COURSE, we didn't all die. Jeff and I have dinner in Little Tokyo in the shadow of the Japanese American National Museum, before we go see Ron perform new work at a nearby space in downtown LA.

In her book *Hold It Against Me: Difficulty and Emotion in Contemporary Art*, Jennifer Doyle writes about Ron Athey: "Blood and sex may be the subjects of the controversy around Athey's work, but neither, taken in isolation, makes the work difficult for his audiences. People are anxious about what is going to happen at an Athey performance—not to him, but to *them*. Athey developed his signature blood-work pieces in the midst of the AIDS crisis. The protocols of safer sex as well as the medical handling of the sick body are sometimes as much a part of his performances as are sadomasochistic practices."[6]

Ron has set up this performance to begin as the audience walks into the space, and so for over an hour Jeff and I stand outside, waiting for the doors to open, watching the crowd gather. Some people we recognize from fifteen years ago, or twenty-five. Some of them look young enough to have been born just on the cusp of the moment we began to imagine survival. We greet a few friends from Fuck! and ACT UP as we all wait, restlessly, for the doors to open.

As the performance begins and Jeff and I watch Ron's new work unfold in a gallery curated by Doyle, I think it may be not only that people are anxious about what may happen to them at an Athey performance but that those of us who have been witnessing Ron—and each other—for more than two decades turn to difficult art, including Ron, to understand what has *already* happened to us. And we are afraid of what we will recognize in reflection. It isn't narrative or narration, isn't story arc and parable, but it isn't simply symbolic either.

Ron performs through a fever-dream state, speaking in tongues as we have heard him do so many times. And still the eerie, almost-familiar-but-not-quite-predicable sounds make the hair stand up on the back of my neck and my breath catch. He and his collaborators move through the space filled with people. No one is bleeding, but still, it is almost as uncontained as the performances years ago at Fuck!

"Real things happen, instead of pretending that they're happening," Ron has said when we've talked about body-based (plague) performance art. Choreography isn't the same thing as control or prediction. The affective experience is filtered through each of our stories, associations, bodily experiences moving through the world.

In his last years, Cory began performing the ritual of painting his shrouds in front of audiences. In gallery spaces he would draw blood from his model/subject, thin the blood, paint the subject's body, and imprint them onto a shroud. Not the blood draw of a sterile medical procedure but the performance of ritual. The intimacy of documentation and a promise of remembrance. Marking the audience as witnesses now responsible for memory. As though they were the now-marked shroud.

In the last section of Ron's new work, dancers move across a scrim laid over the concrete floor. Watching their slow, deliberate movements, I think of Butoh, and the way hypercontrolled movement and meditative slowness invoke a kind of nonnarrative affect of extremity. Back and forth from one end of the room, where their bodies are anointed in paint by Divinity Fudge, who, in echo of earlier performances, is pierced and laced with crystals, to an opposite wall, which has been covered with clean white canvas. Their bodies are paintbrushes across the blank space, thickening it with color. At once gorgeous and grotesque, their faces distorted by paint, feeling an abstraction left on the canvas with the thud and thump of bodies against the wall. Again and again. By the end of the performance, the audience members closest to the dancers are flecked with paint. I feel the hovering questions of death, of expression and desire and sex. I associate to the tension between longing and despair. But maybe it's only me. Maybe it's only my association.

What would Cory's art look like now?

In a description of Ron's work *Incorruptible Flesh: Dissociative Sparkle*, Doyle writes: "Athey not only exaggerates the social vulnerability of his body; he overtly eroticizes it. It's not mystical. It's a carnal refusal to turn one's eye to the heavens, an insistence on both the magic and the banality of flesh."[7]

What our conscious narrative construction wants to forget, our bodies remember. Feelings, sensation/memory insistent and demanding. I watch Ron perform, and as sweat or tears run down his face, down the contours of his chest (which are so different from the shape of Cory—but in that moment the symbolic function overrides the literality of bodily shape in favor of somatic formulation, echo, and resonance), I am reminded of—no—not reminded but living through again—Ron so many years ago, blood carving rivulets down his legs and chest, and Cory, at once wounded, focused, blood dripping down his furious and tender body, daring us to follow to the edge of his experience, to witness the somaticized talk-story.

And now, if Ron sees me respond, tears in my eyes, memory etched on my face, does it matter that I am responding not only to him in current time but/and also to a Ron from over two decades ago, a differently fierce bodily shape and memory, a different internal meaning for him, that we straddle multiple times and places together, those of us who are here, still? Those of us who remember. And when we forget, we are reminded by our own relentless sensory cues.

How do we give language to the experiences that we lived through and that have no prior narrative context within our embodied lifetimes from which to cull language? Only the sense memory of impending traumatic loss and the need to hold on.

The morning after his performance, Ron and I sit in uncomfortable chairs at a conference about live art and archive. We're easy with each other, shoulder to shoulder, body-stories familiar. We're cuing each other, giggling a little in our fatigue, whispering call-and-response to each other as questions are raised about the problem of context and archiving, which is really the problem of translating embodied experience beyond the moment of first feeling. The unarticulated, ephemeral recognition. My hand across Ron's back, my fingers automatically feeling for tightness at the intersection of his trapezius and rhomboid muscles, the curve of his ribs. He takes a deep breath, postperformance landing. I hook the side of my thumb under the sharp spine of his scapula, feeling the twitch and slow spasm of muscle fibers letting go. We both breathe. What year is it? The body is and is not an archive. The body is an updated site of remembrance when we never thought we would move forward into another now.

Ron pushes my hair away from the side of my face to whisper in my ear, and I try not to laugh out loud. My hand softening against his warm back. *This time. This place.* I close my eyes and am lost in time. I open them and see Ron's tattooed hand next to mine, and I am only slightly less lost.

On an afternoon panel of the conference about archiving the sexual body, Ron riffs about the grotesque and the "nasty girls' disease," which is how he and Cory and the *Infected Faggot Perspectives* cohort referred to the plague in reference to *The Color Purple* and the unapologetic sexuality of Shug, with a laugh and a rebellious glint in their eyes, insisting on the glorious messiness of unrepentant desire.

I think again about Ron's dance collaborators, and about Butoh, which was developed in the aftermath of World War II as a way of subverting traditional notions of beautiful movement, to give bodily and symbolic exploratory space—sometimes playful in its exaggerated embodiments—

to the grotesque, to decay, to sexuality and death, and to that which was otherwise taboo. Just as the images in Carolyn Forché's gathered poetry of atrocity are evidentiary of those atrocities even in the absence of specific naming, so too are our bodies evidentiary of the unnamable in our time. And in our bodies' relationships to absence, we are evidentiary of the absent, the missing, the dead.

We make art from the questions in our embodied lives. Magnified, offering not answers but a range of feelings, of affective responses, affective possibilities for when that amplified grotesque becomes the unimaginable present. The way art makes visible that which we are without words to say.

Where did those fragmented knowledges about bodies and boundaries and the defiant resistance to sterile distance live in my psyche as I peeled the blood-saturated gauze from Cory's battered body with my naked hands? It isn't fetishizing as much as it is seeking out the performative models of amplified experience through which we might learn to tolerate our actual embodied lives.

And still.

I will never not have had Cory's blood on my cheeks, my throat, caught in the web of my eyelashes, the astringent tang bursting on my tongue. I will never not have his blood on my hands.

how memory works

I'VE WALKED DOWN the corridor from my doctor's office to the cubby occupied by the phlebotomists, who rotate between the small practice and the larger hospital across town. I haven't met this phlebotomist before. I sit down in the chair to wait for him. When he's ready, he turns around, and I notice four rings through the delicate cartilage at the top of his left ear, black ink swirling up his forearms under the pushed-up sleeves of his lab coat.

"We're taking a lot of blood from you today," he says, looking at the lab slip and noting all of the annual labs my doctor requests, and the HIV test I've asked for. He reaches into a drawer for a stack of empty vials and labels them all with my name and date of birth.

While he rolls gloves onto his hands and pulls them tight against his fingers, I push up my sleeves, stretch out my arm, and make a fist.

"This is beautiful"—he looks closely at the lotus on my outstretched left arm—"the shading is gorgeous. I love that you can see uncolored skin in the middle of the petals. Such an interesting choice."

But that wasn't the original choice. The open spaces where he can see my skin were once filled in with white ink that blended into the delicate pinks and deep fuchsias. Over time the edges have softened, and the white has faded, leaving my skin visible.

I picture Robert, his head tipped low to my arm, tracing the petals with shaking fingers.

Robert.
Wayne.
Roxy.
Tura.
Wade.
Gabe.
Ferd.
Connie.
Jim.
Sister X.
Pete.

Cory and Steven have been dead for more than half my life.

The phlebotomist tightens a tourniquet around my bicep and taps my arm just above Robert's tattoo, trying to get a vein to rise. I know this routine. It's early morning. I've already had two cups of coffee and been to the gym, where I've run toward nothing on the treadmill and lain on the bench press, pushing until my torn rotator cuffs burned, the skin bright red around the adhesions, forcing my blood to run close to the surface. "This will only hurt a little," he says, and slides the needle under my skin.

THIS ISN'T THE WHOLE STORY. *Tell the story, the whole story*, Mary would say. I hate the whole story. And I can't let go of the story. I turn it over and over in my hands, worrying it until it frays at the edges, but still the shape of it stays the same.

It will never be the whole story. Even as I tell it, I remember things that I have not (yet?) said. Moments that have no language. If I cannot (yet?) move it into the realm of language, of articulation that moves it from within my body out into the world as breath and sound, then is it memory? Or is it still present tense, living in me? To declare something memory does not isolate it to the past. It acts in us still.

Memory works like this.

The most accurate memories are those that remain unarticulated, not subject to language and interpretation. Which means that the most accurate memories are those that we have not told together, that remain separate. Isolated. Not compared or cocreated. And so what we mean by memory is something more like story, more like the feeling of bodies responding to each other while metabolizing the histories we carry with us and responding to each other's histories metabolized as body stories. That even without, or before, language, we are telling stories. Representations in service of connection. We remember it as we felt it. As we still feel it when we recall the spaces occupied by our bodies in connection.

And still.

Are the truest stories the ones we still haven't told? The ones we will never be able to tell together?

Memory works like this.

My movements back and forth between Cory and Steven felt a little like the skittering forward and backward movement impulse of my response to Mehmet Sander's dance experience that first World AIDS Day all-night vigil at Highways. A fluid pull back and forth, if only in me. But the spaces they occupied, that they pulled me into with them, kept shifting. One day Steven moved us muscularly out into the world to a demonstration or needle

exchange. The next morning would be quiet with Cory as he fought a fever. Or Cory would pull me out into the world to fight the fundies, or bail Wayne or Pete out of jail, or go to Fuck!, and Steven would ask me to settle into the slow precision of poetry and the lyric riff and breath of Billie Holiday. The movement from Cory to Steven was an embodied enactment of the complications of what our bodies represented to each other. The spaces possible between us.

That night with Cory, the first night he asked for the pills, it wasn't the shit and piss that scared me, the bone-deep tremors he swore wasn't a seizure, and I was too paralyzed not to believe him, needed desperately to believe he was right. It was the look. Or the nonlook, the blank eyes that stared at me in the middle of the night. Sitting upright in bed, facing me. I had turned on the light. He had, without my help, stood up and sat back on the bed. He didn't know what happened, then he did. Then he didn't again. We were looking at each other, neither of us knowing what to do. I felt paralyzed. He said, *I'm all right, honey, I'm OK.* He gathered my hair up into a ponytail in his hands, reaching behind me—we were sitting that close—then twisted my hair into a rope he wrapped around his hand—he had done this before. Before, I had tipped my head forward, leaning closer to him but also testing the pull, the tension between us in the cord of my hair, then tipping my head back, surrendering to his gravity. But when I looked up into his eyes, they were blank. Absent. *Love,* I said, *Love.* Nothing. *Cory.* I took a deep breath. Then louder. *Cory.*

He came back. It was like watching lights flicker on. That moment when you don't know if the light will stay. I don't know how else to say it. He returned from death. From absence. He unwound my hair from his hands and dropped his hands to his sides. *I'm tired,* he said. *Yes, love. Let's get you cleaned up,* I said. He wasn't as unsteady on his feet as I expected him to be. He stood in the shower, and I changed the sheets and remade the bed and then joined him in the shower when he called to me. *I'm so tired,* he said, and I held him up, and then we crawled back into bed. *Sleep, love.* And then the fight. I wanted him to go to the hospital. How do we decide when to let each other make decisions? I acquiesced to his desire not to go to the hospital. And I refused to give him the lethal dose of drugs. Because I had just seen him come back. And I wanted to believe that he always would. That he always could. Come back. I forced him into a liminal space of partial survival. What does it mean to surrender to his will? To not surrender to his will? To have faith not that he will be OK, for the first time not believing that, but believ-

ing that what he had was some sense of control. I never asked him if he took any pills before we went to sleep that night. If he had already decided, and I was there so he wouldn't be alone, and so maybe his waking was itself a sense of betrayal, of his body, his choices, and I amplified it by my refusal. I don't know what it felt like to him that night. But for me, he came back from the dead and showed me his proximity to that edge, moving closer to it, farther away from me.

And so it isn't exactly that Steven was a rebound connection in flight from Cory. It isn't that linear. We don't move from one to the other. We take breaks, refuge. Each of them had a different proximity not just to death but to hope. The proximity is bodily, and so is the refuge. We borrow each other's strength just as Cory and Pete and Wayne borrowed each other's T-cells. It's symbolic. And also, if you believe it, it's real. Steven was never sick. Not in the feeling of our time together, or in the corporeal reality of it. That weekend, I left Cory's broken body. Not in a quick-moving, panicked flight (though it felt that way), but he asked me to leave him. To go back out to our collective of queers moving into the world. Wherein Steven was, not waiting for me, but living, and from that precise vitality held out his hands. And I didn't know what else to do than to comply with Cory's demand. Now, I can look at the story two ways—I was acquiescing to his agency, his authority over himself. Or I was scared and running away.

I lived through the loss of Cory's body, felt it with my own, the thinning of his skin, the thinning of his bones. But not Steven. I wasn't there to witness it. I left. And so I do know he's dead. But some days I still don't believe it. I don't know it in my bones, in my skin. I didn't feel it. There was no transition. No moment of recognition. Just. Here. Gone. Still gone.

I've been finally doing what Steven and Cory asked of me when I was seventeen: writing the story of us. Those of us who are still here struggle to make the unconscious conscious. And none of us remember it the same. Now we each offer our stories to each other, and their intersections hold the space of the possible, the way we make meaning and symbol and narrative now of what happened then. How we give language to the things we couldn't give language to then. We write into the shape of absence, filling in the blank spaces left by each other's vanished bodies. Again and again. The assertion of counternarrative claiming their presence as the history that builds our present. Still here. Even in our breath.

Over and over I write the same words: *Risk. Ferocity. Eros. Love. Lust. Surrender. Loss. Desire. Contamination. Love*, again. *Loss*, again. And they

all mean the same thing: that unendurable and repeating moment when the chest is broken open, stretched wide and collapsed in ecstatic ruin.

I ALREADY KNOW WHAT the test results will be. Sometimes I think it doesn't matter. And I know it matters deeply. It will be the same as it has always been. My body lives in the liminal space of having resisted, at the most cellular level, infection but having integrated, viscerally and symbolically, the most persistent and invasive reminders of the disappearance of those I've loved. Their daily presence and daily absence is written in the fading ink of Robert's lotus.

I talk to Steven, or at him, almost daily. And he teases me, shakes his head. The things I remember, the things I hold on to, I know they aren't the same things he would have held on to. That is the maddening trope of memory's inconsistent collective farce: we don't remember it the same. We don't assign the same meaning. And yet. If only, I tell myself, I tell him, when I argue with the projection of his interpreted psyche in my own head, if only he were still here. His arms around me. The thrum of his heartbeat steadying my own, my arms looped around his waist as they always were, his chin still resting on my head, my cheek against the contours of his chest—the body-stories remember. Just for this moment. As always. Still.

Cory leaves a different absence. My body is the archive not of him but of my relationship to him, his relationship to me, his art, our witnessing of each other and the way we lived through the loss of those we loved. Cory lives not replicated in me but translated in me and through me as I move through the world that he no longer inhabits. Not encoded in my blood but in the sense memory of my flesh, in my kinesthetic story, the way my body has learned to move through space and time—the shape of him metabolized in me, the shape of his absence compelling me. The longing. The feeling memorized. The echo.

We want so desperately to save each other.

We can't save each other.

"It's a love story," Mary says. "Tell the whole story."

But how can we know the whole story? It isn't fixed in time. It shifts even as, or because, we tell it, because we grasp on to memory, to the feeling of it. To the feeling of each other.

There are so many ways the heart can be broken. And there are so many ways the body can be broken.

I watch as vial after vial fills with the deep crimson of my blood, laid out on the phlebotomist's stainless steel tray.

(Is it possible not to die of AIDS?)

This love. This loss. This longing.
 It breaks us.
 It takes our breath away.
 It bleeds us dry.

Nancy MacNeil

1950–2023

Mary Lucey

1958–2023

epilogue

ENDNOTES ONGOING—AN INCOMPLETE LIST

WE WILL NEVER BE ABLE TO COMPLETE THIS LIST. We don't know how many people we lost. How many people died or were killed before we/they knew there was a collective "us" to assemble and find. How many people never came forward because fear and stigma worked to keep people isolated and ashamed. How many people were terrified into complacency and hiding. How many people died alone.

This is the list compiled by some of the remaining members of ACT UP/LA and Queer Nation/LA, who also overlapped with Colors United and the Gay Men of Color HIV/AIDS Network, Club Fuck!, and Highways Performance Space.

This list also includes the known and loved members of our communities who have died of illnesses and addictions not specifically noted as HIV. We understand their deaths to be symptomatic of the plague years, of the assaults on our bodies and psyches, the traumatic toll of loss and survival, as well as the ongoing cultural conditions of inadequate health care access and health industries that continue to prioritize "chronic and manageable" (which will never be manageable for those with insufficient health care) over cures. Their deaths are the result of the long-term toxicity of early HIV medication. Their deaths and absences are results of the ongoing

criminalizations of addictions; sex work; Black, brown, refugee, and immigrant bodies; and HIV.

These are some of the people who we loved and lost and who daily we mourn and remember.

This list will never be finished.

Mark Kostopoulos	Chris Brownlie
Robert Nemchik	Bill Oxendine
Cliff Diller	Gil Cuadros
James Stone	Marshall Rio
Richard Iosty	Rockabilly Dave
Jerry Mills	Curtis York
Sven Svenson	Stuart Timmons
Sister X (John Chidester)	Rana Ross
Michael Callen	Dan Cusick
Rob Roberts	Puck
James Carroll Pickett	Alexis Rivera
Roxy Ventola McGrath	Billy Pollard
W. Wayne Karr	Muffy
Steven Corbin	Branch Hastings
Cory Roberts Auli	Matthew McGrath
Tura (Greg Carlisle)	Robert Navarette
Connie Norman	Stephanie Boggs
Gabriel Arreola	Marco
Renee Edgington	Miranda Rose
Ferd Eggan	Glen Graber
Pete Jimenez	Manny Rodriguez
Mario Gardner	Silvia Arevalo
Lori Avila	Billy Rosas
Sean Kinney	Dwayne Patrick Calizo
Greg Blakeney	Essex Hemphill
Larry Day	Sister Boom Boom (Jack Fertig)

Josh Wells

Tony Madsen

Brian Murphy

Mark Jones

Tony Espinoza

Tim Welch

Rex Shepard

David Pucillo

Debra Eli

Neil Hathaway

Keith Brier

Terry Jones

Marco Giron

Charlie Haberman

Vincent Ventola

James Sakukura

Roger Pamplin

Wilson Ong

J. Víctor López

Butch Dehner

Kaisik Wong

Miguel Beristain

Sara Lee

Travis John Alford

Reza Abdoh

David Wojnarowicz

Randy Amasia

Cary Bobier

Gunther Freehill

Tony Balcena

Robert Birch

Tiffany Marrero

Reverend Mother

Scott Robbe

Cat Walker

Eric Rofes

Justin Chin

Peter J. Corpus

Judy Kristal

David Lacallaide

Mary Lucey

Nancy Jean MacNeil

Paul Monette

Charles Fogarty

Uncle Jimmy Hulse

Jim Kepner

Daniel Blair

Juanita Mohammed Szczepanski

Kiyoshi Kuromiya

Philip Juwig

Robert Sessions

Max Drew

David Stebbins

Joe Fraser

Robert Chesley

Clark Henley

Eric Lim

Michael Taylor

Tom Eyen

Mark Thompson

Christine

Angel

Roberto

Ray Navarro

Unnamed, undocumented
homeless trans woman
from China
The man from Singapore
who once danced
endlessly at Oil
Can Harry's

The man from China
fighting heroin addiction
who could not speak
English but could say
Klonopin

acknowledgments

This book found form over many years, starting with a conversation about Cory's blood art, and how people were starting to forget the early plague years just as Cory's shrouds were beginning to crumble. I thought I was writing an essay about Cory's art practices, but Steven kept entering, and then so did Mary, and the memory of Jim Pickett's last play, and the faces of our dead, and the cacophony of voices just like the chatter during late-night ACT UP meetings. And Jeff and Susan chimed in to help me remember things that were foggy or that I hadn't been present for but knew had shaped my experience. Just as we all continue to enter and shape each other's stories.

The following are some of the people who have entered into my story and to whom I owe deep gratitude:

Rabbi Susan Goldberg, for insisting that we go to Highways on World AIDS Day in 1990 and for always asking me to come home.

Sonia Slutsky, for the photos without which I might not believe we were ever that free.

Maxine Scates, for being my first and most trusted reader.

JD Davids and Joël Barraquiel Tan, for deep love and queer fearlessness and endless conversations about queer histories and the ethical imperative of remembering.

Ian Grand and Becky McGovern, for reading early drafts and asking for more.

Lidia Yuknavitch, for everything.

The following people had important conversations with me at crucial moments of this project: Jorge Ignacio Cortiñas, Ron Athey, Anne-christine d'Adesky, Alexander Chee, Eric Wat, Jih-Fei Cheng, Mattilda Bernstein Sycamore, Susan Forrest, Mia Du Plessis, Rabbi Robin Podolsky, Sandy Guevara, Kate Sorensen, Wendell Jones, Jansen Matsumura, Tristan Taormino, Michael Kearns, Toro Castaño, Dont Rhine, Christopher Roebuck, and Lynn Ballen.

Thank you to the surviving and lost members of ACT UP and Queer Nation.

Thank you to Judy Ornelas Sisneros, Jordan Peimer, Helene Schpak, Mary Lucey, and Nancy MacNeil for the labor and vision of the ACT UP Los Angeles Oral History Project.

Deep thank you to Mark Bronnenberg for holding the whole story.

Thank you to Highways Performance Space, Club Fuck!, Being Alive, A Different Light Books, Skylight Books, and all of the bookstores, cafes, and performance spaces which held us through the nights, and where we were safe in our mutual recognitions.

Thank you to Plummer Park, Echo Park Lake, Elysian Park, and all of the urban green spaces which have resisted the sprawl of gentrification.

I have enormous appreciation for the editorial staff at Duke University Press, who have been so generous with their time and careful with their attention while ushering this book into the world. Joshua Gutterman Tranen believed in this project from the beginning and has guided me through this process with unflinching excitement about the politics and poetics I was reaching for. And I am especially grateful for the ongoing editorial care and wisdom of Ken Wissoker, Lisa Lawley, and Ryan Kendall. Gratitude to Aimee Harrison for the gorgeous book design, and for understanding exactly what the cover needed to be.

Thank you also to the two anonymous readers, whose precision and insight challenged and strengthened this book.

I owe a special thank you to the editors of anthologies, journals, and websites where early versions of some of these stories found a home. Karen Ocamb has long been writing about, with, and for us and graciously published some of my early essays from this project on her now-vanished website LGBTPOV (lgbtpov.com). JD Davids published an early version of the story of the Sex Police/SB-982 civil disobedience action on TheBody: The HIV/AIDS Resource (https://www.thebody.com). Zoe Zolbrod published an early version of the Rodney King rebellion story on the *Rumpus* (https://therumpus .net). Mia Du Plessis published the first few pages in a special edited issue of

CR: *The New Centennial Review*. A section originally titled "Music Is a Scar in the Silence" found a good home with Jennifer Patterson in the now-dismantled journal *Hematopoiesis*, which also nominated that section for a Pushcart Prize in 2017. And a section found conversation and home with Mattilda Bernstein Sycamore in her 2021 anthology published by Arsenal Pulp Press, *Between Certain Death and a Possible Future: Queer Writing on Growing Up with the AIDS Crisis.*

Thank you to the artists, and the guardians of the estates of passed artists, for allowing me to reprint portions of their work and trusting me to nurture and enliven the associative relationships between past and present:

David Wojnarowicz Foundation

Michael Kearns and the Estate of James Carroll Pickett

The Estate of Sekou Sundiata

Thank you to my queer forever family, the living and the dead: Cory Roberts Auli, Steven Corbin, Mary Lucey, Nancy MacNeil, Pete Jimenez, Jeff Schuerholz, and Seh Welch.

Immense love for my parents, Harvey and Kaz Lane, for trusting me and for raising me in a family that believes above all else in making art, taking care of the people you love, and trying to make the world a little kinder and more just.

And always, love, awe, and so much gratitude for my partner, Lisa Denenmark, who makes everything possible.

notes

THE PROBLEM OF THE STORY

1 Pickett, *Queen of Angels*, act 1, scene 1, page 2. An early draft of the play was gifted to me by the playwright in 1993.
2 Translation/interpretation by author.

THE BEGINNING

1 Olga Broumas, "Privacy," in *Perpetua*, 94.
2 Olga Broumas, "The Knife," in *Perpetua*, 89.

AN ARCHIVE OF IMPENDING LOSS

1 Karr, "AIDS-Phobes Make Me Puke," 2–4.
2 Auli and Karr, "Dear Crypta," 2.
3 Auli and Karr, "Crypta la Cockus," 4.
4 Auli and Karr, "Crypta Speaks," 4–5.
5 Gray, personal ad, 7.
6 Karr, "Queer AIDS Activist Free at Last," 3.
7 Duplechan, "BLK Interview," 17.
8 Butler, *Undoing Gender*, 19.

WHAT LOVE IS

1 Meeropol, "Strange Fruit."
2 Meeropol, "Strange Fruit."

AFTER LEAVING

1 Pickett, *Queen of Angels*, act 1, scene 9.
2 Howe, *What the Living Do*, 43.
3 Howe, *What the Living Do*, 44.
4 Forché, "Reunion," in *The Country Between Us*, 49.
5 Szymborska, "Anycase," in Forché, *Against Forgetting*, 458.
6 Seress, "Gloomy Sunday."
7 Seress, "Gloomy Sunday."
8 Sanchez, "Poem No. 10," in *Homegirls and Handgrenades*, 10.
9 David Wojnarowicz, text from *When I Put My Hands on Your Body*, 1990, gelatin silver print and silkscreen text on museum board.

PLAGUE POETICS AND THE CONSTRUCTION
OF COUNTERMEMORY

1 Forché, "The Angel of History," in *Angel of History*, 12.
2 Forché, "Elegy," in *Angel of History*, 69.
3 Forché, "The Garden Shukkei-en," in *Angel of History*, 71.
4 Benjamin, "Theses on the Philosophy of History."
5 Carolyn Forché, poetry reading and lecture, Reed College, Portland, Oregon, October 17, 1996.
6 Brecht, "Motto."
7 Akhmatova, "Requiem," 101.
8 Forché, "The Notebook of Uprising," in *Angel of History*, 32.
9 Forché, "Elegy," in *Angel of History*, 69.
10 Doty, *Heaven's Coast*, 4.
11 Sundiata, "Blink Your Eyes."
12 Sundiata, "Blink Your Eyes."
13 Szymborska, "Anycase," in Forché, *Against Forgetting*, 458.
14 Kushner, "AIDS, Angels, Activism," 54.
15 Des Pres, *Survivor*, 81.
16 Howe, "A Certain Light," in *What the Living Do*, 44.
17 Kushner, *Millennium Approaches*, 32–34.
18 Kushner, *Perestroika*, 20.
19 Clifton, "she lived," in *Book of Light*, 20.

THEN, AFTER

1 Broumas, "The Massacre," in *Perpetua*, 40; excerpt from Cassells, "The Bargain," from "The Magician-Made Tree," in *Beautiful Signor*, 19.

THE REMEMBERERS

1 Tan, "exile—1991," in *Type O Negative*, 75.
2 Butler, *Undoing Gender*, 19.
3 Kushner, *Perestroika*, 144.

ON ARCHIVES

1 Sontag, *On Photography*, 11.
2 Ron Athey, qtd. in Johnson, *Pleading in the Blood*, 61.
3 Szymborska, "Anycase," in Forché, *Against Forgetting*, 458.
4 Muñoz, *Cruising Utopia*, 1.
5 Phelan, *Mourning Sex*, 3.
6 Doyle, *Hold It Against Me*, 20.
7 Doyle, *Hold It Against Me*, 67.

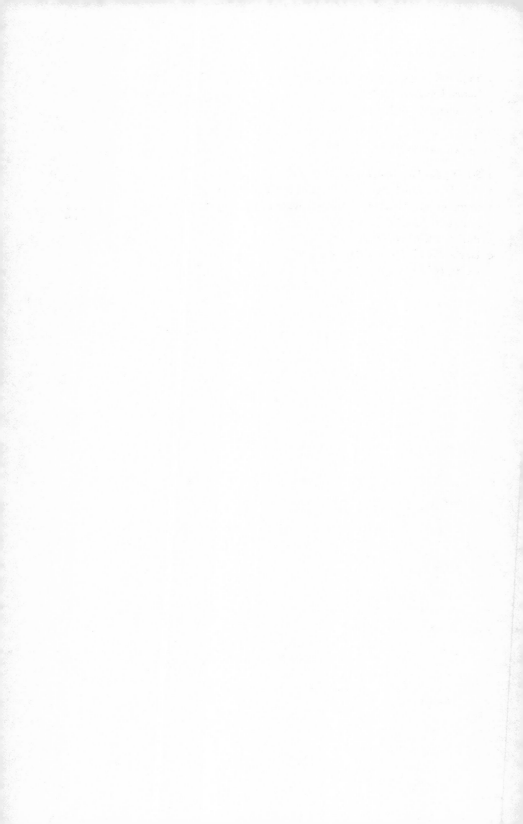

bibliography

Akhmatova, Anna. "Requiem." In *Against Forgetting: Twentieth-Century Poetry of Witness*, edited by Carolyn Forché, translated by Stanley Kunitz and Max Hayward, 101–2. New York: Norton, 1993.

Auli, Cory Roberts, and Wayne Karr. "Dear Crypta." *Infected Faggot Perspectives*, no. 3 (October 1991).

Auli, Cory Roberts, and Wayne Karr. "Crypta la Cockus." *Infected Faggot Perspectives*, no. 4 (December 1991).

Auli, Cory Roberts, and Wayne Karr. "Crypta Speaks." *Infected Faggot Perspectives*, no. 5 (January 1992).

Benjamin, Walter. *Theses on the Philosophy of History*. Quoted in *The Angel of History*, by Carolyn Forché, ix. New York: Harper Perennial, 1994.

Brecht, Bertolt. "Motto." In *Against Forgetting: Twentieth Century Poetry of Witness*, edited by Carolyn Forché, 27. New York: Norton, 1993.

Broumas, Olga. *Perpetua*. Port Townsend, WA: Copper Canyon, 1989.

Butler, Judith. *Undoing Gender*. New York: Routledge, 2004.

Cassells, Cyrus. *Beautiful Signor*. Port Townsend, WA: Copper Canyon, 1997.

Clifton, Lucille. *The Book of Light*. Port Townsend, WA: Copper Canyon, 1993.

Des Pres, Terrence. *Survivor: An Anatomy of Life in the Death Camps*. New York: Oxford University Press, 1986.

Doty, Mark. *Heaven's Coast*. New York: Harper Perennial, 1996.

Doyle, Jennifer. *Hold It Against Me: Difficulty and Emotion in Contemporary Art*. Durham, NC: Duke University Press, 2013.

Duplechan, Larry. "The BLK Interview: Steven Corbin." BLK 4, no 1 (Jan. 1992): 11–25.

Forché, Carolyn, ed. *Against Forgetting: Twentieth-Century Poetry of Witness*. New York: Norton, 1993.

Forché, Carolyn. *The Angel of History*. New York: Harper Perennial, 1994.

Forché, Carolyn. *The Country Between Us*. New York: Harper and Row, 1982.

Gray, Richard. Personal ad. *Infected Faggot Perspectives*, no. 2 (October 1991).

Gund, Catherine, dir. *Hallelujah! Ron Athey: A Story of Deliverance*. In collaboration with Ron Athey. Aubin Pictures, New York, 1997.

Howe, Marie. *What the Living Do*. New York: Norton, 1997.

Johnson, Dominic, ed. *Pleading in the Blood: The Art and Performances of Ron Athey*. London: Live Art Development Agency, 2013.

Karr, Wayne. "AIDS-Phobes Make Me Puke." *Infected Faggot Perspectives*, no. 1 (September 1991).

Karr, Wayne. "Queer AIDS Activist Free at Last." *Infected Faggot Perspectives*, no. 8 (April 1992).

Kushner, Tony. "AIDS, Angels, Activism, and Sex in the Nineties." Interview by Patrick Pacheco. *Body Positive*, September 1993, 17–28.

Kushner, Tony. *Millennium Approaches*. Part 1 of *Angels in America*. New York: Theater Communications Group, 1993.

Kushner, Tony. *Perestroika*. Part 2 of *Angels in America*. New York: Theater Communications Group, 1993.

Meeropol, Abel. "Strange Fruit." 1937. Billie Holiday. https://billieholiday.com /signaturesong/strange-fruit/.

Muñoz, José Esteban. *Cruising Utopia*. New York: New York University Press, 2009.

Phelan, Peggy. *Mourning Sex: Performing Public Memories*. New York: Routledge, 1997.

Pickett, James Carroll. *Queen of Angels*. Draft gifted by the playwright in 1994.

Sanchez, Sonia. *Homegirls and Handgrenades*. New York: Thunder's Mouth, 1984.

Scates, Maxine. "The Border." In *Toluca Street*, 60. Pittsburgh: University of Pittsburgh Press, 1989.

Seress, Rezsó. "Gloomy Sunday." 1933. Billie Holiday. https://billieholiday.com /signaturesong/gloomy-sunday/.

Sontag, Susan. *On Photography*. New York: Farrar, Straus, and Giroux, 1977.

Sundiata, Sekou. "Blink Your Eyes." *The Blue Oneness of Dreams*. Mercury Records, 1997.

Szymborska, Wisława. "Anycase." Translated by Grazyna Drabik and Sharon Olds. In *Against Forgetting: Twentieth-Century Poetry of Witness*, edited by Carolyn Forché, 458–59. New York: Norton, 1993.

Tan, Joël Barraquiel. *Type O Negative*. Los Angeles: Red Hen, 2009.

credits

Sekou Sundiata, excerpt from "Blink Your Eyes" reprinted with permission of the Estate of Sekou Sundiata.

David Wojnarowicz, text from *When I Put My Hands on Your Body*, 1990, gelatin silver print and silkscreen text on museum board. Used by permission of the David Wojnarowicz Foundation.